DANISH PAINTING AND SCULPTURE

DANISH PAINTING AND SCULPTURE

BY

VAGN POULSEN

DET DANSKE SELSKAB

*The Danish Institute for Information about Denmark and
Cultural Cooperation with Other Nations*

1976

Text by
VAGN POULSEN

Translated by
SIGURD MAMMEN

2. edition revised by
H. E. NØRREGAARD-NIELSEN

Cover
C. W. Eckersberg: Study of a Nude in
Front of a Mirror

Printed in Denmark by
KROHNS BOGTRYKKERI

Published with a grant from the foundation:
»Konsul George Jorck og Hustru Emma Jorck's Fond«

CONTENTS

INTRODUCTION

Strictly speaking Danish art has a history of little more than two centuries, but works of art have been known and appreciated in this country as long as it has been inhabited. That glorious outburst of the genius of painting in palaeolithic man, manifested in the caves of Southern France and Spain—Altamira and Lascaux are the landmarks of this first chapter in the history of European art—has left no traces in our part of the world, for the good reason that Scandinavia was not yet fit for human beings to live in. With the arrival of man, Denmark got its share of the widespread Neolithic civilisation whose artistic activity seems to have been limited to crafts and manufactures. This, in fact, remained the attitude of our ancestors throughout the succeeeding periods of the Stone Age, Bronze Age, and even Iron Age, when wonders of painting and sculpture were being produced in the happier countries round the Mediterranean. So pottery, flint carving and, later on, bronze casting were occupations carried to a high degree of perfection in pre-historic Denmark, but when real art treasures occur they are invariably imported from abroad. It is not known for certain where lived the man who created the magnificent Gundestrup silver cauldron—however, he seems to have been a Celt from the part of Europe now known as France. The two fine Hoby goblets with their elegant decorations of Homeric scenes are signed by a Greek silversmith, Cheirisophos, who must have been a purveyor to the court of Augustus in Rome.

With Christianity both painting and sculpture invaded Denmark in the wake of the conquering Church, and a wealth of medieval art treasures have survived the hostility of victorious Lutheranism and the

negligence of centuries blind to the charms of the Romanesque and Gothic styles. It is, however, not yet possible to regard this early stage as part of the history of Danish art, unless we want to take the credit for works by Lombard, French, English, and German artists, whom it should be honour enough for medieval Denmark to have appreciated, to have acquired their masterpieces, or even to have employed them in her service. It is true that not every work of medieval sculpture or painting in a Danish church is foreign; indeed, the great majority can with greater probability be ascribed to native craftsmen, but it is equally true that there is nothing remotely like a national style or even a peculiar Danish flavour, unless it be a sort of crude provincialism. Everything of more than strictly local interest can safely be ascribed to foreign artists. Or nearly so—for it must not be forgotten that the pride of the medieval collection of our National Museum, "The Golden Altars", gilt copper reliefs made to cover the front of wooden altar tables, are monuments which have only survived in our country, and are therefore sometimes supposed to be of local workmanship. The best preserved and oldest among them, the Lisbjerg Altar, dates from the middle of the 12th century. It includes a seated Virgin with the Child, made of cast metal, quite different from, and as a work of art, vastly superior to the chased reliefs. So, whoever created the Lisbjerg Altar evidently imported from abroad a fine statuette of the Virgin in order to make her the centre of his *antemensale*, but there is no indication of where the workshop was located. It must be borne in mind that, no doubt, such chased copper altars were used in many places as cheap substitutes for altars of real gold like the unique treasure of Basle Cathedral, now the property of the Musée Cluny in Paris. Herlufsholm College owns the largest known medieval ivory, a *crucifixus* whose arms are made of walrus tooth. This wonderfully sensitive work of art, a masterpiece of the 13th century, has been ascribed to a French sculptor. Even if he may have carved his crucifix

The altar of Lisbjerg Church, East Jutland, (now in the *Nationalmuseum*). The best preserved and most beautiful of a small number of 12th century altar decorations. Copper, embossed work, possibly executed in a Danish workshop. Only the Madonna and Child occupying the central position on the frontal is in cast metal and, judging by the style, of French origin.

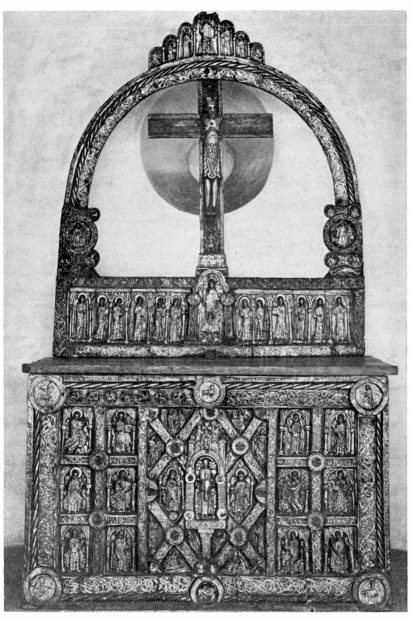

9

during a visit to Denmark, he has, unfortunately, left no other traces of his activity in our country. The 14th and 15th centuries produced an ever-increasing mass of church sculpture, which was, however, dominated by steadily increasing German influences. The greatest name of the late Gothic style in Denmark is *Claus Berg* whose workshop was the most important in Northern Europe during the last decades of Catholicism. Its main work is the large wooden altar in Odense Cathedral.

Besides with sculpture, often imported from abroad, many of our medieval churches were lavishly adorned with wall-paintings in fresco. There are among them sincere and touching works of art, but more often than not they lack the finer shades of expression. Frescos painted in the period preceding the collapse of Catholicism in Denmark were obviously made to serve the purposes of popular ecclesiastical propaganda.

The Reformation dealt a deadly blow to our flourishing late medieval church art. In 1530 a mob, led by the mayor of the city, violently attacked the altars of the Saints in Copenhagen Cathedral, and six years later Lutheranism became the official religion of Denmark. Before that date the enormous importation of sacral art from Germany had begun to be supplemented by altars and tomb monuments from the Netherlands, notably wood-carvings from the famous workshops of Antwerp. Later in the 16th century, when the Kings took over the patronage of the Fine Arts, they definitely looked to the Low Countries for artists of all kinds to meet their growing demand for that artistic splendour which is the glory of a court. Already Christian II had his sinister features immortalized by *Michel Sittow,* a painter born in Reval but trained in Bruges, who visited Denmark in 1514. This small but terrifying portrait, dated 1515, was the beginning of our Royal Art Gallery and can, in a sense, be regarded as the starting point of modern art in Denmark. Christian II was the brother-in-law of the Emperor Charles V, and later—when living in Flemish exile—got in

Michel Sittow: King Christian II of Denmark. (Oil painting dating from 1515, in *Statens Museum for Kunst*). This masterpiece of Flemish portraiture, representing one of the strangest personalities of Danish history, marks our first meeting with the great tradition in European painting.

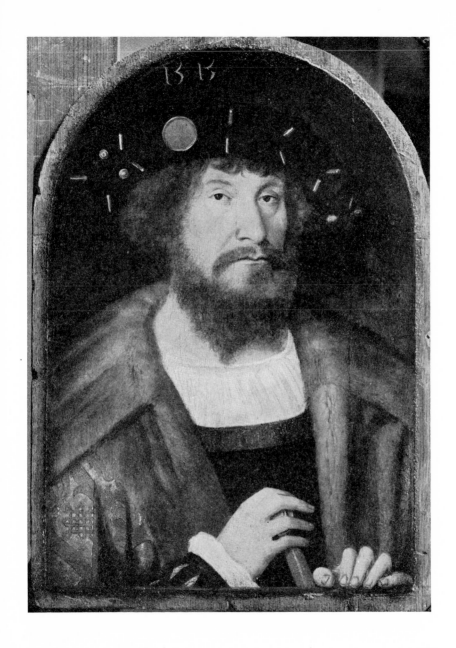

11

touch with Quentin Massys, Jan Gossaert, Albrecht Dürer, and other celebrities of the day. But, as he only returned to his country to end his life in state prison, these contacts were of no consequence for the artistic future of Denmark. The National Gallery in London owns the wonderful portrait which Holbein painted in Brussels in 1538 of King Christian II's young daughter, Christina, then Dowager Duchess of Milan, who happily escaped marrying Henry VIII, and ended her life as Duchess of Lorraine.

Frederik II undertook the transformation of the medieval fortress at Elsinore on the Sound to a modern castle, the most beautiful Renaissance building in Northern Europe, to which he gave the name of "Kronborg". *Antonius van Opbergen,* a citizen of Malines, who in 1577 was appointed to finish the work, which had been begun by others, is given the credit for the glorious result. The courtyard of the castle was adorned with a fountain produced, with the assistance of other artists, by *Georg Labenwolf,* the well-known Nuremberg-specialist. One of his assistants was *Johann Gregor van der Schardt* (born in Nijmegen but trained in Italy), whose painted terracotta bust of the bitter, sharp-eyed king is a treasure of the Frederiksborg Museum, and occupies a place in the art history of Denmark similar to that of Sittow's painted portrait of Christian II. Still more interesting from our point of view, because it pointed in the direction of artistic activity of a more permanent kind, is Frederik the Second's decision to engage *Hans Knieper* of Antwerp to establish a tapestry workshop in Elsinore. Thus, in the 'eighties of the 16th century a magnificent series of Flemish tapestries was produced on the shores of the Sound. The series included even legendary kings, and so was a more than complete portrait-gallery of the Kings of Denmark since the darkest ages. These tapestries were to cover the walls of the enormous banquet hall, and with them was made a splendid canopy to crown the royal seats. The latter is now in Stockholm, while the few surviving tapestry portraits are devided between Kronborg Castle and the National Museum, Copenhagen. We behold the large royal figures, clad in armour or state robes, on a background of luxuriant landscape and lordly architecture. As long as the series was preserved as a whole these hangings must have been an adornment

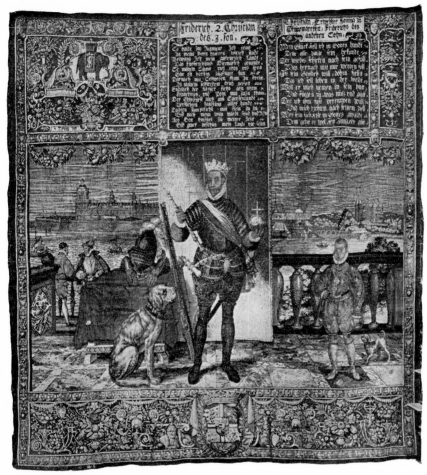

King Frederik II in front of Kronborg Castle. (Tapestry, produced 1581–84 in Elsinore from cartoons by Hans Knieper. Now in the *Nationalmuseet*). The Flemish tapestries for The Knights' Hall of Kronborg Castle resulted from an art policy which — had it been maintained at the same high level — might have raised pictorial art to an honourable position in Denmark already in the 17th century.

worthy of the building. Together these two masterpieces of Flemish art brought the first message to this country of the new grandiose style inaugurated in European art by the Italian Renaissance.

13

In the arts, as well as in politics, Frederik II had a happier hand than his long-lived and much more popular son, Christian IV (1588-1648). The latter, however, in 1616 ordered a fountain for his castle of Frederiksborg from Adrian de Vries, a European celebrity of the first order and pupil of the great Giovanni da Bologna. Its many bronze statues were carried off, incidentally, by the Swedish army in 1659, together with Labenwolf's Kronborg fountain, and only scattered fragments of these two large sculptural ensembles have been preserved in Swedish collections. Painting was favoured by King Christian with more enthusiasm than discrimination. In this domain his most lasting success was the importation of two not very outstanding Dutch portrait painters, *Karel van Mander III* (c. 1609-1670), (grandson of the author of the first historical treatise on Dutch and German painting, published in 1604) and *Abraham Wuchters* (c. 1610-1682), his brother-in-law. They came because they were needed, and the fact that they settled in Denmark proves that they knew both how to meet and how to stimulate the demand for works of art. Even if they fall short of the great Dutch painters of their century, they were like shining stars in Denmark whose King and nobility might easily have been—and on other occasions certainly were—much worse served. Above all, they paved the way for Danish art in the proper sense of the word, whose rise the following century was to witness.

But first taste underwent another change. When, in 1660, Frederik III broke the political power of the old nobility and established hereditary and absolute monarchy, he looked to France for inspiration. Also in the sphere of the Fine Arts France became, and for a long time remained, the great ideal. A French portrait-painter, *Jacob d'Agar* (1642-1715), came to Copenhagen in 1683, after some years spent at the English Court, and stayed here for the rest of his life. The leading sculptor of the period, *Thomas Quellinus* of Antwerp (1661-1709), worked in the romanized style of the time, whose ultimate source was Bernini, and whose flavour was decidedly more French than Flemish. A French sculptor, *Abraham César Lamoureux,* made the equestrian statue of Christian V in Kongens Nytorv (1688). It deserves notice that Frederik IV (1699-1730) travelled in Italy, although this tour proved of

greater importance to Danish architecture than to the Fine Arts. As Crown Prince he—as well as his two half-brothers, Christian and Ulrik Gyldenløve—was painted in Paris by no less a master than Hyacinthe Rigaud. This set an entirely new standard for painting in our country.

THE FOUNDATION
OF THE ROYAL ACADEMY AND
THE ROYAL ART GALLERY

Thomas Quellinus was among the subscribers of a petition to the King, dated October 6th, 1701, for the establishment of a Society For The Promotion Of The Fine Arts. Its aims were to be attained by means of sessions and by the instruction of pupils. The petition was granted, and the new institution was soon referred to as an Academy, but at the beginning nothing much came of the noble effort and in the reign of Christian VI (1730-1746) a fresh start seems to have been necessary. This was repeated under Frederik V (1746-66), and then with lasting success. The present Academy of Fine Arts justly counts its years from the 31st of March, 1754. On that day, His Majesty's birthday, a new "Instrument" was signed by the King, who had the preceding evening been solemnly received by the leading Academicians. This reception took place at Charlottenborg Palace which His Majesty had graciously assigned to the Academy, and which has remained the noble, but now rather narrow, scene of its activities to this very day. Its first presiding artist was Niels Eigtved, the eminent Danish architect who built Amalienborg Palace. However, it was not Eigtved, who died a few months later, but a French sculptor, fresh from Paris, who set the course of Danish art.

Jacques-François-Joseph Saly (1717-1776), as on one occasion the French ambassador to Copenhagen reported to his government, did honour to French taste, and it may be added that inviting Saly to Copenhagen did no less honour to Danish taste. For once official Denmark showed determination to ask for the artistic best and pay for it. Characteristically, the main purpose of Saly's engagement was the execution of an equestrian statue of the King for the new Amalienborg Place,

15

Eigtved's masterpiece. Denmark already possessed architecture of distinction. So the work done in this country by *Nicolas-Henri Jardin,* a contemporary and colleague of Saly's, however beneficial to our art of building, was no pioneer work. The leading personalities of the Court had made up their minds that something had to be done about painting and sculpture. It was their good luck to find the person who could not only provide an unsurpassed Royal Rider for the Palace Square, but who could also, in his spare time, organize the revived Art School. This re-organisation was carried out so thoroughly that when, after seventeen years' service as President of the Academy, Saly retired, Danish artists had won sufficient confidence in their own powers to see without regret the departure of the foreign master. This attitude reveals a somewhat defective sense of proportion, quite apart from their ingratitude to an artist who had devoted the best years of his life to the embellishment of our capital and the future of Danish art.

Danish opposition to Saly was supported by the Swedish painter *Carl Gustaf Pilo* (1711-1793), who painted some of his best portraits while in Denmark, among them one of Saly. Pilo was a brillant virtuoso, with his own, very personal, variant of the Rococo style. His pictures are often bright and even shrill. In others—his later works—he shows quite a delicate sense of colour, masterly handling of light and shadow, and penetrating psychological insight. "Pilo peint en Turc," was the verdict of *Louis Tocqué,* a fellow-countryman of Saly's, who worked in Copenhagen 1758-59. Tocqué was elected a member of the Academy and left superb portraits in Danish collections. Admittedly, in the light of good French paintings of the time, our native efforts in the early years of the Academy may seem rather quaint. But if Pilo be a Turk, what of *Peder Als?* As one of the promising firstlings of the Academy he was sent to Rome in 1756. From there he returned by way of Paris in 1762. Als died in 1776, aged fifty, after a very active career as a portraitist, but having produced little to captivate posterity. Among the

Saly's equestrian statue of King Frederik V in Amalienborg Palace Square (completed 1768), at once the symbol of Danish absolute monarchy and the finest fruit of the singleminded devotion to France which, two centuries ago, laid the foundation of later artistic activities in Denmark.

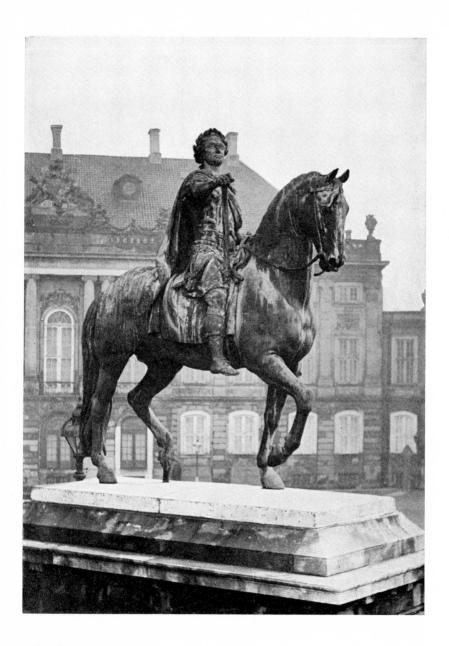

other members of the opposition we note *Johannes Wiedewelt* (1731-1802), the leading Danish sculptor before Thorvaldsen. We shall have more to say about him, but in this context it is of interest to observe that the connecting link between him and Peder Als was their friendship and admiration for the great Winckelmann, whom they had met in Rome. Their reaction against Saly, therefore, was not merely due to a mixture of commercial and patriotic motives. It must in fairness be remembered that their attitude contained an element of honest artistic antagonism. They meant to fight under the banner of "Rome and Antiquity" against frivolous Paris. This contention is rather hard to swallow for anybody who remembers paintings by Als—though even he seems occasionally to have been influenced by incipient Classicism. But there is some truth in it as far as Wiedewelt is concerned.

Among the many benefactions bestowed upon Danish art during the reign of Frederik V, the foundation of a Royal Picture Gallery was not the least. The Kings of Denmark had acquired paintings before that, and Frederik V inherited a few good ones from his ancestors. Nevertheless, he is the founder of the Gallery, being the first of Danish monarchs to make great acquisitions abroad with the specific purpose of establishing an art collection. The driving force behind these efforts was Gerhard Morell, an art dealer who had entered the King's service to do this work for the Court. He saw that it was time to make some radical changes in the "Kunstkammer", the old Curiosity Cabinet where a few real works of art were almost submerged in items of every description. He soon realized, that to make a Picture Gallery one must have pictures, and it is his lasting merit to have brought this obvious truth home to the King. So, in 1759 and 1763, he acquired for the King 171 paintings in Amsterdam. Among these are, of course, not a few Dutch works, notably Rembrandt's "Christ in Emaus", but he also had the good luck of purchasing part of Cardinal Silvio Valenti Gonzaga's collection, which was dispersed in Amsterdam in 1763. From this

Carl Gustaf Pilo: Louisa, Queen of Denmark and Princess of Great Britain, first consort of King Frederik V. This portrait, painted in 1751 and now in *Amalienborg Palace* is one of the Swedish master's most distinguished works, typical of the international atmosphere of the Danish Rococo Court.

source come Mantegna's "Pietà", to this very day the outstanding Quattrocento picture in Copenhagen. Morell was also instrumental in forming a gallery for the noble President of the Academy, Count A. G. Moltke, the King's friend and chief adviser. The best items of Moltke's collection finally joined the royal acquisitions in 1931, when bought by the State Museum of Art. The importance of these events for the beginnings of Danish art cannot be over-estimated, for, though the Gallery was housed in the Royal Palace, and not properly established until 1824, after the addition of the very important West Collection, it was never closed to serious students. Successive generations of Danish artists have there received their first deep impressions of a few great masterpieces of European painting and observed the high average level of Dutch and Flemish 17th-century art, in many respects so closely akin to our own artistic temperament. Unfortunately, similar steps were not taken in the field of sculpture until much later, and then on the initiative of a private citizen. However, in the course of the 19th century, when Danish art was an established fact, both major and minor masterpieces of the Native School were added to the Royal Collection. Finally, towards the end of that century, the collection was moved to its own building and became the State Museum of Art.

THE FIRST DANISH MASTERS

The great ambition of the old Academies was to preserve and develop the European tradition of the grand style of figure-painting. Already the Carracci had dreamt their heroic dream of producing a happy blend of Florentine form and Venetian colour, and about the middle of the 18th century there was so much more to look back to and draw upon. The solutions found by Poussin and Rubens had been added to the store of treasures. The great masters of the 17th century were themselves becoming classics. Antiquity, so dear to European painters and sculptors since Ghiberti and Mantegna, was making itself increasingly felt. Greece proper was hardly known yet, but just then, in the early years of the Danish Academy, its glory was being foretold by Winckelmann. Also, in addition to the accumulated wealth of ancient sculpture in Florence,

Rome and Naples, Pompei and Herculanum were beginning to give even ancient painting back to a posterity ripe for its reception. Looking backwards, we know now that Denmark was very late in entering the scene of European art, but so much greater the satisfaction that our country was able to produce at least one important painter capable of winning for himself a place in what we consider the best tradition of European figure composition.

Nicolai Abraham Abildgaard (1743-1809) went through the regular routine of instruction and prize-winning, culminating in the Academy's great travelling bursary, which enabled him to study in Italy from 1772 to 1776. On his return, he was soon made a professor in his old school, where he also served two periods as Director. He is known for noble architecture, and even took a hand in modelling, but he is mainly remembered as our first serious painter in the grand manner. A set of large wall-paintings for Christiansborg Palace, which he considered his chief work, was (with the exception of three pictures) destroyed by fire already in his own life-time. Small sketches are preserved, however, of all these canvases, which represented scenes of the history of the Dynasty down to the painter's own time. In spite of the undeniable good qualities of the preserved historical compositions, we feel amply compensated for the loss of them by the best of his smaller paintings showing scenes from ancient authors. The old gentleman was often described as a lonely and querulous character. But particularly the output of the last years of his life, when a happy marriage seems to have produced in him an Indian summer, is justly counted among the most valuable heirlooms of Danish art. The four fairly large pictures illustrating scenes from Terence's "Andria"—and made for his own apartments at Charlottenborg—reveal an intimate knowledge of classical culture, unsurpassed in the history of Danish art. His handling of colour and composition reveals his dependence on Poussin and Pompeian painting, but they also show that he is not unworthy of comparison with them. His respect for the Academic rules of composition is a matter of course, and he applies them with a musical grace which shows the born artist; his colours are soft and subtle, but distinct, and he shows enough feeling for light to make us regret deeply that he hardly ever painted

landscapes. To the above-mentioned qualities we may safely add a subdued and dry but unmistakable sense of humour. Modern spectators may not laugh uproariously at his famous illustrations for Holberg's "Niels Klim", in which the human trees seem to be a loan from Mantegna. On the other hand the picture of young Papirius telling his mother stories to satisfy her curiosity does not at all look like the work of a pedantic mind. The Danish public, unfortunately, soon lost the classical education necessary for the appreciation of his wit. Further, his innate sense of colour seems to have been wasted on the 19th century, but he has had a glorious come-back in our time as one of the very greatest of his profession in this country, and a greater painter than many who in the next generations seemed temporarily to outshine him.

Portraits were the kind of paintings most constantly in demand in 18th century Copenhagen, but at the Academy it was figure-painting which counted, the portraitist being considered an animal of a lower order. This attitude proved a serious handicap to *Vigilius Erichsen* (1722-82), for he was not allowed to enter the competition for the Gold Medal (in 1755) except as a figure-painter, in which field he was beaten and by Peder Als too. He spent several years at the Imperial Court of Russia (1757-72), but ended his days in his native Copenhagen. He was the first Danish master in his field to win a well-deserved international reputation. His large portraits of the Empress Catherine of Russia, standing or on horse-back, or the monumental likeness of statuesque Juliana Maria, Dowager Queen of Denmark (painted in 1778; now in the State Museum) are both truly majestic portraits and very good paintings. He possessed a great and noble simplicity of outline as well as a cool colour-scheme of great beauty, and he knew how to display the exquisite materials of the queenly state robes to their greatest advantage without impairing the harmonious equilibrium of the whole. He may not have been a penetrating observer; he seems rather to have regarded his models as noble works of art, a not unwise attitude in a court painter.

However faultless was the style of Vigilius Erichsen, his fame was soon eclipsed by a rapidly rising star. *Jens Juel* (1745-1802) was a born

N. A. Abildgaard: Scene from Terence's "Andria". (*Statens Museum for Kunst*). One of four compositions, masterpieces of Danish classistics painting, produced by the artist in the opening years of the 19th century for his official residence at Charlottenborg.

painter. Very early this precocious young talent was sent to Hamburg to spend a few years as apprentice to a painter named Michael Joh. Gehrmann. Returning to Denmark at the age of twenty, he went through the regular curriculum of the Academy, finishing with the successful acquisition, in 1771, of the First Class Gold Medal for a not very inspired biblical composition. He had by then already won such fame as a portraitist that he easily found private support for a prolonged journey to the South, the official travelling purses being at the time reserved for others. He left Copenhagen in 1772, and did not return till eight years later. The rest of his life he stayed at home, working as professor, and in some periods as Director, of the Academy, honoured with the title of Court-Painter—and all the time restlessly working away on portraits of contemporary Society.

As a youngster in Hamburg he seems, very naturally, to have been influenced by Dutch art. His "View of the Alster by Moonlight" (Kunsthalle, Hamburg) was inspired by the well-known night scenes of Aert van der Neer, but he strikes a very personal note in the dashing "Self-Portrait by Artificial Light". The dramatic touch manifest in this picture is shared by the little street-scene illuminated by a veritable flash of lightning—also in our State Museum . It is amazing to observe how quickly Juel ripens to mastery during his first years in Copenhagen, and little surprising that he soon found admiring and grateful patrons, while still nominally a pupil of the Academy. Helped by a few French portraits, notably those of Tocqué, and—indirectly—by the study and instruction of Pilo, he succeeded in transforming his portrait style into a more than passable French one, before he ever set foot in Paris. But, in addition, these early masterpieces have all the ardour of youth, the exuberance and perfection of those mental efforts through which a young man of genius sets out to conquer the world. There is an interesting contemporary parallel—but certainly not an explanation—in the early work of John Singleton Copley of Boston. It is doubtful if

Vigilius Erichsen: Juliana Maria, Queen Dowager of Denmark, widow of Frederik V. (Painted in 1778, now in *Statens Museum for Kunst*). Not only in the rendering of the likeness, but also in plasticity of style, a marked contrast to Pilo's portrait of Queen Louisa.

Juel, or anybody else in this country, ever painted a better portrait than the likeness of demonic-looking Ahron Jacobson with his bright, blue eyes (1767). And the "Study of a Holstein Girl" is unsurpassed for crisp sweetness of expression and delicacy of colour. His *clientèle* was at first *bourgeois,* but already in 1769, he climbed as high as possible when commissioned with a portrait of Queen Carolina Mathilda. This "Blue Portrait" of the unhappy Queen shows that, whatever the character of our artist, he was certainly no snob; it is an amiable, but absolutely unflattering likeness of the young First Lady of the Land, who was, evidently, less goodlooking than those of her humbler contemporaries who usually did Juel the honour and pleasure of sitting for him. This period of his activity was concluded in 1772 by two masterpieces. In that year he painted the portrait of Saly recently purchased by our State Museum of Art in Paris, where it had for some time passed for a Drouais! This picture clearly shows Juel's mastery of the painter's art. How astonishing that, in Copenhagen, a young Dane should be able to produce a work so completely "Louis Quinze" as this portrait of the great French sculptor with the air of an elderly statesman, gracious and yet aloof. It also reveals his limitations. For we are not shown the marks of failure or bitterness in this rendering of the features of an older fellow-artist who was dismissed, honourably yet ungratefully, after years of distinguished service in a foreign country. Our eyes are not blinded by tears of sympathy—we do not sense the tragedy, perhaps there was none. The other great work of the year '72 is the double portrait of Count and Countess Reventlow, now at Brahetrolleborg, possibly painted on Juel's way southward. Here the bond of sympathy between artist and sitters is obvious. Juel, himself of humble origin, always felt at his ease with kind and cultured people, and Christian Ditlev Reventlow was an aristocrat in more than one sense of the word. Both the Reventlow group and a smaller double portrait of Colonel and Mrs. Gautier, from about the same time, strikingly remind of François-Hubert Drouais.

Tantalizingly little is known about how Juel passed at least two years in Rome. Only the forbidding picture of Bajocco, the dwarf, can safely be referred to his stay in the Eternal City. Some portraits have

Jens Juel: Study of a Holstein Girl. (*Statens Museum for Kunst*). A masterpiece dating from the early years of the artist's career. Painted in the 1760ties.

been placed, tentatively, in the same period, but there is not the faintest trace of Roman classicism! During his, rather short, stay in Paris (1776-77), he painted the fine, intimate portrait of his engraver friend J. F. Clemens, in his studio. This masterpiece reveals his susceptibility to the new climate in French portraiture, the ease and grace of the last phase of *"l'ancien régime"*. This very portrait earned him a good living for the next three years, spent in Geneva, busily painting members of the aristocratic *élite* of that prosperous republican city. All the Swiss portraits, with the exception of the likenesses of Mme Prangins and Monsieur J. A. Tronchin som years ago acquired for the State Museum, still belong to the descendants of the sitters. Both portraits show the elegantly dressed sitters seated in Swiss landscape settings with a view of the mountains. This type of portrait—depicting the burgher on his country estate—was originally invented for the Dutch *bourgeoisie* of the 17th century (e.g. the large family group by Frans Hals at Villa Favorita near Lugano). Soon it spread to France, whence it was taken over enthusiastically by English 18th-century artists. At the time with which we are concerned it was imbued with the sentimental spirit of the day and a slight flavour of "The return to nature". In the case of Juel, there is reason to assume an inspiration from English art, but it is evident that its influence has reached him through the medium of monochrome engravings. In Switzerland he also took to the habit, never afterwards quite relinquished by him, of painting landscapes just for the fun of it.

The remaining twenty-two years of his life he spent in Copenhagen, industriously portraying the Court, nobility, and *bourgeoisie*, in short everybody who cared to pay the fee. And Denmark was just then experiencing one of the most prosperous periods of her economic history. Juel was censured, already in his life-time, for overdoing the business. Not everything that left his workshop can stand the scrutiny of severe criticism. Nevertheless, it seems a miracle that he was able, at that rate, to keep up the high average level he did, and even to produce masterpieces. So the public was at his feet. Certainly, the sons of the founders of the Academy were being rewarded for the work of their fathers. For, to optimists it might seem that Copenhagen was becoming a miniature

Jens Juel: Portrait of Saly. (*Statens Museum for Kunst*). Painted in 1772, shortly before Saly terminated his many years' work in Denmark end returned to Paris. In the background of the picture is seen the model for the equestrian statue of Frederik V.

Paris. Juel never again visited the city which was the spiritual birth-place of his art, but he never lost the almost telepathic faculty which had enabled him, in younger years, to absorb the spirit of Parisian art at such a long distance. The accomplished oval portraits which he painted in the 'eighties, (e.g. the elegant one of Professor Winsløv in the University of Copenhagen), are pure "Louis Seize". So is that of the Holmskiold Family, or at least the small compositional studies for the large picture (one of which is at Frederiksborg Castle). Later, in the closing decade of his life, Juel's style gradually assumed an unmistakable air of "Early *Empire*". Before the wonderful portrait of the newly married artist and his wife, painted in 1791, and still more in front of the "Portrait of a Lady with her Son" (in the Ny Carlsberg Glyptotek) —a masterpiece from the very end of his life—we clearly feel that now he had become a contemporary of David. And yet, he remained the same innocent country boy who had so confidently entered upon a splendid career.

We have seen Juel, at the beginning of his career, painting a land-scape in the manner of Aert van der Neer. It was not till the Swiss years, apparently, that landscape painting became a permanent habit with him. In later years, he occasionally adopted the manner, which had served him so well in Geneva, of placing his portrait models in a land-scape. The portrait of Colonel Greenway, (National Gallery, London), is of this type, which is not surprising, considering the nationality of the sitter. The Colonel sat for it when visiting Copenhagen on an official British Mission in 1788. The same method is also applied in two of his large figure-groups, the Raben-Levetzau Family (at Glorup Manor) and the Ryberg Family (Statens Museum for Kunst), both painted in the 'nineties. His real landscapes, however, are of special interest as including the first impeccable specimens of a *genre* destined, in the succeeding century, to become the glory of Danish art. However carefree some of Juel's Danish landscapes may seem, they were not created outside of time—the time of their maker. The famous "Sealand Farm. On-Coming Storm" is such a convincing picture of country life, but in spite of its local tone, it is demonstrably modelled upon an engraving after Rubens. Which is, of course, in no way dis-

Jens Juel: Double Portrait of a Mother and her Young Son. (*Ny Carlsberg Glyptotek*).
A masterpiece of the artist's late manner, presumably painted shortly before his death
in 1802.

31

creditable to Juel. His work as a restorer, at the Royal Gallery, brought him into the closest possible contact with the classical Dutch school of landscape painting. This again—almost paradoxically—may have strengthened his love of nature. For towards the end of his life, at least, Juel displayed a loving understanding of the smiling and harmonious character of the scenery of his native country. This is made manifest by the clear-coloured "View of Middelfart", now in Thorvaldsens Museum. A very happy blend of his love of nature and his experience as a composer of figure groups is achieved in two views from the immediate vicinity of Copenhagen, "Emilia's Fountain" from 1784 (Odense Museum) and "The Dancers' Hill, near Sorgenfri" (in a private collection). Juel may be called the father of Danish landscape painting. A few excellent flower pictures also make him the founder of the noble *genre* of the "still-life" in this country. It is interesting to note that one of them was painted in order to create a counter-piece to a picture ascribed to Frans van Mieris the Elder, now in the Royal Gallery.

Juel, like Abildgaard, was an early climax of Danish art. In a way, he was never surpassed. Compared with Abildgaard he seems to have been an unsophisticated spirit. No learning, no grumbling, and no visions—except in the physical sense of the word "vision", and there he beat them all. Cézanne's famous saying about Monet, "A mere eye—but what an eye!" comes to mind when we think of Juel. He painted in the idiom of the day, always sensing its changing tone with an unfailing ear, but his fundamental gift was that instinct for the visual beauty of the world which would have made him a lovable painter in any period. He set a standard which imposed upon his successors a responsibility heavier than they knew. To C. W. Eckersberg he left, besides both of his daughters, the example of a great Danish painter.

Abildgaard and Juel were really attractive artists, whose works give us spontaneous pleasure. *Johannes Wiedewelt* (1731-1802) is one of those artists commonly described as "interesting". Now, in the language of modern art history, this word has almost become a politer synonym of its opposite. Nevertheless, Wiedewelt was our first serious—much too serious—sculptor. He went to Paris in 1750 to work in the studio of G. Coustou, the Younger, and at the world-famous *Académie des*

Jens Juel: Sealand Farm. On-Coming Storm. (*Statens Museum for Kunst*). Juel's finest landscape, and a most characteristic example of his ability to combine his impressions of nature with studies of old art, in this instance of Rubens.

Arts. In 1754 he was enabled by the re-established Danish Academy to proceed to Rome, where he spent four decisive years. There he became the friend of *Johann Joachim Winckelmann* (1717-1768), who initiated him into Northern Classicism.

To understand the far-reaching influence of Winckelmann one must realize that he was a genius. Nobody can influence contemporaries and posterity so profoundly as de did—for better or for worse—without possessing some extraordinary mental quality. Winckelmann's medium was the word. Goethe hailed him as a master of the German language, and Winckelmann certainly mastered that formidable instrument of persuasion. Through his study of ancient art, he became the founder not only of modern *"Altertumswissenschaft"*, but in a sense of the whole of 19th century *"Kunstforschung."*. Not content, however, with research he endeavoured, with all the conceit of a literary man, to re-

form the Fine Arts of Europe in order to purify taste. His great discovery was "Greek Art", and that was indeed a prophetic inspiration, for he hardly ever saw any. He never went to Greece, and almost all ancient sculpture or painting within his reach was Roman. He even embarked on a historical survey of Greek art and, though it may seem almost incredible, succeeded in tracing the outline of its development. He did it by combining the literary information given by ancient writers with the study of Roman copies or distortions of lost Greek works of art. Now, the relics of ancient art had been most eagerly studied by European artists since the early days of the Renaissance, and the classical spirit had, at least in the 16th century, deeply impressed and inspired the greatest Italian masters. Since then European art had never lost sight of the masterpieces of Antiquity, whose number was being steadily increased through new discoveries. Particularly French art had kept a never interrupted line of communication with that silent academy, the treasures of the Italian soil. What, then, was Winckelmann's message? After a sober consideration of the facts, we come to the conclusion that he disapproved of the Rococo style in general, and of French art in particular. Realizing that all that was modern in his time ultimately descended from Michelangelo, Winckelmann ended by denouncing, in the name of "the Greeks", the very man who, of all the artists of Christendom, could most properly bear the honorary title of a latter-day Hellene. Against the alleged abuses of the Baroque and Rococo he set his famous ideal of *"edle Einfalt und stille Grösse"*. The ground proved ready for his seed, the time was ripe for simplicity, and it got it.

Once within the spell of such a personality, poor Wiedewelt was helpless, and it is almost touching to see him dipping his pen to echo the oracle in a little Danish pamphlet *"Tanker om Smagen udi Kunsterne i Almindelighed"* (Considerations on taste in the Arts), published in 1762. Turning from his words to his deeds to survey his life-work as a sculptor, one is mildly surprised—to say the least—that such is the embodiment of the new creed. Not even the most perspicacious student, familiar with the ideas of Winckelmann, would, on becoming acquainted with Wiedewelt's Fredensborg Sculptures, be able to guess at an intimate connection between the two. The first impression of sculptures by

Wiedewelt is one of dullness, an almost hopeless boredom. This is hardly a new style, it is just Rococo falling asleep, Baroque art smothered in the grip of incompetence. And at the thought that their maker considered himself a champion of Taste, and New Taste at that, we cannot help a smile. The decorations for the Royal Garden at Fredensborg were the greatest commission of his career. The architect of the new lay-out of the beautifully situated grounds was Jardin, whose plans were approved in 1761. Evidently, Jardin aimed at the creation of a Danish Versailles. Small wonder, therefore, that the large sculptural decorations for the park, as carried out by a former pupil of Coustou, were of a predominantly French character. It is, of course, of no real importance to us, whether Wiedewelt lived up to the ideology of Winckelmann or not. The only thing that matters in an artist is genius, and his was admittedly small. It would, however, be unfair to deny him praise for certain minor virtues in which he was far from deficient. He had a sense of order and proportion, he was hard-working and, undoubtly, he was doing his best. Above all, in what he did we sense that spirit of solid honesty, which we are wont to flatter ourselves, is a national characteristic. Of many funerary monuments which Wiedewelt created, the most important is the pompous tomb of Frederik V in the beautiful chapel added by C. F. Harsdorff to Roskilde Cathedral, a Danish masterpiece of early classical architecture. Late in life he created "Faith", the most beautiful of the four allegorical figures around *"Frihedsstøtten"*, the fine monument erected in Copenhagen in memory of the abolition of serfdom. However, in this work Abildgaard, who was the leading artist in the creation of the monument, may have taken part.

Wiedewelt's life ended tragically, in 1802. He was the first Danish artist to make sculpture his life-work, and thanks to one of his pupils, Danish Sculpture was soon to rise to sudden glory.

BERTEL THORVALDSEN

Bertel Thorvaldsen (1770-1844) was the first, and so far the only Danish artist to conquer a place among the masters of European art. To do so he actually had to emigrate. He would not have been equally successful, if like most of his Danish fellow-artists, he had returned to Copenhagen after a few carefree years abroad. Only by obstinately remaining in Rome was he able to win international recognition, nay world fame. But he never forgot his country, and, once he was an established success, his fellow-countrymen were glad to remember him. So it is of more symbolic significance that he finally came back to Copenhagen to live his last years in the very Academy whose greatest pupil he was.

In the opinion of so many connoisseurs of his own time, Thorvaldsen was the man who gave, if not flesh and blood, at least physical form and visual reality to Winckelmann's dreams. He appeared to them to be the re-incarnation of the Classical Spirit, the new Phidias. To-day this view is considered arrant nonsense, and logically but most unjustly, Thorvaldsen has come to be regarded as a failure. The best approach to his art and personality is the chronological one, which makes us realize that he was not only a child of the 18th century but a full-grown man of at least thirty (the year of his birth not being fully established) before it ended. In personal appearance, in manners and habits, he seems to have belonged entirely to the old era. Though of the humblest origin, and practically uneducated in everything except his art, he went through life with apparent ease and obvious grace, associating with persons of the highest rank, who came to recognize in him a man of princely status in his own realm. He soon learnt from his social superiors that amiable yet non-committal attitude to his fellow-beings. If, indeed, it was not part of his nature, since it served him also in matters of the heart. But always he remained unfailingly loyal to his origin and his profession. This must be counted all the more in his favour as there was, undoubtedly, a hard core in his character. The lazy-looking, complacent Dane, on whom Fortune might seem to be actually showering her gifts, possessed an almost incredible capacity for

Bertel Thorvaldsen: King Numa and the Nymph Egeria. (Plaster relief, dating from 1794, in *Thorvaldsens Museum*). This work shows Thorvaldsen's mastery of the late 18th century figure style.

work. Also, behind his friendly manner and genuine good-will towards his friends there was always a practical business acumen and a purposeful ambition. He knew the struggle for existence, and he meant to win and to keep the position Fortune had reserved for him.

Thorvaldsen's father, who was born in Iceland, was not an artist, and yet his occupation was an artistic one. For he earned a modest living as a wood-carver. Apparently, it was only the assistance of his gifted son which enabled him to enter into competition with the makers of figure-heads for sailing-ships. The son began his studies at the Academy in 1781, at the tender age of eleven, according to the official records. His academic career lasted until 1793, when he won the First Class Gold Medal. He left Copenhagen in 1796 (on what was meant as his "Grand Tour") for Italy, arriving in Rome on the 8th of March 1797,

which day he afterwards celebrated as his birthday. He was not to take his final leave of the Eternal City until forty-one years later. At the Academy, his teachers of sculpture were Wiedewelt and his colleague *Andreas Weidenhaupt* (1738-1805). Abildgaard who was the leading spirit of the school, is known to have taken a special interest in the gifted student. Besides the influence of his teachers, there is reason to mention that of *Hartman Beeken* (1743-1781) and *Johan Tobias Sergel* (1740-1814), the great Swedish sculptor who was an intimate friend of Beeken, Abildgaard, and Juel. Whether we study Beeken's terracotta group of Adam and Eve, his famous portrait of the Danish poet Johannes Ewald, or a sculpture so obviously inspired by ancient art as Sergel's "Faun", we behold the same sensitive and sensuous eighteenth-century style. In spirit this style is so French that it prefers to select its ancient prototypes among the Hellenistic works of art most congenial to the Gallic *ésprit*. The not very numerous sculptures Thorvaldsen left behind in Copenhagen when he departed for Rome show him as a master within this small Scandinavian circle whose productions still give out a sweet Rococo fragrance. There are at Amalienborg Palace two Muses, modelled in 1794, so sure and masterly of form and composition that the active cooperation of Abildgaard has been taken for granted by some historians. There is also, from the same year, the captivating relief representing "King Numa Taking Council with the Nymph Egeria", so essentially plastic and—a gift which rarely deserted Thorvaldsen—so wonderfully coherent and expressive in the way the story is rounded off. In portraiture the masterpiece of his youth is the bust of Count A. P. Bernstorff, executed in 1795, a grandiose portrait of the good-looking, benign Prime Minister, the very picture of a statesman of the old school. It was no fumbling beginner who set sail for Italy in 1796, but a young master, worthy of the tradition founded by Saly.

In Rome Thorvaldsen was subjected to new influences that were to effect a transformation of his artistic idiom. First he met ancient art as an overwhelming reality, and then he met people ready to instruct him in the latest wisdom as to its use and interpretation. In *Georg Zoëga* (1755-1809) he found an adviser who was his fellow-countryman and happened to be the most learned archaeologist of the time.

And in *Asmus Jacob Carstens* (1754-1798) he made the acquaintance of an older fellow-artist whose enthusiasm for Antiquity must have been a source of inspiration to his contemporaries which is difficult to understand by simply looking at his works. The first practical result of Thorvaldsen's Roman studies is rather amusing. He had brought the mask of his Bernstorff bust with him in order to carve the portrait in marble. He soon realized that the florid 18th century bust of the old version was something to be dropped for ever, and he made the new one in the shape of an ancient herm, substituting a heroically bare breast for dress-coat and decorations—and cutting the hair of the sitter. Now, if that was Classicism, anybody could be a New Greek. The young Danish sculptor had to take his time over a more penetrating study in the Grand Schools of the Vatican and the Museo Capitolino; but it speaks very much for Thorvaldsen's natural gifts and academic training that the simplified Bernstorff, made in Rome immediately after his arrival and now at Brahetrolleborg, is a perfectly successful work of art in its new Roman style. At the same time Thorvaldsen carried on an intense study of ancient portrait-sculpture, he soon found his way to those mythological sculptures that are the Roman embodiment of the Greek spirit. A token of his efforts is the preserved small-scale copy of one of the Dioscurs of Monte Cavallo. It matters little that we now take a more sober view of the two marble colossi, which were then taken at the face value of their Renaissance inscriptions as masterpieces by Phidias and Praxiteles. They are, certainly, grandiose statues and the lesson they taught our "New Phidias" is clearly seen in the admirable small group of "Achilles and Penthesilea", from 1801, which forms the link between his 18th century past—and Jason.

Thorvaldsen had his academic travelling-bursary prolonged twice; now it was to expire for good with the year 1802. And he had not yet created a work which would satisfy the great expectations of his fellow-countrymen, much less made any advance towards the fulfilment of his dream of staying on in Rome. Tradition has it that he modelled a full-scale "Jason" as early as 1802, but had to give up casting the figure in plaster. Next spring, in the nick of time, he repeated the performance, and this time he succeeded. The figure lasted, it established

his fame and found him a customer, who ordered it carved in marble, and was patient enough to wait a quarter of a century to get the finished statue. Later Thorvaldsen described how he sought daily inspiration in the Vatican, while working on his Jason. Artists never like to admit dependence on others—but of course it was all right for young Thorvaldsen to have looked to the treasures of the Belvedere (unfortunately, they were on leave in Paris at the time). He did not tell anybody that he had had a careful look at a much restored statue of "Ares" in the cortile of the Palazzo Borghese. It was far less popular than the Apollo di Belvedere, but happened to suit Thorvaldsen as a model for his Jason. This statue was not discovered by art history until 1893, when Adolf Furtwängler proclaimed it a copy after Phidias. It is somehow related to the Roman colossus on the Monte Cavallo, which had just been Thorvaldsen's guide to the Classical Style. In Scandinavia, Thorvaldsen's Jason had precursors, Sergel's "Diomedes" being one, C. F. Stanley's "Amor Patriae" another, but they are of little importance and can hardly have influenced him. His "Jason" was really a work in *uno stile grande e nuovo*, to quote the admiring commentary of Antonio Canova, the greatest Italian sculptor of the day. In Paris the military hero of the generation, Napoleon, was crowning his career with the imperial diadem, thereby forfeiting the dedication that a young German composer in Vienna had already inscribed on his Third Symphony. In Copenhagen, Oehlenschläger published his epoch-making "Poems. 1803", the beginning of the Romantic movement in Danish literature. So Thorvaldsen was not alone in making a fresh start.

What Greek elements there are in "Jason" point in the direction of the 5th century B.C., the great era of Phidias and Polyclitus. In the course of those early years in Rome Thorvaldsen adapted for his own use the classical style of relief composition, as witnessed by the "Abduction of Briseis from the Tent of Achilles" (1803), executed in marble for the Duke of Bedford together with a *pendant* from 1815 "Priam Entreating Achilles for Hector's Body". It caused some surprise when, in 1920, a Roman silver goblet decorated with a relief of the same subject and in much the same style, was found at Hoby in

Bertel Thorvaldsen: Jason. The Jason, which Thorvaldsen modelled in Rome, in 1803, proved a turning point in his career. But it was only in 1828 that he delivered the marble rendering to Thomas Hope, the Englishman who had ordered it, and from whose descendants *Thorvaldsens Museum* bought it in 1917.

Bertel Thorvaldsen: The Princess Baryatinska: Modelled in Rome, 1818. This, the original marble copy, belonging to *Thorvaldsens Museum,* is the finest of all the Master's portraits of his contemporaries.

the Danish island of Lolland. One writer, ignorant of the circumstances, even went so far as to declare the Roman treasure a modern forgery, made in imitation of Thorvaldsen! But the ancient glass paste which served Thorvaldsen as a prototype can still be seen in his

41

Museum. The composition, which was simply a commonplace of the classicistic art of the early Roman Empire, was revived a second time by Neo-Classicism. From then on the classical relief style, which consists almost exclusively in one-plane figure composition became Thorvaldsen's preferred medium of expression. However, it is interesting to observe that in spite of these changes of style and manner, he remains fundamentally unchanged. Here are the old virtues of good, honest plastic stability, self-contained composition, clarity of outline, and rhytmic beauty, besides an instinctive spiritual elegance. As soon as Thorvaldsen had mastered the "classical" idiom he even seems to have receded to a position in better keeping with his inmost inclinations, in short more suitable to an artist of the 18th century. For he soon showed an increasing interest in the style of the 4th century B.C. The "Adonis" of 1808 (made for Ludwig of Bavaria), the "Venus" (1813-16), the "Graces" (1817-19) are all of a dreamy sweetness, which makes them more worthy af a "new Praxiteles" than of a "new Phidias". And the famous relief of "Amor and Anacreon" (1823) shows him as the faithful pupil of subtle, learned Abildgaard, whose Antiquity was the Hellenistic world.

During the first decades of Thorvaldsen's stay in Rome, Greece was being rediscovered, and classical art became a reality to Western Europe. The archaic pedimental groups of the temple of Aegina actually made their way to Thorvaldsen's workshop, where they were being restored before proceedings to the new Glyptothek at Munich. We could not expect him to be deeply impressed by archaic art, yet he created the statue of "Hope" (1817) in an archaistic style. There is reason to suppose that the Roman "Spes" in the Munich Glyptothek was his real prototype—rather than the genuinely archaic acroterial figures from Aegina. He may even have restored the other one as well. However that may be, his "Hope" is a beautiful work but remained a solitary figure in his life-work. Meanwhile the Phigalia Frieze had found its way to London, soon to be followed by the "Elgin Marbles". They included a choice selection of genuine Phidian originals: pedimental statues, metopes, and frieze plaques from the Parthenon—besides the Erechtheum Caryatid, and other Attic sculp-

tures of the best period. Canova (whom a sound instinct made refuse to restore the Parthenon pediments) and Goethe, were equally enthusiastic, but—paradoxically enough—these wonders of ancient sculpture, although they appeared when the tide of classicism was at its highest, had no effect upon 19th century classical art. The reason is the simple one that they came too late. The human mind is formed in youth, and the leading artists were no longer receptive to fresh impulses. At least in Denmark, the younger generation was blinded by the light of Thorvaldsen, and then the days of Classicism were over. Of course, Thorvaldsen became acquainted with the new Greek treasures. Casts and drawings spread rapidly, and, indeed, he studied them well enough to be influenced by the Parthenon Master in his Alexander Frieze. This work he created in 1812, with incredible speed, to adorn the Quirinal for the expected reception of Napoleon. Also the "Hebe" (dated 1806) he remodelled ten years later to bring her into conformity with his improved understanding of classical drapery. However, those were just incidents of his professional career. He was not deeply moved by seeing eye to eye with Phidias. He never went to London, or to Athens—a healthy immunity protected him from the final insight, so devastating to the ideology he believed he was serving, the realization that the true spirit of the Parthenon pediments has only been revealed—Heaven knows how—to one modern sculptor: Michelangelo Buonarroti.

Besides the classical subjects, so dear and so natural to the enlightened public of old Europe, Thorvaldsen produced numerous portraits. Here Classicism and Naturalism went hand in hand, for Antiquity, so sacred to his heart, provided many an example of unrestricted realism in the field of portraiture. Particularly, the pathetic, furrowed visages from the last decades of the Roman republic aroused his vivid interest, as they had spellbound sculptors since the 17th century. And if, sometimes, he mistook forgeries dating from the Baroque Age for genuine Romans, the science of archaeology is to blame for that. For masterpieces of that order (like the famous "Marius" and "Sulla" busts in Munich, or the Louvre "Maecenas") have fooled even professional connoisseurs till our time. In other cases the

43

noble, idealized style of the Augustan empire, in many ways so closely akin to his own epoch, gave him what he needed—in short, he combined plastic feeling, physiognomical acumen, and tact. So wealthy customers flocked to his studio, enabling him to leave to posterity a fascinating gallery of portraits from the period when the foundations of modern Europe were being laid. After two decades of industrious activity in Rome, he succeeded in making the two main streams of his productivity converge. As a recognized champion of modern, i.e. classicistic, taste in sculpture, and as an undisputed master of portraiture, it was only natural that he should attract wealthy people in search of an artist for the execution of a tomb monument, or chairmen of committees working for the erection of public memorials. It was his good luck that Europe was navigating into a period of prosperity and consolidation, and yet there was enough to commemorate after the turmoils and disasters of the Napoleonic era.

Thorvaldsen's gift for monumental portraiture is nowhere more apparent than in the captivating statue of the Princess Baryatinska, modelled in 1818. For some reason the beautiful marble was never delivered, so it passed from his possession directly to the Museum. This is an instance of perfect harmony between the spirit of exemplary classical art and the taste of the time, between the fresh beauty of an attractive young lady of the Empire Period and Thorvaldsen's aims and abilities in the best years of his life. It is one of the rare moments in art, when nature and style appear to become one and the same. This one statue would suffice to explain why all Europe came to him for monuments and memorials, the work on which was to fill the 'twenties and 'thirties of the 19th century. He never created anything to surpass the Princess Baryatinska, still he succeeded in making his name famous all over Europe. Her male counterpiece is the wonderful statue for the tomb of Prince Wladimir Potocki in the Cathedral of Krakow. (1821). The Prince stands before us beautiful as a young Greek god. Or rather he looks as if, in him had come to life again one of the youths who formed the Panathenaic procession in the days of Pericles. For Poland he also made the famous equestrian statue of Josef Poniatowski, the long story of which is an interesting demon-

Bertel Thorvaldsen: Priamos Imploring Achilles to Surrender Hector's Body. (1815).
Marble relief executed after the Master's model by C. Peters for *Thorvaldsens Museum.*
This work is the classical example of Thorvaldsen's Roman relief style.

stration of his ability to handle customers. Out of long discussions about dress and action, all those circumstances and paraphernalia considered so important in art by the inexpert, came exactly what Thorvaldsen wanted to make: a younger Marcus Aurelius. No other modern rider is so much in the spirit of that most beloved of all princely horsemen, the jewel for which Michelangelo created the marvellous setting of his Capitoline Piazza. His most spectacular social success was, perhaps, the commission for the tomb of Pope Pius VII, at St. Peter's in Rome, which fell to him after the death of Canova. It was unique in the annals of the Roman Church, since Thorvaldsen had never been converted. He created a very impressive and noble portrait statue of the Pope, but the monument, in its surroundings, is no convincing proof of his superioty to Bernini and the other giants of Baroque sculpture.

Thorvaldsen's native country and his own church made demands on him, too. The Academy had, in vain, elected him a professor in 1805. However, as nothing succeeds like success, his growing fame increased the desire to make use of him in Copenhagen. It was rightly felt that nothing could attract him, if not a big commission. Denmark

45

had been consistently on the wrong side in the Napoleonic Wars, and our Capital had suffered severely from British bombardment. Now the public buildings were being re-erected under the artistic leadership of formidable *C. F. Hansen* (1756-1845), the greatest architect of powerful early 19th century classicism in Denmark. He did not care for sculpture, but could not flatly deny that there existed classical precedents for the use of statues and friezes as ornaments of monumental buildings. So it came about that, in 1819, Thorvaldsen was finally lured to Copenhagen by the promise of great commissions for sculptures for the new Cathedral. However, he stayed only until the next year, when he went back to do the actual work in Rome. Besides there were all the other obligations he incurred so optimistically— and, except as regards punctuality, hardly ever failed to meet. The amount of work done by Thorvaldsen for Copenhagen Cathedral was great. It included several reliefs of varying sizes and even a, rather tame, pedimental group, but the most substantial part of it consisted of the large statues for the interior: Christ and the twelve Apostles, besides a most charming baptismal Angel. These were not his first experiments in Christian subjects, but still they meant a departure from his usual type of work. He had the Christian subject-matter in mind when he travelled northwards from Rome, and it is reported that he showed an interest in certain medieval works of art he came across in Germany. Most likely these studies only gave him some knowledge of sacred iconography, but in Milan, where he stayed for a couple of days, to contract some business, he must have had a close look at Leonardo's "Last Supper". Evidently its famous figure of the Saviour was at the back of his mind when he got the inspiration for his statue of Christ.

The large-scale monuments caused a great change in Thorvaldsen's workshop. About 1820 he had nearly forty sculptors and masons in his service. It goes without saying, that his personal share in each work could not be the same as before, but both the quantity and quality of his output testify to his genius for organization, in which he equalled Rubens. His ability quietly to make everybody conform to his own artistic will worked miracles. We know less of the effect

upon himself of the collaboration with so many fellow-artists of a younger generation. We cannot say for certain if their presence may not in part be responsible for the slackening of his resistance to certain demands from outside, like those he had so successfully resisted in the case of Poniatowski. At any rate, it is a fact that his second equestrian statue, that of Maximilian I, Elector of Bavaria, (erected 1839 in Munich) is no longer a Roman. His Elector is correctly dressed as a marshal of the Thirty Year's War. This is not the only instance of concessions unheard of only ten years before.

The period of mass-production came to an end in 1838, when finally the ageing artist let himself be persuaded to return to his native country. His entry into Copenhagen was triumphant, and this time he meant to stay. He only saw Rome once more, on a short visit. In his last years he was a National Institution, spoilt by admirers, among whom energetic Baroness Stampe took the lead. But he did not spend his old age in idleness. The best of the works of his last years show that he remained faithful to the ideals of his youth. It is the lasting merit of Baroness Stampe that she persuaded him to make his life-size self-portrait (1839). Twenty-nine years had passed since he carved the wonderful portrait herm which is one of the treasures of our Academy Collection. In looking back over his long and industrious life he seems to have found that he had changed little: True, the ardour of youth is gone, but there is in the features of the old master a great mental alertness, besides an unpretentious wisdom. With a stroke of genius he has shown himself in the simple overall of a sculptur, thereby suggesting Vulcan, the godly protector of his art, and quite naturally keeping the statue within his usual artistic language. He is leaning on the statue of "Hope", ready to start working on it with chisel and hammer. So many artists make unconscious self-portraits. When Thorvaldsen made his own statue, he consciously transposed it to the less personal key of the harmonious classicism of which he was a master. The same year he did the sketches for four big statues to be placed in the courtyard of Christiansborg Palace, another of C. F. Hansen's buildings. Only one of these sketches, the Hercules, he lived to carry out on the colossal scale, the year before

his death. This was a truly magnificent effort, not only physically; his last great work has pathetic reminiscences of Jason, as if at the end of his life the old man had come to think once more of the masterpiece of his early Roman years. For Jason had been the beginning of his brilliant career, which, despite all its glamour, had not, perhaps, quite fulfilled the noblest dreams of youth.

When Thorvaldsen came home for good it was with the intention of bequeathing his life-work and his collections to his native city, and he did not move from Rome until he had the promise that it would all be gratefully accepted and cared for. He lived long enough to have a decisive influence on the site and appearance of the Museum which was also to be his Mausoleum. He saw the building almost finished and visited the place of his future tomb a short time before his death. Thorvaldsen's Museum became a spectacular success. The choice of the architect, M. G. Bindesbøll, proved a very happy one; he provided an original, colourful and yet entirely dignified frame for the white figures it was to contain. The idea of painting the glorious reception of Thorvaldsen by his fellow-countrymen on the outer walls of the building, the work entrusted to Jørgen Sonne, was as fortunate as it was unorthodox. And Thorvaldsen's antiques and paintings were, too, an important addition to our public collections. To this very day the house exercises a spell to which few Danes are quite immune, and its moral influence in the century since it was built is immeasurable. Here was a tangible example of what art could mean in human life. It is known to have found at least one admiring and receptive emulator, Carl Jacobsen, the founder of Copenhagen's Ny Carlsberg Glyptotek, who ascribed to Thorvaldsen's Museum a decisive influence in making him a collector and public benefactor.

It may be questioned, however, if the influence of Thorvaldsen's Museum has been only for the good. Not content with leaving his sketches and plaster models to the Museum, Thorvaldsens arranged for the execution of fresh marble copies of everything for the permanent enjoyment of its visitors. But, unfortunately, he did not live to supervise their execution. The very idea of the Museum, as conceived by him and his admiring advisers, was completeness, but another cen-

tury of experience in museum work has convinced most authorities on the subject that selection is a better principle. It may also be assumed that the very existence of an extensive and exclusive Thorvaldsen Museum has meant an obstruction to what would otherwise have been considered a natural development of our National Gallery of Danish Art.

Thorvaldsen's reputation in the century following his death has been quite different in- and outside his country. The world at large has forgotten him. Europe was at his feet in his life-time, today he is almost unknown, even in America, and his marbles which were scattered over the world now find their way back to Copenhagen as welcome successors to the copies made for the Museum. For Danish sculpture whose standard he raised so high, he was perhaps in the long run too great. Its development during the rest of the 19th century might have taken a happier course without the abiding shadow of his authority. Unfortunately, the classicistic ideology he stood for was respected longer than his personal gifts, that transparent harmony of grace and power which was the essence of his art.

C. W. ECKERSBERG

It is, perhaps, the greatest blessing for Danish painting that the man who was to set its course in the new century did not equal the grandeur of Thorvaldsen. *C. W. Eckersberg* (1783-1853) has been called the "Father of Danish Painting", and this epithet, though an exaggeration, is at least not undeserved. He was not a genius, and yet he produced a few paintings that have still an undiminished appeal to even the most fastidious. He was a more complex nature than might appear at first sight. He might be described as the *"petit bourgeois"* turned artist. He possessed all the obvious virtues and hidden vices of the bourgeois, but then there were glimpses of sublimer aspirations and of an unselfish devotion to his profession which surpassed the mere bourgeois sense of duty. His career has nothing extraordinary. He was born and grew up in the Duchy of Slesvig where he was apprenticed to local painters. At the age of twenty he went to

Copenhagen where he studied at the Academy until 1809. From 1810 to 1813 he was in Paris, then spent the next three years in Rome. On his return, in 1818 Eckersberg was elected a professor in his old school, whose most beloved and inspiring teacher he remained till his death.

His early paintings do not look very promising. His academic compositions are particularly awkward, and he never became a more than tolerable painter of historical pictures, although he tried hard. He was singularly deficient in visual imagination, and there may have been little in the old Academy training to encourage the particular gifts that were his. But he painted some fine landscapes in the manner of Jens Juel, e.g. the "Prospect of Elsinore with Kronborg" in the Hirschsprung Collection. By its distinguished colour and composition as well as by intensity of observation it augurs the coming master. The Paris years set the course of his development, through the acquaintance with Jacques-Louis David (1748-1815), whose instruction he enjoyed for some time. In David, who had been the leading painter of the French revolution and now prospered in the service of Napoleon, Eckersberg met the new spirit of orthodox Classicism.

In French art political events had lent a special sting to the inevitable reaction against the Rococo style. The Revolution had been propagated through invocation of the austere virtues of Republican Rome, and Napoleon had followed it up with clever allusions to Augustus. So Classicism swept France as well as the rest of Europe. Since French painting set the fashion, Eckersberg could not have come to a better place for the latest developments in the painter's art. To the art of painting Classicism means a reinforcement of what may be called its sculptural qualities. It gives priority to drawing and perspective in order to emphasize and clarify space and plastic volumes. It logically involves isolation of colour, it favours brightness and perspicuity. In short, it stresses what is historically the Florentine tradition in European painting at the expense of the truly pictorial attitude of the great Venetians who had preached the gospel of colour and discovered the wonders of light and shadow. But David had another catchword. Like all convinced classicists he believed himself a cham-

C. W. Eckersberg: Bertel Thorvaldsen. Painted in Rome, 1814. (In *the Royal Danish Academy of the Fine Arts*). Eckersberg's admiring portrait of his successful older compatriot and fellow artist has become the classical picture of the great sculptor, and the most inspiring of the painter's many and excellent portraits.

pion of "Nature". Rococo, to the contemporaries of the Revolution, meant affectation, pretentiousness, hypocrisy, while Ancient Greece and Rome had come to stand for natural beauty, honest modesty, nay, for truth itself. This must be borne in mind if we want to understand Eckersberg, for it explains how, without feeling that he was betraying his classical ideals, he was enabled to express his ardent and instinctive love of nature.

David gave Eckersberg, besides instructions in ideal composition which were mostly wasted on the Dane, the example of a portraitist working in the new style. To this was added, in Rome, the influence of a former pupil of David, Jean Auguste Dominique Ingres (1780-1867), who was to surpass the master in the sensibility and acuteness of his unforgettable Roman portraits. For landscape, which they hardly ever practised, Eckersberg had to turn to others. Corot had not yet made his appearance, so Eckersberg wisely stuck to the French 17th century classicists, Poussin and Claude Lorrain. He had made their acquaintance in the Louvre and, in two large pictures belonging to the Doria Gallery in Rome, he got a fresh opportunity to admire Claude. His recollections of the two great French classicists and of the works of their Dutch contemporaries in the Royal Gallery provided Eckersberg with a knowledge of how his greatest predecessors in the field that was his by deepest inclination had approached nature and solved the formal problems of a *genre* that enjoys the privilege of being almost without ancient precedents.

In France and Italy he continued the habit taken over from Juel, and still in vogue in Paris and Rome, of painting prospects of interesting and picturesque sights, blending architectural elements and landscape, and often adding distinct but unobtrusive accessory figures. We get a "View of Paris" from the Quai Voltaire with the Pont Royal and the fine bathing establishment in the Seine (1812) and a wonderful "View from the Chateau Meudon" (1813). In Rome he painted quite a series of the classical prospects, many of which were admittedly more idyllic in those days than to-day. But in Rome, if not before, he saw the ancient world with fresh eyes. The sentimental spirit of the 18th century had evaporated; we only have to think of the

C. W. Eckersberg: Landscape Scene at Fontana Acetosa. (Oil, 1814, in *Statens Museum for Kunst*). This is the most spontaneously beautiful of Eckersberg's many unpretentious studies from Rome and the surrounding countryside.

heroic and romantic Roman ruins of a Piranesi or a Hubert Robert to realize how much the world of painting had changed. Here, evidently, was a man bent on painting what he saw, a painter in search of truth, a humble and careful observer devoted to the visual beauty of nature. Here, if anywhere, was a harmonious combination of the classical ideal of pictorial perspicuity of space and colour with a faithful rendering of the subject. So the best of Eckersberg's small Roman prospects compel our admiration as lasting interpretations of the beauty of the Eternal City. Paintings such as the "View of the Castel S. Angelo across the Tiber", or the view through three arches of the Colosseum, or the many glimpses of the sun-baked ruins of the Forum Romanum in their green setting of grass and trees are wonders of careful observation and yet fresh in their appreciation of the colours of Rome. In one case, the marvellous "Landscape Scene at Fontana Acetosa", he seems to have surpassed himself in the saturation of its colour; perhaps we are struck by an unusual quality because the painting is not

quite finished. We may have reason to regret that he did not stay long enough in Rome to meet Corot.

A major event of Eckersberg's life was his meeting Thorvaldsen in Rome. The latter, as usual, received the younger compatriot and fellow-artist with genuine friendliness and was anxious within reasonable limits to be helpful. Two paintings in Thorvaldsen's Museum give proof of their friendship and of the sculptor's influence upon the painter. The little Homeric scene, entitled "The Farewell of Hector and Andromache" has, alas, more of David than of Thorvaldsen, whereas the study of a sleeping woman clad in a classical drapery displays a grace and grandeur worthy of its former owner. It seems significant that the better one of the two pictures, which were both painted in the same year (1813), is the one for which Eckersberg could draw inspiration from observation of nature. And the ripest fruit of his meeting with Thorvaldsen are the two wonderful portraits he painted of his famous friend and the latter's mistress, Anna Maria von Uhden, née Magnani, both painted in 1814. Thorvaldsen's portrait, now the property of the Academy, has remained the best likeness of him—and the unsurpassed masterpiece of its painter. Thorvaldsen is dressed in the uniform of a member of the "Accademia di San Luca"; the background for his head is formed by the Alexander Frieze, the very part of it where the triumphant Macedonian is received by the personification of peace on behalf of conquered Babylon. Meaning, of course, Thorvaldsen and Rome! The figure is seen and rendered by a loving admirer of the successful Danish sculptor, as well as of French portrait painting. It may well be that admiration for once urged him to go beyond the strict limits of truth when he conceived this almost heroic portrait—albeit idealization is felt in the conception of the whole figure with its upturned gaze rather than in the details of the features. Nowhere did he ever more happily apply the lessons of David and Ingres than in this picture. It is no less masterly in its melodious expressiveness of line than in the subtle handling of light and colour or the optical illusion of the various materials. The much smaller portrait (now in the Hirschsprung Collection) of the woman who became the mother of Thorvaldsen's children is another masterpiece. Eckersberg was a pas-

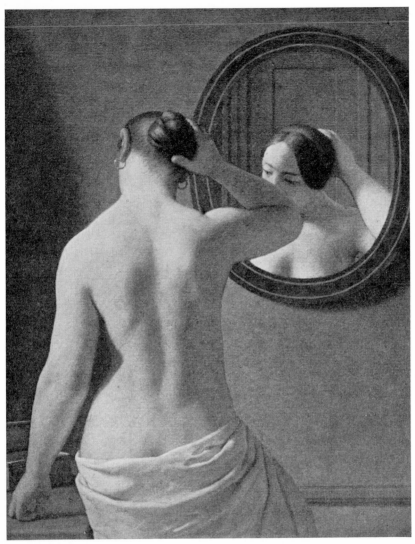

C. W. Eckersberg: Study of a Nude in Front of a Mirror. (Oil painting from the 1830es in *Den Hirschsprungske Samling*). Eckersberg's most brilliant study from the life.

sionate, if at times too uncritical, admirer of the fair sex. There exists a charming little study of Emilie, the girl that became his favourite model in Paris, and, in Eckersberg's rendering, Anna Maria Magnani is, if not a beauty, a most attractive Italian woman. Her rather doubtful reputation, mentioned in the official biography of Thorvaldsen, should not mislead our judgment about those obvious charms of hers which kept both Thorvaldsen and, if we are not mistaken, Eckersberg, too, in her spell. Judging by the artistic passion, he was never more in love than when he painted this little jewel of sparkling light and cool colours.

In Rome Eckersberg rounded off and finished his education as a painter. It is hardly an exaggeration to say that throughout the thirty-eight years of busy activity which followed his return to Copenhagen he added nothing to his artistic stature. But it is only fair to add that, although he produced many an indifferent painting, he also made good ones as long as he lived. The inherent dullness of life in Copenhagen may in part be responsible for his stolidity of mind, but then he did not do anything to relieve his monotony by seeking fresh impulses abroad. So the conclusion is forced upon us, (and is in fact supported by much evidence), that there was a considerable element of pedantry in his character. He appears to have been a happy man, living a peaceful family life in successive marriages with the two daughters of Jens Juel, and surrounded by clever pupils, who loved and admired him. He had found what to him was the final wisdom in painting. And he was no longer willing to give way in matters of principle in order to please the public (such weaknesses had occurred in his youth) even if he often was, and at times badly, in need of money, and lived long enough to see his art considered a back-water by people addicted to novelty.

Shortly after his return, he painted (in 1817) the amiable, many-coloured double-portrait of Count and Countess Bille-Brahe (now in the Ny Carlsberg Glyptotek). The great inspiration of the Thorvaldsen portrait is fading away. Although we are still reminded of Ingres this is obviously a Danish version. With the high-strung feeling of the Roman portraits, flattery, too, is taking its leave. The spectator is left in the company of his common-place fellow-countrymen of the reign

of Frederik VI. What a mirror of their age are these portraits by Eckersberg which tell the truth with such disarming honesty! In 1818 he painted the large group-portrait of the Nathansons. The head of this family was his staunch and admiring supporter. The family is portrayed with the dignity of a classical composition, although the subject is not a Trojan tragedy, only Mr. and Mrs. Nathanson returning to their nice and well-bred children from an audience at Court. The picture may contain a reminiscence of the elegant composition by Ingres for a group of the Lucien Bonaparte family in Rome, known from the wonderful drawing dated 1811, now in the Fogg Art Museum in Cambridge, Mass. But the true monuments of the Danish burgher of the day, and something essentially Danish, are the phantastic paintings of Mr. and Mrs. Schmidt in the Hirschsprung Collection. This wealthy East India merchant and his wife are so delightfully vulgar that their portraits do the greatest credit to the combined naivety of themselves and their painter. It is simply impossible not to like them. And then, in 1820, he painted with equal skill their social antipodes, F. W. C. von Benzon, a Gentleman of the Bed-Chamber, and Miss Massmann, his fiancée. Her portrait, especially, is a masterpiece of cool beauty, subtle in line and colour and of the most impeccable aristocratic detachment.

A daring modernism, introduced (in 1822) at the Academy through the initiative of Eckersberg and his colleague *J. L. Lund,* was the establishment of a school aiming to train the pupils in painting from nature and in day-light. The tradition was instruction in drawing, and it used to take place at night. In the early days of the Academy nude models were invariably male, but now the study of female models became part of the curriculum. Eckersberg often availed himself of this opportunity to practise a kind of figure-painting that appealed more to him than the customary historical compositions. Most of the results are rather scholastic, and some in bad taste, but no praise is too high for the "Study of a Nude Figure before a Mirror", in the Hirschsprung Collection. It shows ingenuity of observation and is a most exquisite sample of his true gifts as a colourist.

Once established on the shore of the Sound, Eckersberg took a real fancy to the sea. Thorvaldsen had a maritime past, making figure-heads

in his father's workshop, and the proud sailing ships became the consolation, nay, the passion of aged Eckersberg. Ships have often proved fascinating to artists, and Eckersberg carried his boyish delight in their building and rigging so far as even to make, and with his own hand sign, the still-existent model of a sailing vessel. They had to him the additional charm of lending themselves to intricate problems of perspective drawing. For perspective became an obsession with him as the years went on. In that, if in nothing else, he was the equal of Uccello and Piero della Francesca. But ships meant much more to him and his art. They provided endless opportunities for observing and enjoying the beauty of nature. So, without any conscious effort on his part, this passion of his enabled him to pursue the true love of his heart without betraying the innate pedantry of his mind. His study of ships and their element was a thorough one; it included daily observations of the weather, carefully recorded in his diary, visits to harbour and wharfs (a new source of information about the arrivals and departures of vessels), or long excursions at sea, from which he brought home the studies which were to become the starting points for his many paintings of Danish sea-scapes. He even once strayed as far as London, only to return home by another ship on the very day of his arrival! Usually he stayed much closer to his base, and he had justly been called the artistic discoverer of the Danish coasts.

The highest perfection was not reached by Eckersberg in the works on which he lavished the greatest care. The last of his life-work to sink into oblivion will be a few small and entirely unpretentious landscapes. The "View of Renbjerg", a brickyard near Flensburg, must be counted among them. This was where he spent his childhood, and nowhere has his love-of-country been more exquisitely expressed than in this little canvas. It is saturated with the sweetness of a Danish coast, caressed by the wind and the light of summer, a harmony of green and blue colours intensified by the deep note of the red roof of the brickyard buildings. And yet, there are a few more paintings which give evidence of his communion with nature, and which are of still more absorbing interest to modern admirers. They are small but sensitive studies of sky and lake, trees and grass, painted on his carefree

Sunday excursions with his pupils. We see him doing one of them in a drawing made by Købke during such a picnic. Three of them are on show in the State Museum, a fourth in the Ny Carlsberg Glyptotek. In them he shows, almost unconsciously, what a wonderful painter he might have been. There is no self-conscious "perspective", no nonsense of any kind about them, they were just made for the fun of it, but they were duly appreciated by the few people for whom they were meant. On them depended the future of Danish painting.

THE AGE OF KØBKE

The first half of the 19th century is usually described as the "Golden Age" of intellectual life in Denmark. This is rather a vague term, borrowed from literature, so, having dealt separately with Thorvaldsen and Eckersberg, we prefer to name the period between the Napoleonic era and 1848 after its greatest artist. It may be futile to weigh Thorvaldsen and Købke against each other, but undoubtedly the latter is superior to Eckersberg, whom he beats on his own ground. If Danish painting is ever to be appreciated by the world at large, Købke will be its first discovery.

Practically all the painters dealt with in this chapter belong to the school of Eckersberg. There is, however, one exception. As this solitary man is older than the others and was not without importance at least to Købke, it is natural to deal with him first. *C. A. Jensen* (1792-1870) left the Academy in 1816, just before the return of Eckersberg, and was abroad when the latter began working as a teacher. He is only known to us as a portrait painter, and as such he was rooted in the 18th century tradition. C. A. Jensen never became anything like a classicist, though he was at times not uninfluenced by the new virtues brought to the fore by Eckersberg. Jensen, however, maintained a standard of pictoral independence which certainly had a salutary influence upon his younger contemporaries as an antidote to too much "perspective". In Jensen's pictures there is no obvious linear drawing. Nor is there any respect for the isolation of colour, or what is known as "local colours" (this was typical of Eckersberg). Jensen's portraits

59

are painted boldly and with vivacious brushwork. They do not aim at truth in the philosophical sense of Classicism, but at an optical illusion. When C. A. Jensen was successful, he produced brillant likenesses, but when he missed the target only superficial concoctions of colours. He is seen at his best in some exquisite works from the 'twenties, e.g. the portraits of Mr. and Mrs. Hohlenberg (of 1826). There is also the fine portrait of his wife, in the Hirschsprung Collection. Towards the middle of the century he almost gave up painting, but he came back to round off his career with the fulminant likeness of A. G. Rudelbach (1858). This masterpiece has often evoked the name of no less a colleague than Frans Hals. The last twenty years of his life he earned a modest living in the service of the Royal Print Cabinet, and in his leisure hours made important "discoveries" of old masters at the small dealer's shops. And, by the way, Jensen was not the last Danish artist to indulge in this exciting eccentricity.

No life could be more modest and uneventful than that of *Christen Købke* (1810-1848). He would undoubtedly have been the most surprised of all, to see his name given first place among those of Danish painters. The son of a prosperous baker, he began studying at the Academy already in 1822. Like C. A. Jensen, Købke became the pupil of *C. A. Lorentzen* (1746-1828). After the latter's death he turned to Eckersberg. He left the Academy in 1832, but did not go to Italy until six years later. On his return in 1840, he was accepted as a candidate for the Academy, but failed to be elected a member. He died of pneumonia in the fateful year 1848. Købke, if anybody, was the born painter. He was endowed with an eyesight more penetrating and better fitted for the registration of shades of colour than most people's. He was endowed, too, with a hand which, when holding pencil or brush, unfailingly obeyed the commands of that perceptive brain. He combined acuteness of observation with a fundamental innocence of mind, a noble simplicity as rare in art as it is in life. He never painted ideal figure-compositions, but his instinct for the well-balanced structure of the picture was infallible. Already at the age of twenty his personality and his gifts were fully developed. The "Interior of Aarhus Cathedral" (1830) is the work of a ripe master of painting, precise in the handling

C. A. Jensen: A. G. Rudelbach, the Theologian. (Oil, dated 1858, in *Statens Museum for Kunst*). A solitary work of the old age of the greatest Danish portraitist of the 19th century.

of space and extremely sensitive to colour and light. It shows how thoroughly Købke had absorbed the spirit of Eckersberg, but there is also in it something warm and atmospheric so rarely met with in the work of the teacher. The "Aarhus Cathedral" quite naturally reminds of Dutch 17th century church interiors. The Royal Gallery contained no artistically adequate specimen of this genre. Nevertheless, Pieter de Hooch's fine "The Minuet" (acquired 1809 with the West Collection) was not wasted on Købke. The same year he painted a study from the Charlottenborg Collection of Plaster Casts (the Hirschsprung Collection), which is masterly in the handling of light and movement. In 1832 he produced the most beautiful of all Danish portraits, the likeness of his friend Frederik Sødring (also in the Hirschsprung Collection). There is a close connection between the picture of Sødring and the two mentioned above. For this is not just a portrait in the conventional sense of the word, it is an intimate study of a young painter in his studio. We perceive an interior though we do not see much more of the room than the door against which Sødring is sitting. We sense it so clearly, because Købke conjured up the air and light of the day. It is his secret how he created this perfect colouristic illusion of atmosphere without giving up the perspicuity so dear to Eckersberg. From the latter he may well have learnt how to heighten a painting dominated by cool colours by the limited application of deep red. Though Eckersberg's "View of Renbjerg" (from 1830) is a good instance, it is almost breath-taking to see the same thing done by Købke. Nowhere in Danish art do we find anything exactly like the effect of the little red etui on Sødring's table. And we are no less impressed by the purity of spirit radiated by this miraculous painting.

Somehow it becomes evident to the student of the Sødring portrait that the artist who made it must have been a great painter of landscapes. Of this the loving care he lavished on the sitter's none too luxuriant flower-pot is not the only evidence. Indeed, Købke was a master of landscape painting, too. In the early 'thirties he painted that wonderful series of small views of the countryside just outside the gates of Copenhagen. First of all there are the peaceful idyls of the Citadel, where the Købke family lived until 1834. Diminutive in size, the best of these

Christen Købke: Frederik Sødring, the Painter. (Oil, from 1832, in *Den Hirschsprung-ske Samling*). Købke's portrait of his friend ranks as the most beautiful picture of Denmark's Golden Age.

unpretentious studies of nature have a concentrated wealth of colour and light which gives them an outstanding place in the history of Danish painting. We must evoke the memories of Guardi and Vermeer van Delft to convey to the foreign reader an adequate idea of their

importance. About the middle of the 'thirties, Købke was induced to make what must have seemed to him a more serious professional effort. It was the production of paintings of larger size and aiming at a stricter observance of the venerable rules of composition. This change was brought about by two friends, H. E. Freund, the sculptor, and Georg Hilker, a painter specializing in decoration done in the Pompeian style. When Købke went so far out of his way as to paint the old Frederiksborg Castle, we have, no doubt, the first result of the influence upon Danish art of N. L. Høyen, about whom we shall have more to say in the next chapter.

The first of his large paintings is the "View outside the Northern Gate of the Citadel" (in the Ny Carlsberg Glyptotek), painted in 1834. The following year he made the unusually large portrait of his sister, Mrs. M. Petersen. Both paintings testify to the difficulties he overcame to adjust his habits of vision and his ideas of colour to canvases of such unwonted dimensions. He soon thought he saw a solution in a conscious simplification of colour, in toning down the light. A very interesting episode was the work on the decorations for the dining-room of his father's new home at "Blegdammen". Unfortunately the four pictures are now divided between the Kunstindustrimuseum which keeps the two austerely architectural landscapes with motifs from Frederiksborg, and the C. L. David Collection where are to be seen the painted copies of Thorvaldsen's famous relief tondos of "Day" and "Night". Immediately after, in 1836, he painted the large "View of Østerbro in Morning Light", a picture reminiscent of Abildgaard in the dignified harmony (within a fastidious colour-scheme, dominated by violet tones) of its architectural elements and figures. The masterpiece of this period is, however, the smaller "View near the Lime-Kilns Looking towards Copenhagen" (in the Nivaagaard Collection). This study in green on a greyish day, is equally perfect in composition and colour. It shows, too, that Købke had kept that almost miraculous power of vision, so obvious in his early landscapes. It would be unpardonable to leave this period of his career without a reference to two of his best portraits. One is the striking likeness of Constantin Hansen (in the Museum of Ribe), a work of a certain "Dutch" quality

64

Christen Købke: View of Østerbro from Dosseringen. (Oil, from the 1840es, *Winther-thur museum*). A fine example of Købke's intimate landscape-style; a masterpiece worthy of the brush of a Guardi.

similar to that of his early Cathedral Interior. The other is a monumental "Pompeian" portrait of H. E. Freund (now at the Academy).

The right man for Købke to have met, when travelling abroad, would have been Corot. But no pupil of Eckersberg's repeated the master's experience of a stay in Paris. They all went straight to Italy, and even Købke could not avoid a passing touch of the unwholesome influence of such German painting as he became acquainted with on his way. The picture for which he was eventually turned down at the Academy was admittedly one of the less successful fruits of his Italian journey. It would have been against the rules, of course, to award an Academic prize for any of his numerous good paintings. On the other hand, he made the wonderful study of Castel dell'Uovo in Naples, which to posterity seems worth the whole trip.

His last years were clouded by misfortune. Cbviously he was doubtful about the future and diffident about his own genius, astonishing as the latter statement may seems to us. He wasted much time on finishing Italian paintings and some on taking part in the interior decorations of Thorvaldsen's Museum. Staggered by the blow of the Academy's fatal decision, he is even said to have considered becoming a professional decorator. But he could not, of course, give up the habit of painting the immediate surroundings of his everyday life. So during the last troubled years of his life, he again produced a number of small gems, which have given later observers an inkling that, with better luck and more self-confidence, Købke might have changed the whole course of Danish, or—if Thorvaldsen's good fortune had been his—of European painting. But then he would perhaps not have been the Købke we love. For that deep natural modesty of his seems to have been one of the sources of his art. In this period, among many dull portraits, he painted the deeply moving one of his sister-in-law, Johanne Købke. However, it is the small open-air studies that are the real surprise of these years of doubt. Witness the painting—now in the museum at Winterthur—representing the "Dosseringen" along one of Copenhagen's beautiful lakes. It was in the immediate vicinity of his home, and he had often painted it. So he now caught all the strange intensity and suspense of the moment when a dark cloud disturbs the sparkling light of a summer day. That may remind us that it was then the age of Søren Kierkegaard, who has described the same lake. But we do not perceive any intended literary allusion in this dramatic accent, new to Købke's art. He remains the personification of the art of painting, while life itself adds ripeness to his outlook. And in pictures like the "Garden Scene with a Great Tree" or the "Study of Clouds over the Skyline of Copenhagen" there is a breadth of brushwork and a freedom of colour that seems to anticipate the discoveries of Impressionism.

The heritage of Classicism fell to *Constantin Hansen* (1804-1880) who, as the son of *Hans Hansen* (1769-1828), a modest competitor and successor of Jens Juel's in the field of portraiture, literally grew up in the 18th century tradition. It is a significant fact that he began his

Constantin Hansen: The Forum Romanum. (Oil, from 1837, in *Ny Carlsberg Glyptotek*). The most distinguished of all Roman studies produced in the golden age of Danish painting.

Academic studies in the school of architecture. After he had switched over to painting he became the pupil of the professors surviving from the old era. However, on the death of his father, if not before, he finally succumbed to the influence of Eckersberg. His earliest works, a self-portrait and portraits of his sisters, still reflect the old style. They have something of the air and grace of the 18th century. Nevertheless, Constantin Hansen, the former student of architecture, was by the nature of his gifts particularly receptive to the theories of Eckersberg, especially to their classical elements. He sympatized with the demand for clarity of composition, plasticity of volume in figure-drawing, and luminous colour. So we see him living up to this program of modern painting in the firm and clear portrait of Mrs. Wanscher, née Wegner, which he painted in 1835.

Constantin Hansen stayed in Italy from 1835 to 1844, and we owe to him some of our most beloved pictures of Rome. He was more successful than Købke in creating pictures which conformed to the popular conception of Italy and yet were artistically tolerable, e. g. the "Portrait Group of Danish Artists in Rome" (painted in 1837) and the "Temple of Vesta and its Surroundings", of which there is a good version (painted in 1836) in the Hirschsprung Collection. He evidently had a better understanding of architecture than Eckersberg, so in the happy moments when he was really successful in colour, he even beat the master. It is doubtful if any European artist of the period, with the exception of Corot, has made a finer study of much-painted "Forum Romanum" than Hansen's captivating picture (from 1837, now in the Ny Carlsberg Glyptotek). Its beauty is rivalled by his own composition "From the Garden of the Villa Albani" a few years later.

After his return to Copenhagen, Hansen, like Købke, failed in his effort to become a member of the Academy (he lived to obtain that honour in 1864). But, unlike Købke, he received an important commission, which enabled him to create what became the swan-song of Classicism in Danish painting, viz. the decoration of the vestibule of the new Copenhagen University Building. Its architect was Peder Malling (1781-1861), and it was one of the first manifestations in our architecture of a new spirit, reacting against despotic C. F. Hansen. Before going south, Constantin Hansen had lent a hand in the Pompeian decorations for the house of H. E. Freund. In Italy he carefully availed himself of the opportunity of studying the famous ancient mural paintings in the Museum of Naples. He also studied Renaissance painters, first of all Raphael, the declared favourite of the classicists, and even Michelangelo. For his aim was the creation of a monumental style worthy of his dreams. The scenes of classical mythology he painted for the University vestibule, surrounded by a decorative framework by *Georg Hilker* (1807-1875), still command our respect, if not our love. It must be borne in mind that, in their present state, they are much-restored ruins. Even so, it is difficult to believe that, when they were new, they should have had any quality comparable to the freshness which must have been felt when, almost half a century before, Thor-

Wilhelm Bendz: The Blue Room. (Oil, from the late 1820es; in *Den Hirschsprungske Samling*). A genuine masterpiece by the short-lived artist.

valdsen launched his Roman style. But anybody inclined to feel bored in the Vestibule should be advised to step into the Main Hall of the building, the walls of which are ruined beyond repair by "historical" paintings by later 19th century artists. This shock will teach him due respect for the values of the Golden Age.

Købke and Constantin Hansen may be said, through a comparison of their respective styles to afford interesting examples of the two main possibilities offered by Eckersberg's guidance to his docile pupils. It is characteristic of this happy and fertile epoch in Danish painting that quite a number of young men of promising talent frequented Eckersberg's studio and there found inspiration for what often turned out to have been the climax of their life-work. Shortlived but precocious *Wilhelm Bendz* (1804-1832) is a good example of this. It would be difficult to imagine a more intelligent, a more poetic adaptation of Eckersberg's doctrines than his fine "Study of a Blue Interior" with two

Martinus Rørbye: Greeks at Work in the Ruins near the Acropolis. Oil, from 1835; in *Statens Museum for Kunst*). A painterly rendering of a colourful scene near the entrance to the Acropolis.

reading figures, his brothers (in the Hirschsprung Collection). Bendz took a special interest in the pictorial representation of figure-scenes in artificial light. This attitude should not *eo ipso* be considered a heresy in a pupil of Eckersberg's, but it does seem open to suspicion. The large picture of an "Evening Party" of young gentlemen addicted to music and tobacco (first exhibited in 1828 and now in the Ny Carlsberg Glyptotek) adds an interesting new voice to the chorus of the school. In spirit and style it remains within the sphere of the master but Bendz was soon to give proof of heretic tendencies. On his way to Italy he stayed for a whole year in Munich, where he came under the spell of the romantic movement, so attractive to many of the young Danish travellers. We shall never know what would have been his lasting balance in art, as he died immediately after his arrival in Italy.

Jørgen Roed: Ribe Cathedral. (Oil, from the 1830es; in *Statens Museum for Kunst*). The most subtly coloured of the period's many excellent descriptions of Danish medieval architecture.

In the course of his brief career, Bendz manifested a versatility that might have carried him far if he had survived. *Martinus Rørbye* (1803-1848) had the spirit of an explorer. He visited Norway, Paris, Italy, Greece, Turkey, and Stockholm. As for Denmark, he was the first painter to discover the Skaw, the sandy northern tip of Jutland. The list of his travels gives a hint that he was not guided in his choice of destinations by any fixed artistic principle. Like Hans Christian Andersen, he was just fond of seeing places. It speaks for his painter's eye that in Athens he was led to no excesses of classicism. He was moved by the irresistible beauty of the sunburnt ruins in their landscape settings under the luminous sky of Greece, and enlivened by the picturesque figures of natives still wearing colourful Turkish costumes. He is

at his best in his picture of the entrance to the Acropolis, so redolent of the charm of oriental life among classical ruins, a sight nowadays only to be enjoyed in more distant countries of the East. In other paintings from the Levant the ethnological elements is, alas, more emphasized so as to evoke memories of the famous Horace Vernet, then much in vogue. Had Rørbye lived longer, he might have become rich, for he anticipated that taste for "folk-life" which in the course of the 19th century became increasingly widespread.

If *Jørgen Roed* (1808-1888) had died young he would have been sincerely regretted, for in the earlier part of his life he painted some of the most attractive pictures of that great epoch. Roed was a pupil of Hans Hansen's, and an intimate friend of his son Constantin. So he did not seek the guidance of Eckersberg until after the death of his first teacher. His earliest masterpiece is the captivating picture of a "Girl Carrying a Basket of Fruit", (once in the possession of Vilhelm Hammershøi, the painter). It has a delicacy of colour which is all his own, but is more in accordance with the 18th century tradition than with the gospel according to Eckersberg. His colouristic merits are undiminished, and there is, in addition, a sense of structure in the study of "The Exterior of Ribe Cathedral", painted a few years later. This is, indeed, a picture of unique quality among the many good architectural *motifs* in Danish painting. In 1835 he painted at Frederiksborg, together with Købke. The influence of the latter is obvious in a small but masterly landscape in which the towers of the castle are glimpsed among clumps of trees (in a private collection). In 1837 Roed went to Italy, where he stayed for four years. He painted at Paestum with Constantin Hansen, and in 1838 again produced a wonderful view of a great work of architecture. This study of the so-called Temple of Poseidon, is as intelligent in its structural understanding of that marvellous Doric building as it is sensitive to the chaste beauty of its colours. His "finished" pictures never equalled the studies. So in his later years he was chiefly important as a professor of the Academy.

The young man who in Købke's drawing of "Eckersberg Painting in the Open Air" stands admiringly behind the master, is *Wilhelm Mar-*

Johan Thomas Lundbye: A Danish Coast. Painted in 1842; (in *Statens Museum for Kunst*). This monumental painting bears witness to Lundbye's deliberately romantic glorification of Danish scenery.

strand (1810-1873). He began studying painting in 1826 (on the 7th of August, according to Eckersberg's diary!) and became genuinely liked both by master and fellow-students. He travelled 1836-41, mostly in Italy where he met Constantin Hansen and Roed, but he also paid a visit to Paris, and 1845-48 went abroad once more. By nature he was quite different from the other members of the group, and was to display powers which won for him a wider popularity than they have ever enjoyed,—if not a lasting fame. But at first he seemed to conform to the prescripts of the school. To judge by the two clever portrait groups commemorating events in the home of Waagepetersen, the wine merchant, the "Musical Evening Party" (1834, now at Frederiksborg) and the "Family Group" (1836), he seemed the legitimate heir to Bendz' genius. Alas, he evidently inherited some of the weaknesses, too, of

73

that early-lost member of the clan. Very early in life he had been attracted by etchings of Italian folk-life by Bartolomeo Pinelli. They satisfied that taste for the anecdotic which Eckersberg had almost succeeded in suppressing in his own art, but now indulgently tolerated in this favourite pupil. Thus, sentimental or comic Copenhagen street scenes became the subject of various Marstrand paintings. They were, however, soon to be succeeded by those romantic orgies of gaiety, song, and dance so inextricably bound up with Danish popular notions of life in Italy.

When in the middle 'thirties *Johan Thomas Lundbye* (1818-1848) began painting, not only was Eckersberg still very active, but Købke had already painted some of his best pictures. Further, Høyen had begun work as a lecturer. It was soon felt in the works of this precocious young painter that a change of intellectual climate was impending. True, the starting-point of his art was Eckersberg's ideology. Lundbye stuck to the latter's fundamental attitude to colour. If beauty of life was a prime consideration of the master's, he never found a more sympathetic follower. And yet, Lundbye's outlook was different, he had another message to bring. The "objective" world of Thorvaldsen and Eckersberg could have no attraction for young people growing up in that riot of individual feeling known as Romanticism. It is extremely interesting that he should have succeeded in bringing this attitude to our admiring attention only by painting landscapes and cattle (except for a few, none too captivating, portraits). And still more, that in doing so, in speaking more directly to our sentiment than any of his older contemporaries, he never goes out of his way to appeal to sentimentality. Throughout his short life he was incredibly prolific. He was not always equally good, the romantic painter being almost by definition less stable than his classical colleague. Nevertheless, every year of his working life he produced paintings which to-day compel our admiration and remind us of the beauty of our country-side. An early masterpiece deserves to be singled out. It is the fine picture of the medieval church of Kalundborg (painted in 1837, now in Statens Museum for Kunst). Here Lundbye was still close to the style of Eckersberg and undoubtedly also inspired by Købke's work at Frederiksborg

Johan Thomas Lundbye: Brofelde. Cows Being Watered at a Pond. Painted in 1844; (*Statens Museum for Kunst*). One of the most subtly coloured pictures of the artist's enormous output.

Castle. From the following two years date three more openly romantic landscapes in Thorvaldsen's Museum; as a collector of paintings the venerated head of the classical school indulged in a more catholic taste. The wide view of the country round "Vejrhøj" near Dragsholm Castle (in the Ny Carlsberg Glyptotek, painted in 1840) is a superb example of his unfailing ear for the sweet music of the long, melodious lines of the scenery of his native island. Next year, he painted the "Winter Scene" (now at Nivaagaard), a most convincing rendering of the chilly light of a cold day. In 1842 he found himself working on the enormous canvas which he called "A Danish Coast", not the topographically correct picture of any particular Danish beach, but a deliberate composition. Which is exactly how all 17th and 18th century landscape painters used to work. However, in Lundbye's days this manner had sunk sufficiently into oblivion to regain all the freshness of a startling novelty. Here, it was thought, was something really and truly romantic. If we feel that in this major effort he is, perhaps, somewhat over-

strained, full compensation is offered by the small painting from Brofelde "Cows Being Watered at the Village Pool" (painted in 1844), combining intensity of observation with spontaneity of colour-effect.

Lundbye was abroad from 1845-46, going south by way of Germany but returning from Italy by way of Belgium and Holland. Italy had no visible effect on his art but, even before his travels, he was indebted to old Dutch as well as to contemporary German painting. He has often been compared with Caspar David Friedrich (1774-1840), who had been a pupil of the Danish Academy (1794-98), and there was a connecting link between Danish painting and German Romanticism in the person of a Norwegian painter, J. C. Dahl (1788-1857). He had been a pupil of the Copenhagen Academy, spent several years and left many friends and paintings in Denmark, before settling in Dresden. After his return from abroad, Lundbye in 1846 painted the study for "A Cottage near Lodskov", the larger and extremely popular version of which he finished the following year. Not this picture, however, but two paintings from 1847 (now in the Hirschsprung Collection) are the true glories of the last year of his busy life. It is impossible to imagine a fresher or more inviting rendering of the perfect beauty of a Danish summer day than his "Hankehøj", with its grazing cattle on the wind-swept field near the little hill, in the form of which the searching eye of every Danish schoolboy has been trained to spot the tomb of an ancestor. Its saturation of colour is only equalled by his "Søndersø near Vognserup", in which Lundbye displays an unbounded intensity of vision and a freshness of execution akin to the last masterpieces of Købke.

In 1848, that year of unrest, a German rebellion broke out in the Duchies. Lundbye, like a true Romantic, joined the Danish Army as a volunteer, only to meet untimely death by a chance shot. His legacy to the Nation was, besides a treasure of pictures, the memory of a lovable personality. His diaries and letters have proved a mine for psychological research-workers who have not, perhaps, sufficiently kept in mind that it was fashionable in romantic circles to be restless and high-strung. The moment a man puts pen to paper he is subject to the laws of literature, whether he is aware of the fact or not. Painting was

Johan Thomas Lundbye: Hankehøj. Painted in 1847; (in *Den Hirschsprungske Samling*). One of the most important of Danish landscape paintings, and a notable proof of the artistic stature attained by the artist in the course of his short life.

Lundbye's true medium of expression, and we can rest assured that he told us all he had to say in the idiom he mastered.

Dankvart Dreyer (1816-1852) is visibly a contemporary of Lundbye's. He studied at the Academy, but never travelled abroad. For his style he is deeply indebted to Eckersberg, and he was evidently inspired by Købke's early landscapes. Like Jens Juel he was a native of Funen, but, unlike him, he remained faithful to that wonderful island. Unfortunately, the people of Funen were not in those days as appreciative as later of its deserving sons. So Dreyer's life became a struggle for bare existence. His landscapes are distinguished by very subtle observations of atmosphere, a noble differentiation of colour and a certain

poetry which is entirely his own. There is something as fresh and virginal as the morning air in his "View of Assens", his native town (now in Odense Museum). Standing before the "Landscape with a Rainbow" and the "Landscape with a Moor" we are reminded of classical Dutch painters—and of course Dreyer had studied the Ruysdaels of the Royal Gallery which in the course of the 19th century have won ever-increasing appreciation. Among his geographical discoveries were the Jutland heaths, as witnessed by a masterly darkish landscape in the Oslo National Gallery. He even proceeded as far as to the west coast of the peninsula. He is at his most brilliant in the "Landscape with Sunlit Clouds", while two prospects of Odense have the particular fascination of a brittle colouring that might have won the approbation of Corot.

While Dreyer was a solitary figure whose life-work had to wait half a century for due appreciation, *P. C. Skovgaard* (1817-1875) became one of the pillars of Danish art. He is mainly remembered for works done after the middle of the century, but it would be impossible not to introduce him here, as an intimate friend of Lundbye's with whom he even occasionally collaborated, and then, what is perhaps his most accomplished painting, the "View of the Region near Kongens Møller" was executed in 1844. This picture is already distinguished by that quality which seems to have been his special contribution to Danish art, an original grasp of what may be called the architecture of the landscape—and it has unsurpassed spontaneity, too. Its painter was easily the best compensation for the tragic loss of Købke and Lundbye within the same year.

In Danish sculpture *Hermann Ernst Freund* (1786-1840) is remembered with the veneration felt for an artist of merit who did not live to realize the expectations caused by his talent. He was a German immigrant and learnt the blacksmith's trade in Copenhagen before he entered the Academy to become a sculptor. He went abroad from 1817 to 1828, most of the time staying in Rome, where he served the interests of Thorvaldsen, without ever forgetting his own. Their friendship seems occasionally to have been stormy, the main cause of friction being Freund's contention that the commission for the Twelve Apostles for Copenhagen Cathedral had, originally, been meant for him. Thorvald-

Dankvart Dreyer: View of Assens (Oil, from the 1830es; in *Fyens Stiftsmuseum, Odense*). A charming picture by an artist little esteemed by his contemporaries.

P. C. Skovgaard: View of the Region near Kongens Møller. (Oil, 1844; in *Statens Museum for Kunst*). An early masterpiece by the greatest Danish landscape painter of the post-1848 period.

sen only accepted the commission on the promise of compensation for his younger colleague and collaborator. However, C. F. Hansen, who had an earlier date, too, put a spoke into Freund's wheel, saw to it that the promise was not fulfilled.

Freund was old enough to get his own modest share of the 18th century tradition, and just in time to be permeated by Thorvaldsen's new Roman style. On the other hand, he was so much younger than the master as to feel the longings and inspirations of those who outlived Thorvaldsen long enough to see the romantic movement victorious. There was in those days a growing interest in the representation of subjects from Scandinavian mythology. This interest was first manifested in literature, where its chief exponent was the poet Oehlenschläger. In spite of his Icelandic descent, Thorvaldsen successfully resisted all temptations of what must have seemed to him sheer barbaric balderdash. Freund was less clear-sighted. In the 'twenties he began working on a frieze meant to comprise the entire Nordic mythology. Freund, however, soon reduced its scope to the "Ragnarok", or End of the Gods. Even this reduced project was unfinished at his death. It was completed by H. W. Bissen but only to be devoured by the flames which destroyed Christiansborg Palace (1884). Freund also modelled small-scale figures of Nordic gods—a Wotan (purely classical in style) and a Loke, an original representation of the scheming and mischievous figure of our Pantheon. After all, Thorvaldsen was right—the Nordic movement never became much more than a perversion of Classicism, and the future was to belong to neither. Freund was at his best in portraiture where his greatest assets were acute powers of observation and expression. Which was all the more remarkable as his portraits always kept within the disciplined idiom of the school. The busts of P. M. Wagner, the German sculptor, and that of his enemy C. F. Hansen, a marble herm in the Academy, rank among the finest achievements in that field of Danish sculpture. Late in life he executed a number of tomb monuments of the most exquisite beauty and taste. He had a particularly fine sense

H. E. Freund: Bishop F. C. H. Münter. (Marble herm; 1834; in *Copenhagen University*). Among Thorvaldsen's pupils Freund was the undisputed master of portraiture.

of the adaptability of the spirit and language of the classical Attic tombstones to the service of the Christian Faith. From 1829, he was a professor of the Academy, and he lavished the greatest care on the "Pompeian" furnishing and decorations of his official residence. These were much commented on, at the time, and they had, no doubt, a salutary influence on taste.

It was fortunate for the career of *Hermann Wilhelm Bissen* (1798-1868) that he survived both Thorvaldsen and Freund. He made his most personal contribution to Danish sculpture after the middle of the century but must be introduced here as the most faithful and assiduous of Thorvaldsen's Danish pupils and assistants. Like Eckersberg, Bissen was born in the Duchy of Slesvig. He studied at the Academy 1816-23, then stayed in Rome 1824-34, and again, for several visits, later on. During his first long stay in Italy he acquired such perfection in the style of his master that he could be entrusted with the greatest share in the execution of such important commissions as the Gutenberg Monument for the City of Mainz, which was delivered in the name of Thorvaldsen. Likewise he was chiefly responsible for the execution of the three colossal statues for the Christiansborg Palace courtyard for which the master had left sketches. Mention should be made of two of his own works from this period, viz. the marble statues of Athena and Apollo for the vestibule of the new University Building, a contribution worthy of Constantin Hansen's wall paintings. He became a prolific portraitist, from whose hand we have quite a Pantheon of important mid- 19th century Danes. Perhaps his most beautiful performance in this field is the marble bust of Bishop J. P. Mynster, executed in 1835-36.

The third of the Triad of clever Thorvaldsen pupils, *Jens Adolf Jerichau* (1816-1883), belonged to the generation of Lundbye. He did not arrive in Rome until the very year of the master's final departure, just in time to be duly impressed, without losing the spirit of independence. In 1845, he executed the large group of Hercules and Hebe, which was in the heavy classical style of the decade. Within the same year there was also the "Panther Hunter", which, strange to say, was something shockingly realistic for those days. For it depicted a scene of momentary action without even the pretence of a classical subject.

82

ART AND PATRIOTISM. YEARS OF CONFLICT

The century between the foundation of the Royal Danish Academy (in 1754) and the death of Eckersberg (in 1853) had, seemingly, witnessed the complete success of the Royal Art School and Association of Artists. Its express purpose, the creation of a body of Danish artists had been rapidly and successfully accomplished. So a century after its foundation there was every reason to consider both Danish art and the Academy well on their way. However, now that the venerable society has added another century to its age, we realize that the first hundred years were the happiest in its history. In retrospect it becomes clear that the rejection of Købke and Constantin Hansen spelt disaster for the Academy, no less than for the artists concerned. It was the symptom of internal weakening, a warning that the monopoly by which the Academy controlled Danish art would, before long, prove as hollow as political absolutism. In art, no less than in politics, a crisis was impending.

It would be impossible to write the history of Danish art from the Roman years of the early Academy exhibitioners to the death of Thorvaldsen without including an appraisal of the influence of Winckelmann and his classicistic art theory. Likewise, no record of the Golden Age of Danish art—the age of Købke—and of its transformation in the latter half of the 19th century—would be complete without mention of *N. L. Høyen* (1797-1870). It was a sign of the times that it was not then, as in the preceding century, a foreign celebrity whose bookish philosophizing set the course for Danish art. This time it was a Dane who showed the way. For the 19th century knew no European cultural ideal capable of inspiring the young. Their slogan was Artistic Nationalism.

Høyen, our first professional art historian, after a prolonged study tour of Germany, Austria, and Italy, worked away tirelessly (from the 'twenties) as a professor in the Academy, a museum official, and (from 1856) a university lecturer too. In the study of our early architecture he was a pioneer. Though he is responsible for the disastrous "restoration" of Viborg Cathedral it must in fairness be borne in mind that

he is not the only outstanding expert to have killed an architectural monument with kindness.

His importance to contemporary art was, above all, due to his eloquence. He did not write much, but his appetite for lecturing was insatiable. Not content with his professional duties, he invited audiences to informal private lectures, on which occasions he would carry on for hours. Nor was he inexpert in the gentle art of swaying "popular opinion" simply by force—an art which a man can practise single-handed in his official work or other public service.

Høyen's sphere was the Academy, which had already in 1829 made him Professor of History and Mythology, and the museums, on whose organization and purchases his influence was decisive. His sphere included, too, the "Kunstforeningen" (the Art Society, founded in 1825) which, twenty years later, he forced into competition with his "Selskab for Nordisk Kunst" (the Society for Nordic Art).

Høyen became the spokesman of Artistic Nationalism as opposed to Europeanism, of popular Nordic opposition to aristocratic Classicism. He became the spiritual leader of those artists who represent the romantic element in our pictorial art. It is all the more to his credit that his sound instincts led him into opposition to the German influence to which young Danish artists were exposed on their way to Italy. It does not seem to have occured to any one that France might be worth a visit. Høyen even came to the desperate conclusion that it was better for our artists to stay quietly at home and concentrate on Danish scenery and folk-life. Perhaps the best proof of contemporary respect for Høyen was the fact that the best of Eckersberg's pupils, as well as the sculptors and architects of the day, joined his following. He was a loyal and helpful friend of those to whom he felt bound by mutual admiration. On the other hand, his life-long persecution of poor C. A. Jensen makes it evident that as an enemy he was pitiless and implacable.

The political tension which had been making itself increasingly felt within the Danish Realm ended in a violent explosion after the death (in 1848) of King Christian VIII and the succession to the throne of his none-too-talented son, Frederik VII. That year of European revolu-

tions hurled Denmark into a veritable war between the Crown and the pro-German Schleswig-Holstein Party, which was, temporarily, supported by Prussia. At the same time the pressing problem of the Constitution was solved in the spirit of peace and democracy by the King's voluntary resignation of Absolutism.—*H. W. Bissen,* till then Thorvaldsen's most loyal and pliable pupil, provides a typical example of the transformation taking place at the time in Danish art. In his war memorials he found beautifully mature expressions for the new spirit of the age. In memory of the Battle of Fredericia (a Danish victory won on July 6th 1849), he created the "Landsoldaten" or statue of the unknown soldier. On the tomb of the fallen soldiers was placed Bissen's relief of two soldiers burying their dead comrade. A striking innovation was his introduction into these two monuments of realistic costumes, contemporary military uniforms. Without abandoning the classical idiom to which he had been trained Bissen found popular expressions for such universal human feelings as the triumph of victory and grief for the fallen. And just as naturally, in his portrait-statue of King Frederik VI (modelled 1855-56 for the Frederiksberg Gardens), Bissen cast off the last vestiges of heroic masquerade. He portrayed "The father of the Nation" dressed in the simple uniform which had served him for everyday wear. It soon became evident how great a loss European sculpture had suffered by the jettison of the rich and universal symbolism of the classical tradition. However, be that as it may, Bissen deserves praise for being able in his art to serve the need of the moment without sinking into vulgarity.

Popular romanticism delivered *Constantin Hansen* into the hands of Nordic Mythology (always a fatal influence upon Danish art). But even if his most ambitious work in this field, the "Egir's Feast", can only be described as a complete failure, Hansen's sketches for it gave us some of his most plastic figure-studies, e.g. the "Sif", (the portrait of woman, now in the Collection of the Carlsberg Glyptotek).—The masterpiece of his old age was an enormous portrait-composition "The Fathers of the Constitution", i.e. The National Assembly of 1848 who laid the foundation of our democratic life. It was painted 1860-64, and is now at the Frederiksborg Museum. This painting is the civilian

counterpart of Bissen's "Landsoldaten". Like Bissen, Constantin Hansen made his classical training and pictoral genius serve the needs of the day, while at the same time expressing the New Spirit in a masterpiece of painting. There is great natural dignity in the ageing painter's monument for the Creators of Danish Democracy. It may be lacking in immediate colouristic charm, but more than makes up for this defect by the solidity of its composition and portraiture.

The most gifted painter of the period after 1850 was *P. C. Skovgaard*. After the tragic death of Lundbye, who had been the friend of his youth, it became increasingly clear what was to be Skovgaard's special contribution to the interpretation of the Danish landscape. It was neither the linear beauty, nor the rhytmic motion, nor the moving sentiment characteristic of Lundbye's work with which his spiritual heir chiefly concerned himself. And that rare eye for chromatic splendour which had been Købke's, was denied to Skovgaard. The strange artistic spontaneity by which some of Lundbye's and Købke's late paintings excel does not seem to have tempted him to emulation. But there were compensations. For Skovgaard had the gift of seeing and painting the glades of the Deer Park and Sealand's tree-lined country roads as if they were classical landscapes. Timeless peace pervades his monumental Danish summer scenes. The trees lift up their tops over a rich and substantial soil, the blue dome of the sky is gay with majestic white clouds, like sedate sails on a calm sea. This earthly Paradise knows neither dryads nor legendary huntsmen. Only now and then its peace is disturbed by one or two ladies carrying sunshades, a painter at his work, or the sleek, well-fed deer which inhabit our forests. Or, when the painter is in his liveliest mood, a few bathing boys may, unwittingly, strike an Arcadian note.—P. C. Skovgaard's landscape style was clearly formulated already in 1848, when he painted the grandiose "Summer Day in the Deer Park". If called upon to single out individual works from the following decades, when Skovgaard was the undisputed master of Danish landscape painting, the modern spectator would, presumably, first turn to such large canvases as combine majesty of size and style with a freshness of handling which is all their own and due to their being technically unfinished. Such are the State Museum's

H. W. Bissen: King Frederik VI. (Bronze statue from the 1850s in the *Frederiksberg Gardens*). The classical portrait of the popular monarch, the grandson of Frederik V, whose long reign proved fatal to Danish absolutism.

"Cows in a Wood, Evening" and "Woodland Scene with Cattle", or the "Summer Afternoon in the Knabstrup Milking Enclosure", in a private collection. Such poetic, yet substantial, paeans in praise of the Danish countryside marked the climax of the Eckersberg tradition.

Vilhelm Kyhn (1819-1903), whose working career extended until the opening years of the 20th century, seemed an echo of Dankvart Dreyer and P. C. Skovgaard. Still, he did not possess Skovgaard's most fundamental quality, his sense of the plastic structure of landscape. Kyhn's most valuable asset was a lyrical feeling for nature and a subtle sensibility to the beauty of light, qualities which give to the best of his landscapes a poetry of their own. Other pictures, especially his larger ones, often suffer from a peculiar lack of compositional unity. Kyhn reacted sharply against the new trends manifested in the French-influenced realism of the 'eighties. So, in his old age, he naturally came to be regarded as the typical representative of conservative values in Danish landscape painting. But he was by no means a die-hard reactionary. He gathered younger artists in his so-called "Den Academy". Influenced by his younger colleagues, he even began painting his pictures in the open.—A picture from 1860, the "In the Summer House", with three life-sized figures, holds an exceptional place among his productions—it is a regular tit-bit for lovers of unmitigated artistic fumbling.

The artistic development of *Jørgen Sonne* (1801-1890), the chief exponent of international Romanticism in Danish pictorial art, was very slow. He frequented the Academy, which he left in 1828, to pursue his studies in Munich. In 1831, he proceded to Rome, where he remained for a full decade. In his youth, he painted battle-scenes, and in Rome the customary *genre* pictures. But it was not until the late 'forties that his real *début* in Danish art history took place, his contribution consisting of such sentimentally poetic scenes of peasant life as the "Tisvilde, Invalids Sleeping on the Tomb of St. Helen" (1847) or the monumental "Rural Scene" (1848), which is in a private collection. The sweetish colours of these sentimental compositions show us the effect upon Sonne of his years of study in Germany and provide a very favourable foil for the virile clarity of contemporary Lundbye. Sonne's youthful experience as a painter of battlescenes proved useful

Wilhelm Marstrand: The Suitor's Visit. Oil, dated 1854; in *Statens Museum for Kunst*. One of the finest of this popular artist's scenes from everyday life.

to him for the large-scale pictures in this *genre* to which the Three Years' War (1848-50) inspired him. Existent studies for these pictures, e.g. the State Museum's sketch for the "Battle of Isted", have truly artistic qualities. His masterpiece, however, was the frieze for the outer walls of Thorvaldsen's Museum whose colour scheme was prescribed by others and limited by the austere technique of mural painting. How much of the beauty of this particular work is due to the influence of M. G. Bindesbøll, the architect, it will hardly be possible to ascertain. At least, Sonne must be given credit for the execution of this unique pictorial frieze, which is now being replaced by, it is hoped,

a weather-proof copy. It is an indication of the change of artistic climate which had taken place in Copenhagen that the most striking exterior decorations for Thorvaldsen's Museum were the record of a contemporary event, viz. the Master's triumphal entrance into his native city on Sept. 17th, 1838. On the roof, only, pure Classicism, embodied in Bissen's splendid quadriga, stood firm.

Popular *genre*-painting, as exemplified by Sonne, was especially favoured by Høyen. He considered it a useful preparatory exercise for Historical Painting which he regarded as the most elevated ideal of National Art. But most artists got no further than to rural *genre* paintings—e.g. *Frederik Vermehren* (1823-1910), *Christen Dalsgaard* (1824-1907), and *Julius Exner* (1825-1910). In their small-sized pictures these artists displayed genuine gifts for the painter's art. But their inspiration soon dried up, while they busied themselves with the anecdotal pictorial compositions which won them wide popularity.

We last met *Wilhelm Marstrand* in Rome, intent upon the joys of the vintage season. On his return to Denmark in 1848, he was elected a professor of the Academy. Following a suggestion by Hans Christian Andersen, the famous author of the fairy-tales, Marstrand on his honeymoon trip visited Dalecarlia in Sweden, whence he got the subject for a picture which he finished in 1853. It was the "Boating to Church on Lake Siljan", a colossal composition with numerous figures, but which had, unfortunately, more of size than style. This was Marstrand's contribution to Danish "peasant romanticism". Afterwards Marstrand, who remained incurably sceptical to Høyen's theory of the selfsufficiency of Danish art, spent a most profitable and prolific year in Venice. As far as we know, that was the first time a Danish painter was heard of as having seriously studied the city in which European painting was brought to perfection, the home of Titian, Tintoretto, and Veronese. It would be an overstatement to say that he returned as the apprentice of the Venetians, but no doubt our quick-witted artist had seen a new light. In happy moments he showed that he had learnt how Painting can create an entire world of its own by the noble medium of Colour. The Lagoon city had drawn its magic circle round him, but the agile mind and sure hand which were his strength also marked the

Jens Adolf Jerichau: Girls Bathing. (Marble group, dating from the 1860s; in *Statens Museum for Kunst*). As the youngest of Thorvaldsen's pupils, Jerichau introduced a new spirit into Danish sculpture.

limits of his powers. So our final judgement on his life-work must be that he remained "promising" to the day of his death.

Marstrand was somewhat of a jack-of-all-trades. His enormous output consists for the most part of studies and sketches—not to speak of innumerable drawings. By and large, he concentrated on a limited range of subjects. The Danish and Italian *genre*-pictures became "literary" classics through his constant preoccupation with scenes from Holberg's comedies and from Don Quixote. Unfortunately, Marstrand's sense of humour was stronger than his sense of pictorial values—but to him too can be applied the words of Fritz Jürgensen (that classic Copenhagen wit) that "Our hearts are nurseries of noble aspirations". However, through all vicissitudes paintings like the monumental "The Artists Wife and Children in his Charlottenborg Studio" and "The Suitor's Visit" have kept green the memory of his great powers. Also, his great altar-piece "The Doubt of Thomas" constitutes a serious attempt to renew Danish church art in the spirit of the High Renaissance.

There is little to be said for the historical paintings executed by Marstrand towards the close of his life, viz. two scenes from the life of King Christian IV on the walls of that popular monarch's sepulchre in Roskilde Cathedral and the "Consecration of the University" in the festival hall of Copenhagen University. After painting the last-mentioned composition Marstrand died, and so the two pictures which were to flank it, and for which he had provided sketches, were excuted by *Carl Bloch* (1834-90). This artist brought the grandiose style of European Historical Painting (based on somewhat superficial studies of the Renaissance) which was coming into fashion everywhere, to the fore in Denmark. He created a *furore* by his colossal composition of the "Liberation of Prometheus" (in a private collection). It was exhibited in 1864, that bitter year of defeat, when Denmark lost the Duchies, and is said to have breathed new hope into despondent hearts. On the other hand, Bloch's representation of "King Christian II in the Dungeon of Sønderborg Castle" (1871, on view in the Frederiksborg Museum) has plunged successive generations of sentimental spectators into depths of despair.

While Freund and Bissen were close friends of Høyen, *J. A. Jerichau*, the third and youngest of Thorvaldsen's talented pupils, became the standard-bearer of the opposition who fought that eloquent art-historian and his party. Into this position he was, largely, forced by purely personal circumstances, such as Jerichau's rivalry with Bissen for public commissions, and even more his marriage with a fashionable Polish paintress at whose German-influenced historical scenes a fellow-countryman of Eckersberg and Købke might well shudder. Jerichau was appointed Academy-professor in Copenhagen in 1849, but did not give up his studio in Rome, to which he frequently returned. Life did not fulfil the dreams of his youth. It was impossible after 1848 to repeat Thorvaldsen's feat. So Jerichau's bid for European fame was doomed to failure. And in Denmark, Bissen was both too strong and too stable for him. Jerichau was a restless soul, an artist sensitive to the finest nuances, and an intelligent critic of the classical tradition in which he had been brought up. Of the numerous works from his mature years it is especially his sensitive renderings of female figures which have a claim on our admiration to-day. The "Reclining Harvest-Girl" (executed in 1852, a marble copy in the Ny Carlsberg Glyptotek) is a plastic embodiment of the romantic spirit which was at the same time expressed in some of Sonne's pictures. The "Girls Bathing" (executed in 1861-62, a marble copy in the State Museum) is a beautiful conception, based on a study of the models so intimate as to bring to memory 18th century sculpture. His talent is also seen at its best in the two versions of the "Leda and the Swan", both of modest dimensions (the Glyptotek and the Hirschsprung Collection). Jerichau's rendering of this classical *motif* (which later on Kaj Nielsen was to make famous in Danish sculpture) reveals a sensuous warmth and grace, a primitive sense of form, which are profoundly original and amply prove his right to the permanent place of honour he won for himself in the history of Danish sculpture.

NEW LINKS WITH PARIS. THE AGE OF PHILIPSEN

It is not difficult to see, that praiseworthy as Høyen's endeavours to keep our artists out of bad company might seem, they would, had they been successful, have reduced Danish art to a fatal state of isolation. For, until this day, Danish artists have only been able to rise to their best performances when spurred on by good impulses from abroad. Nor is it surprising to a modern spectator that, after the decline of the arts in the years of national crisis, the revival should have been made possible by that contact with Paris which Danish artists had so shamefully neglected, although that city had *made* their beloved Eckersberg. However, to understand how this contact, so vital to us, was re-established, we must realize that, in the first decade of the Third Republic, French art did not at all look the same to the young Danish artist who went to Paris in the middle 'seventies as it does in historic retrospect. For the artistic crisis which set in after the middle of the 19th century was international. In Paris the struggle between a universally recognized and officially patronized art school, whose productions were worthless, and a group of relatively unknown Titans, the coming men (if only they could manage not to starve to death), had been much fiercer than in Copenhagen. For the full understanding of the implications of this statement a study of the Great Exhibition of French Art, held in Copenhagen in 1888, will prove rewarding. This exhibition, almost entirely the result of Carl Jacobsen's personal initiative, was of importance because of its lasting effect upon the Glyptotek's Collection of French Sculpture. A study of P. S. Krøyer's "The Exhibition Committee" (in the Carlsberg Glyptotek) will among the splendid character studies of the men round the committee-table (a veritable academy of Greek philosophers) reveal only one member whose fame has survived till this day. It is Louis Pasteur, whose presence seems to indicate that he was one of those unhappy celebrities who lack the moral courage to decline invitations. Or his presence on that occasion may have been due to Carl Jacobsen's special exertions. Among the painters, Puvis de Chavannes is the only one who has not sunk into oblivion. If we turn over the pages of the illustrated catalogue, the impression will not be

Theodor Philipsen: An Octroi in Granada. Oil painting, dated 1882; (in *Ny Carlsberg Glyptotek*). One of the finest fruits of the tour which changed Philipsen into the first Danish Impressionist.

quite so grotesque, although, from our point of view, it will be sufficiently odd. It was, in the main, an exhibition of modern art. Among the works of artists belonging to the preceding generation we find one masterpiece of French romanticism, viz. Delacroix's "Death of Sardanapalus", and a "Portrait of the Artist" by Courbet. Of Corot not a trace, but no less than three pictures by Manet (who had recently died). One was the portrait of his friend Antonin Proust, a member of the committee. We can see his face in Krøyer's painting; Manet's has wandered to Toledo, Ohio. Of the young painters who, by our standards, should have been the pride of France in 1888, Claude Monet was represented by three seascapes, and Alfred Sisley by four landscapes. We look in vain for Cézanne, Degas, Pissaro, and Renoir—to mention only four of the greatest names among the Impressionists. On the other hand, we find, on every page of the catalogue, artists whose names and works are either entirely forgotten, or most unwillingly remembered.

95

The fact that such an official representation was deemed adequate on an occasion when the re-established Franco-Danish art contacts were already ten years old, will enable us fully to realize the difficulties facing the young pioneers of the new era in Danish painting.

Since it was not so easy as one would have thought to go to Paris and discover Impressionism, there is all the more reason for admiration of the one and only Danish painter belonging to the same generation as the great Frenchmen who realized their importance and profited by their examples in much the same way as, two generations ago, Eckersberg had benefited from the best of French art in Paris and Rome. *Theodor Philipsen* (1840-1920) could not be said to have lacked appreciation, for critics and collectors possessed of *flair* appreciated him already in his life-time. Nevertheless, he has not yet won general recognition as the pioneer of his generation, the only one to have obtained results at all comparable to those of the French painters we value most highly.

This under-valuation of Philipsen's art was partly due to the limited range of his subjects. His attitude to figure-painting was extremely reserved, and only very occasionally did he do portraits. Throughout his life, he gave proof of unalterable devotion to landscape-painting in all its forms, and a predilection for cows and horses. It is an open question whether this preoccupation with domestic animals was natural to him, or must be regarded as a heritage from Lundbye. This specialization he shared with some of the inveterate Impressionists such as Monet and Sisley, who most of their lives painted nothing but landscapes (including purely pictorial studies of architecture). Curiously enough, in the opinion of his fellow-countrymen Philipsen was long overshadowed by less gifted contemporaries, who were able to give brilliant, even virtuose pictures of their age in a style which unsophisticated Copenhagen spectators willingly accepted as the latest Parisian novelty.

Philipsen gave up farming to follow his artistic vocation. After some delay caused by the war with Prussia, he graduated from the Academy in 1869. Afterwards he got an opportunity to go abroad on a ship belonging to his brother. So, in 1872, he visited Amsterdam, where (except for what he had seen in Copenhagen's Royal Gallery) he received his

Theodor Philipsen: Rémy Cogghe, the Belgian Painter. Oil, 1883; (in *Ny Carlsberg Glyptotek*). This portrait of a fellow-artist, painted in Rome, is irrefutable proof of Philipsen's early sympathy with Impressionism.

first impressions of the Old Masters. To the end of his life he remained an admirer of his old Dutch and Flemish colleagues, from whose incomparable landscape- and animal paintings he had learnt so much. Towards the close of 1874 he travelled via Brussels to Paris, where he stayed till the spring of 1876. Before going abroad, this young Dane had been painting very creditable pictures in the best tradition of his country—and among them some showing his understandable love of Lundbye. So, very likely, he could not at once find his bearings in the Metropolis of Art and grasp the extent of the revolution then taking place in Painting. But when, of this first visit to Paris, we learn that he was among the subscribers to an address in favour of Manet, we have written proof of his being alive to the latest developments in international art. Not only had recent events in French painting passed almost unnoticed in Copenhagen. Even the recent fundamental change in the intellectual climate of the world was little noticed in the provincial capital on the Sound, whose literary circles, in those very years, were being so rudely awakened by Georg Brandes' inspiring—and provocative—lectures and articles. No doubt, the first advantage that Philipsen gained from his stay in Paris was his acquaintance with the works of painters belonging to a generation somewhat older than his own. They were the much admired teachers of his French contemporaries: Théodore Rousseau, Millet, and Corot. Both Rousseau and Millet died in 1875. So their commemorative exhibitions offered Philipsen the opportunity for a closer study of their works. Besides, he attended an evening school at Bonnat's studio. But what makes Philipsen's first visit to Paris so interesting to us is that it coincided with the rise of Impressionism (1874-75). The first exhibition of the group of young artists who were to make their nickname world famous had been held a few months before Philipsen's arrival in Paris. Their second exhibition was held shortly before the death of his father called him back to Denmark.

"Impressionism" is a sobriquet which has become the honorific title of a group of French painters (who were still young in the 'sixties of the last century), united in the struggle against the reactionary academic style and trivial anecdotage of contemporary "Salon-Painting".—They

Theodor Philipsen: Meilgaard. On the Banks of the Sorteaa River. Oil painting from 1894 (in *Statens Museum for Kunst*). A Danish landscape whose colour scheme of green and violet displayed a daring and self-assurance till then unheard of.

discovered in nature the whole gamut of the colour spectrum and observed how colour changes under the influence of light. This discovery enabled them to paint the weather as it had never been done before in landscape painting. With the same open-mindedness, and partly under the influence of Japanese woodcuts, they broke the shackles of all traditional rules of composition. So the purity and unrestrained freedom of these works of art gave contemporary spectators a rude shock. Historically, their war against the academic style of David and Ingres was a re-enactment of the revolt of the Venetians against the Florentines, and their eventual success meant the victory of Colour over Line. The immediate predecessors of the Impressionists were Delacroix, a colourful romantic, gentle Millet, Courbet, the fanatic realist, and above all Co-

rot, that genius of landscape painting. In the 'seventies Manet, who was a few years older, became the beloved leader of the young rebels. The core of the group, which stuck together only of a comparatively short time, was made up of such landscapists as Camille Pissaro, Claude Monet, and Alfred Sisley. They were joined by Edgar Degas, the great draughtsman and master of composition, Pierre Auguste Renoir, the universal genius, and Paul Cézanne, the creator of an entirely original pictorial world. The fair sex was represented by Manet's pupil (and sister-in-law), Berthe Morisot.

From the start Impressionism was of special interest to Denmark. For Pissarro who, as the rightful heir of Corot, was one of the leaders of the movement, was a Dane. He was born in 1830 in the Virgin Islands (then Danish), and remained a Danish subject until his death in 1903. In 1852, when still in the Danish West Indies, Pissarro met *Fritz Melbye* (1826-69), a Danish seascape painter who in Paris introduced him to *Anton Melbye* (1818-75), his brother and fellow-artist. It was Anton Melbye who became Pissarro's first regular instructor in the art of painting and introduced his exotic "compatriot" to Corot. He also introduced him to *David Jacobsen* (1821-71), a Danish painter, who made Paris his home from 1856 to 1869. A no less interesting Paris representative of Denmark was *Lorenz Frölich* (1820-1908), the romantic artist who spent most of the period 1851-75 in the French capital. Philipsen met him there, and Frölich is known to have been personally acquainted with Manet and Degas. He produced drawings and etchings, and his work was not visibly influenced by Impressionism.

Between 1877 and 1879, after the death of his father, Philipsen travelled in Italy. In 1879, immediately after his return, he left for Antwerp onboard his brother's ship to make a short trip to Paris. From 1882 to 1884 he made a prolonged tour of France, Spain, Tunesia, and Italy. It was this stay in the South, which turned him into an out-and-out Impressionist. A possible influence can be pointed out: his Belgian friend and fellow-artist *Rémy Cogghe*. For that matter, the pictures he painted during the trip clearly reveal his intelligent appropriation of the new French style. So daring a compositional element as the penthouse in the "Octroi in Granada" (in a private collection) was unparalleled in

100

Theodor Philipsen: Sulmona, the Market Place; oil painting from 1907; (in *Ny Carlsberg Glyptotek*). In Danish art history second only to Constantin Hansen's Study of the Forum Romanum, as an intelligent description of an Italian "town-scape".

Danish painting. And never had it known such brilliance of colour as in this dazzling rendering of the Sunny South. The shimmering light in Philipsen's studies from Tunesia have more than their subjects in common with the pictures painted by Renoir in Algeria at above the same time. Likewise, the unpretentious portrait of Rémy Cogghe (painted in Rome in 1883, and now in the Ny Carlsberg Glyptotek) is pleasantly reminiscent of French painting. It is an intimate yet elegant delineation of a fellow-artist, rather like Degas' portrait of James Tissot, the painter, or Renoir's of Frédéric Bazille, that ever-to-be-lamented young master. The best known portrait of this kind is Manet's famous painting of Emile Zola, the literary friend of the Impressionists. At about the same time, Philipsen painted the grandiose "Carcass of an Ox" which

may owe something to the memory of Rembrandt's famous picture, but shows complete originality of composition, while there is something very modern in the mellow splendour of its colours.

In 1884-85 a young French impressionist dwelt in Copenhagen for private reasons. In Paris he had had a lucrative job as a stockbroker, had married a Danish girl, and become the father of a large family. Some years had been spent dabbling in paint and getting together a small collection of Impressionist paintings. Then the longing for the artist's adventurous life had grown so strong within him, that he threw up his job to become a painter. This man was *Paul Gauguin* (1848-1903), and at the time when he arrived at Copenhagen he was known by the narrow circle who took Impressionism at all seriously as a promising apprentice of Pissarro's. His emigration to Denmark, which can only have been meant as a desperate attempt in his wife's country to return to a well-ordered middle-class existence without having to give up the occupation which had become a necessity to him, ended in complete failure. Many witnesses testify to the *difficile* character of this French artist who, after his death, was to become world famous. As far as we know, only one Danish connoisseur and fellow artist, Theodor Philipsen, showed a sympathetic understanding of him. Some years later Philipsen bought from Fru Mette Gauguin, née Gad, the large "Nude" (from 1880) which he bequeathed to the Nation, and which is now one of the treasures of the Glyptotek's Gauguin collection. Unfortunately, Fru Gauguin was obliged to cede her husband's collection of French Impressionists to a wealthy relative, who did not follow Philipsen's example. Nevertheless, the presence of this collection in Denmark was for some years not without importance for the development of Danish art.

All his life Philipsen remained a great traveller, and his travels were a constant source of inspiration to him. Nevertheless we, his fellow countrymen, regard him as the painter who brought Danish 19th century art to maturity. We take this view of him, because his fundamental loyalty to the tradition of Eckersberg, Købke, and Lundbye was just as natural to him as was the loyalty of his French contemporaries to Corot. Another reason for the esteem in which we hold him is his life-long

Theodor Philipsen: Saltholmen, the Wood and Water Reservoir. Oil painting; 1913; (*Ny Carlsberg Glyptotek*). This masterpiece from the artist's old age anticipates modern Danish painting.

love of the Danish landscape and the brown cows which graze in it. He painted in many parts of Denmark, but his favourite domain was the country round Kastrup, where he lived. In his day, this neighbourhood was a rural idyl. There was, too, the nearby islet of Saltholm—a plot of virgin soil where the cattle lived as in a state of nature. The fact is that the Impressionists and the school of Eckersberg were very much alike in their intensive study of nature. It was this fundamental harmony which gave Philipsen's art its healthful vigour.

At the close of the century, Philipsen painted some of his master-pieces. In 1891 there was the "Avenue in Kastrup", a radiantly colour-ful picture, a large and freely handled composition, by some considered

103

his principal work; in 1894 a more intimate woodland scene, the "On the Banks of the Sorteaa River"; in 1899, a landscape, the "From Voersaa in Vendsyssel" (the Ny Carlsberg Glyptotek), which has reminded more than one spectator of Renoir's magnificent "The Banks of the Seine at Champrosay", in the Louvre. Few Danes have painted a picture so "French" as Philipsen's unpretentious, humourous study of "The Market Place in Sulmona" (1907, in the Glyptotek). There is great beauty in his way of "seeing" and unfaltering mastery in his handling of colour and light in this picture of one of those charming little towns which have always attracted Danish travellers in Italy. On flat, wind-swept, Saltholm he painted pictures in which, because of the similarity of its scenery with that of Holland, he could make use of the principles of pictorial composition with which he had familiarized himself through years of intensive study of classical Dutch landscape painters. Of course mere "borrowing" and imitation are out of the question in the case of a composition so mature and so characteristic of its creator as the "On-Coming Thunderstorm" (painted in 1910, now in the Glyptotek), which is a magnificent proof of Philipsen's *"Wahl-Verwandschaft"* with Jacob Ruysdael and Paulus Potter. On Saltholm, too, he painted those much simplified landscapes and cattle studies of his old age, with heavy, almost brutally painted shadows. It has been said that, in his old age, a physical weakening of the eyes forced upon him a quicker and more summary technique. It is more important to note that his late masterpieces, like the Glyptotek's "Saltholm Wood with the Water-Reservoir" (1913), have certain qualities in common with the art of a younger generation of painters who looked upon kind-hearted and perhaps slightly eccentric Theodor Philipsen as their beloved Guide, Philosopher, and Friend. His portrait was done by Peter Hansen, but posterity is more likely to remember him by his "Self-Portrait", in the large Saltholm pastel (1910) where he is shown at work in the marches among his beloved cattle. The calf is licking his brush—but it

Laurits Tuxen: Queen Victoria. Oil painting, dating from 1894; (*Den Hirschsprungske Samling*). A brilliant study, painted at Windsor Castle, for the large painting representing "The Duke of York's Wedding".

is no mere animal lover who glances obliquely at us from under the wide hat-brim.

While Philipsen adopted the new French style in his own quiet way, there were other Danish painters whose conversion to Paris created a *furore*. During his first stay in Paris Philipsen was soon joined by another young Dane, *Laurits Tuxen* (1853-1927), with whom, in the winter of 1875-76, he frequented Léon Bonnat's art school. Bonnat was not an important painter, and it was not Impressionism in its extreme forms which the young Danish Academy students absorbed from him and his school. Still, his was a new and modern philosophy of art, and they may be said through Bonnat to have become acquainted with some of the raw materials out of which Manet and the Impressionists created such noble works. They were taught to study 17th century figure-painting, especially the Spaniards who were, for very good reasons, unknown to Denmark. And they learnt to look at nature with the eyes of that French realism whose greatest name was Courbet—likewise unknown to contemporary Copenhagen. Bonnat also instilled into them new ideas about the Importance of Light for Colour. And he made a point of teaching his pupils broad and unrestrained brushwork, free from petty fear of gay colours, and forms which, by customary Danish standards, must have seemed rough and sketchy. Besides there flourished a new kind of studies from the nude and figure-composition from which the two bright young Danes who frequented the school after Philipsen benefited greatly. Tuxen, a thoroughly cultured and self-critical man, in Paris acquired the technical proficiency which was to make him the fashionable portraitist of his generation. In the course of his career, he tactfully and skilfully executed a considerable number of portrait commissions for the Danish Royal Family and their relatives within the British and Russian dynasties. His portraits satisfied the royal demand for modern execution in a conservative spirit of traditional family groups and coronation scenes. Tuxen had the courtier's ability to associate with princes, but at least one portrait, his brilliant study of Queen Victoria (in the Hirschsprung Collection), sufficiently proves that, in all this international splendour, he preserved a painter's eye and the amiable malice of a Dane.

P. S. Krøyer: An Artists' Luncheon at Skagen. Painted 1883; (*Skagens Museum*). A masterpiece by one of the most popular Danish pupils of Bonnat).

After Philipsen had gone home, Tuxen, in 1877, was joined at Bon-nat's school by *P. S. Krøyer* (1851-1909), a young painter of just about his own age. In public consciousness he came to stand as the chief exponent of the new ideas in Danish art, which was quite natural, con-sidering the ease with which this precocious young artist climbed to the top of his profession. Some portraits of Hornbæk fishermen, painted before his first visit to Paris, reveal that the young artist was then a promising but reverent upholder of the Eckersberg tradition. Paris changed him. Under the influence of modern French art he developed into a *virtuoso* with a marked taste for picturesque and dramatic effects. Although, in fact, he only got into close touch with second-rate artists, a modern student of his art can hardly help comparing him with Manet. With Manet he seems to offer several points of resemblance, both in his development from a dark, "Spanish" style to a brilliant *Plein-airisme* and in his choice of subjects: the beach and the sea, the fishermen and holiday-makers, flowers and landscapes, portraits of lovely women and venerable grey-beards.But the superficial Dane cannot bear comparison with the Frenchman. Krøyer is found sadly wanting in that masterly sense of picturesque quality, that incredible sureness of colour and mus-icality of composition which are so eminently characteristic of Manet. But the comparison would hardly be fair: it would be a truer measure of Krøyer's artistic stature to call him Denmark's Fantin-Latour. Typical of his early French style is the "*Sardinerie* at Concarneau" (1879) and the "Italian Village Hatters" (1880, the Hirschsprung Collection). These are realistic subjects rendered by means of dramatic light-effects in dark interiors. In 1883 Krøyer painted what is surely his best picture the "An Artists' Luncheon" (Skagen's Museum). In this picture he gets closer to good French painting than in anything he painted in France. Gradually, Krøyer became a fashionable portrait painter. For he com-bined the ability to build up a large "group" into an acceptable whole with an eye for detail. Group portraits like the above mentioned "The Exhibition Committee of 1888", (painted 1890, in the Glyptotek), the "On 'Change" (1895, at the Exchange), and the "A Session of the

Michael Ancher: Girl with Sunflowers. Oil painting; 1889; (*Statens Museum for Kunst*). A colourful picture by the most solid artist of the Skagen School.

Royal Academy of Science" (1896-97, the property of the Academy) will keep alive the memory of this intelligent portrayer of the outstanding personalities of his day.

In the 'eighties of the last century Skagen, a fishing village situated on the Skaw, Denmark's most notherly peninsula, became the meeting-point of a group of Scandinavian artists, all of them inspired by the new French *Plein-airisme*. Admittedly, the most gifted member of the group, *Christian Krogh* (1852-1925), was a Norwegian, whose influ-

ence on his friends was considerable. Nevertheless, by its numerical superiority and by its more enduring interest in the locality, the Danish element was decisive for the artistic reputation of the whole group. It is safe to say, that Krøyer was the pivot of the "Skagen Academy". In a wider sense it included, too, *Holger Drachmann* (1846-1908), the poet, and *Karl Madsen* (1855-1938), the art historian. Both had been painters before winning literary fame. While Tuxen only settled in Skagen at a later date, the most faithful lover of that village was *Michael Ancher* (1849-1927). He moved to Skagen in 1874, married Anna Brøndum, the beautiful and gifted daughter of the local merchant, and settled down for life in her home town. Less keen on travelling than other members of the groups he did not visit Paris till 1888-89. So the impulses which made him a modernist must have been second hand, presumably coming from Krøyer. He has himself acknowledged his debt to old Dutch painting, represented by none other than Vermeer van Delft. He was at his artistic best in the 'eighties, and such pictures as the "Christening" (1886, in Ribe Museum) and the "Girl with Sunflowers" (1889) will be remembered for subtle yet substantial artistic qualities which we would like to regard as part of the Danish inheritance contributing to the formation of his artistic personality.

To those eccentrics who, simple souls that they are, love painting for its Colour, *Anna Ancher* (1859-1935) is the greatest of the Skagen painters. Already by the choice of her first teacher—she went to Vilhelm Kyhn in Copenhagen—she revealed that innate sense of quality, which in 1889 made her seek the guidance of Puvis de Chavannes in Paris. She was one of those rare colouristic geniuses—a Danish Berthe Morisot—who would, one feels convinced, thrive wherever they find the material facilities for painting. And yet, of the whole group, she alone was, literally speaking, a true-born "Scawian". In her sensitive renderings, the fishing population's poor cottage interiors never smack of the folklore collection. In those Skagen interiors which are the flower of her artistic output, e.g. the "Girl in a Kitchen" (1883-86, the Hirschsprung Collection) her French schooling blends with less manifest Dutch influences, and of this union is born a most aristocratic harmony of colour. Anna Ancher was the most self-effacing member

Anna Ancher: Girl in a Kitchen. Oil painting; 1883-86; *(Den Hirschsprungske Samling)*. An intimate, domestic scene, inspired by the study of the Dutch masters, by the subtlest colourist of the Skagen School.

of the Skagen group, yet now that the Skagen era is a closed chapter of our art-history, she is found to have been the most original personality of them all.

Viggo Johansen (1851-1935) belonged to the inner circle of the Skagen School, and even if he did not fulfil the promises of his youth, he played too great a part in the art-life of the 'eighties to be entirely omitted in an historical summary. His artistic ideals, like those of the Anchers, were determined by admiration for both the old Dutch and the youngest French art. Besides painting the customary Skagen landscapes and interiors, he soon applied himself to certain specialities. He was one of the first Danish still life painters, and he systematically drew upon his home life for pictorial subjects. His subjects ranged from the children being bathed in the bedroom to the evening parties to which he invited relatives and artist friends, and culminated in the dance round the Christmas tree (the Hirschsprung Collection).

It seems natural to group with *Viggo Johansen* another artist, *Julius Paulsen* (1860-1940), who was his junior by nine years. Together they travelled to Paris by way of Holland and Belgium in 1885, and Julius Paulsen shared the views of the Skagen Group. Still, he maintained his artistic independence and has, presumably, secured a more enduring place in the history of Danish art than Viggo Johansen. He is admired for the colouristic subtlety of his landscapes, often depicting the vague half-light of approaching night. With years, he became a busy portrait painter. Extraordinary sympathetic insight is revealed by those studies of female models which he practised more assiduously than any other artist of his generation. In this field he developed a rich maturity. An early example was the large "sculptured" picture of the "Models Resting" (1887, in Gothenburg Museum) which, when first shown, excited considerable horrified attention, because in it the critics saw not only fine artistic quality, but also an element of what was then considered improper in the treatment of the subject. The final stage of this development is represented by the exquisitely luminous "Sleeping Girl" (1910, in the Glyptotek).

The generation of painters who undertook the transformation of Danish art in the spirit of French Naturalism included also *Hans*

Hans Smidth: A Railway Compartment. Oil, 1887; (*Statens Museum for Kunst*). One of the most important works of our foremost portrayer of the scenery and folk-life of Mid-Jutland.

Smidth (1839-1917) and *L. A. Ring* (1854-1933), two outstanding talents, whose style and manner have often been regarded as typically Danish. Since Hans Smidth's foreign travels extended no farther than to Flensburg, his life-work has been cited to prove that Høyen might be right in maintaining that National Art is capable of happy and characteristic growth without foreign pabulum. But this view is based upon a misunderstanding. We admire Philipsen, Smidth's contemporary, not because he was the apprentice of the French Impressionists, but because he was a great painter. Only history has revealed to posterity the salutary effect which the study of excellent foreign masters had upon Philipsen. And we see, above all, the genuine Danish quality of his art. On the other hand, one would have to be naive to think that by remaining at home Hans Smidth escaped French influence. The ways travelled by artistic impulses are many and devious, and not

always easy to trace. Jens Juel made himself an able portraitist in the best French manner of his day before ever setting eyes on any part of the world outside his home island of Funen, Hamburg, and Copenhagen. Our Capital may have been a European backwater when Hans Smidth spent his youth there, but ideas travel far and fast. Those of his fellow painters who did go to Paris, did not after their return brood silently over their experiences. And among the personal friends of young Smidth we find none other than Philipsen himself. Besides there were the exhibitions. The Great Exhibition of French Art in 1888 was not the only opportunity of becoming personally acquainted with Parisian novelties. A year later the Kunstforeningen itself arranged a special exhibition of the Impressionists, where, among others, Cézanne was on view. It is natural to suppose that, far from being wasted on our lonely and, according to many descriptions, rather eccentric artist, these experiences considerably stimulated his mental activities. And the supposition becomes conviction when we study his works. At an early age, he made up his mind to become a painter, and through long years of adversity he stuck to this decision, but he was no precocious artist. He matured slowly, and did not produce the sweeping, colourful pictures which made him famous, till after the time when the above-mentioned French exhibitions could have influenced him. Hans Smidth is our most distinguished portrayer of Jutland. He kept aloof from the Scandinavian, or cosmopolitan, artists' colony which had settled in the desert of the Skaw. But neither the Limfjord nor the moorlands have ever been depicted more faithfully or with such magnificent colour. He had the same familiarity with Jutland as Blicher and Johannes V. Jensen, our two great story-tellers. He had, too, their intimate knowledge of gipsy life, of the fairs and the moorland farmers' patient toil. This natural familiarity with the folk-life he described became his forte, although it was an acquired, not an inborn asset. Many of the figures he painted in the 'seventies show that like other Copenhagen painters of the day, Smidth was in the habit of shutting himself up in his studio when working. But in the course of time, he entirely outgrew the wax-work quality which mars so many of our romantic portrayals of country life. Paradoxically, his greatest triumphs in this field were the green and

Hans Smidth: View of the Sea from a Wharf. (Oil; painted in the 1890s; *Statens Museum for Kunst*). Our best sea-scape since Eckersberg.

red interiors, without accessory figures, which he painted about the turn of the century. In them the painter reigns supreme, and that is why he was able to give us these unforgettable descriptions of Jutland peasant homes. Among his "figures" the priceless "Third Class Railway Compartment" (1887) is outstanding. It invites, and can almost bear, comparison with Daumier's famous "Railway Carriage" (in the Metropolitan Museum, New York) which, in the original, Hans Smidth cannot have seen. The mastery with which he painted brilliant daylight is equalled in night scenes like the "A Fire in the Moorlands" (in the Hirschsprung Collection). The number of his fresh and grandiose marines is smaller. The "View from a Wharf across the Sea", is believed to date from the 'nineties. In the last year of his life he gave us the marvellous "Ferry Crossing to the Island of Fuur", (in a private collection) a synthesis of his art. It shows human life as a function of nature, painted with a vigour and freshness unsurpassed in any of the old artist's numerous works.

8*

Hans Smidth is the stay-at-home who, in inspired moments, painted as if he had been apprenticed to the finest French masters. *L. A. Ring,* on the other hand, is the type of the cultured artist who, after extensive travels, finished by painting as if he had never left his parish. When looking at one of Ring's pictures, the spectator is often mildly surprised by his almost uncanny feeling for ordinary things, his love of detail, which leads to a purely graphic mapping out of even the smallest line (as in Eckersberg's most pedantic productions). Nevertheless, Ring has the same right as any other artist to be judged by his best performances. And thus we find that he is far from being the poorest painter of his generation. His first foreign tour took him to Paris, by way of Holland. Later he spent a long time in Italy. There, characteristically, he copied Brueghel's two paintings in Naples. Wonderful pictures, but not the usual goal for a trip to Italy. He seems to have been interested in Millet and (now forgotten) Bastien-Lepage. Both artists were represented in the Glyptotek's collection of French paintings almost from its start. Ring sometimes reminds of Degas by cutting off a picture at the edge in a striking "Japanese" manner. But this similarity is only one characteristic feature of French modernism and should not blind us to the fact that, on the whole he was untouched by recent developments in French art. His own ideas were even fundamentally opposed to Impressionism. For he never abandoned the principle of basing his paintings upon drawing. So, unlike certain contemporaries, Ring never complained of the "unpicturesque" Danish landscape. On the contrary, he created his best pictures in the thin and rather crude light with which we are so familiar. This light is not inconsistent with distinct colouristic beauty, but contains nothing which will serve to veil outlines. On one point, however, Ring agreed whole-heartedly with the modernists. After having sown a few romantic wild oats, he became an uncompromising realist The first fanatic draughtsman since Eckersberg placed his powers entirely at the service of visual truth. His pictures contain a twofold truth: they depict nature and human life without idealization, and they cling to that technique based on perspective which, since the Renaissance, we have been accustomed to regard as *the*

L. A. Ring: Workman Whitewashing the Walls of a Cottage. (Oil, painted in 1908; in *Statens Museum for Kunst*). One of the principal works of the great portrayer of Sealand scenery and country folks.

Truth. Further, in the choice of subjects for his figure-paintings, Ring stuck to "ordinary people", and so he may be regarded as a pioneer of "social realism". His artistic message, and the manly integrity of his character, may be exemplified by one picture, the masterpiece of his large and memorable output, viz. the "Workman Whitewashing his Cottage" (1908). His artistic genius is clearly revealed by the wonderful rendering of the panes of the open casement, and of all his paintings it is perhaps most successful in the handling of colour. Rarely is an artist at once so popular and so aristocratic.

In some respects, *Kristian Zahrtmann* (1843-1917) was the most peculiar painter of his generation. It is not for nothing that he was a pupil of Marstrand. An important aspect of his work may be adequately described by calling him: A clear-headed Carl Bloch, a man undeniably possessed of the psychological insight and the gift for composition which make a historical painter. A favourite subject of his was Leonora Christina, the unhappy daughter of King Christian IV. To Zahrtmann she symbolized his mother, to whom he felt bound by extraordinary filial affection. His finest historical painting was, however, the rejected draft for a mural painting for the Ceremonial Hall of the University. It represents "The Undergraduates Marching Out to Defend Copenhagen in 1659" (painted in 1888, now in the Hirschsprung Collection).—Zahrtmann's attitude to colour was, to put it mildly, peculiar. His delight in colour was expressed in unrestrained welters of brilliant, pure colours. He wallowed in colour like an oriental fairy-tale potentate in diamonds, so that many of his pictures almost blind us by the vulgarity of their barbaric splendour.—In this respect he was, probably, self-taught—at any rate it is needless to say that he had not learnt this treatment of colour in France. Nevertheless, the French painters and their Danish admirers may be partly responsible for breaking down Zahrtmann's respect for our sober classical colour tradition. The originality of his mind was also shown by his travels. At the moment when the current was shifting from Rome to Paris, and Spain was coming into fashion too, Zahrtmann passionately went in for the splendours of Italy. And he harboured, besides, a genuine and entirely unconventional

118

Kristian Zahrtmann: Undergraduates Marching out to Defend Copenhagen in 1659. (Oil, painted in 1888; in *Den Hirschsprungske Samling*). Rejected draft for a mural for Copenhagen University. The most remarkable of this eccentric painter's historical pictures.

admiration for classical Greece the perennial beauty of its scenery. Zahrtmann was most important as a teacher. He threw himself enthusiastically into the revolt against the Academy, and when, in the 'eighties, free art schools were first established, by Tuxen and Krøyer, all Zahrtmann's passionate energy was poured into this work. From

119

1885 to 1908, Zahrtmann taught in the Artists' Study School. His work as the teacher of the most gifted painters of the next generation is second only to what Eckersberg accomplished after his return from Paris. Unlike Eckersberg's success, Zahrtmann's was not based on any theory of style or, indeed, on any consistent art philosophy at all. Nor could his own pictures give rise to more than short-lived emulation. The profounder must have been the effect of his personality, his manly example, his infectious enthusiasm, and wise criticism. All accounts of Zahrtmann's school agree that rarely has there existed so liberal and self-effacing a teacher. It was by these sterling qualities that he inspired his young friends to rise to their best performances.

PETER HANSEN AND HIS FRIENDS

What made Zahrtmann's work as a teacher really important was his inspiring guidance of a group of young painters. They are generally known as "the Funen School", because most of them were natives of that central Danish island, where Mads Rasmussen, a wealthy art-lover, set them a lasting monument, viz. Faaborg Museum. Like Eckersberg in the Golden Age, Zahrtmann became their fatherly friend and adviser. But it was impossible for them to take their beloved teacher for an artistic exemplar. For this they looked to Theodor Philipsen. So it came about, that Zahrtmann hatched a belated brood of Danish Impressionists, and because they modelled themselves upon Philipsen, "the cow-painter", their aristocratic academic antagonists dubbed them "the peasant painters". Which only goes to prove the impossibility of acquiring connoisseurship from books—even though they be contemporary sources.

Peter Hansen (1868-1928) was the most gifted of the Funen painters, one of the rare colouristic geniuses in Danish art history. He was one of our most assiduous travellers in Italy, while he paid only one visit, and that a late one, to Paris (1909). He had, however, as yet only visited Holland, when, in 1894, he painted that lightly handled impressionistic masterpiece the "Waving Rye", whose very title indicates how the new generation treated landscape. From about

Peter Hansen: Boys Bathing. (Oil, painted 1902; in *Statens Museum for Kunst*). A brilliant open-air study by the first artist to carry on Philipsen's impressionism.

the same time dates the "Ball in a Provincial Town" (Gothenburg Museum), an early proof of his gift and inclination for figure-painting. The sketch for this painting (in the State Museum), at least, is excellent and establishes the perfect ease with which, solely by means of colour, Hansen created a complicated composition of figures in varying states of motion. Italy's greatest gift to Peter Hansen was an increased richness of light and colour. His Italian experiences stood him in good stead for the rest of his life, whether he painted in the South, or in the less brilliant atmosphere of his own country. But his love of colour never tempted him to stray into the gaudy barbarism of Zahrtmann. He handled colour with that perfect musical self-control, even in his *fortissimo*, which before him had been won only by Købke and Philipsen.

Never has a *plein air* study sunnier and more richly coloured than his "Bathing Boys" (1902) been painted in Denmark. A truly impressionistic subject (Renoir delighted in it in the early 'eighties),

Peter Hansen: Scene from Pompeji. (Oil, painted 1913 or 1914; in *Faaborg Museum*).
Also in this picture the great colourist acknowledges the debt he owes to Philipsen.

and in Denmark rendered by Krøyer, Willumsen, and Johannes Lar-
sen—besides Peter Hansen who, later on, returned to it again in a
small fresco.

Now and then, like many a fine painter, Peter Hansen would lose
some of the original inspired freshness in the course of the final,
large-scale execution; but his early drafts are nearly always without
blemish. Some of his finest Italian studies are among the treasures
of Faaborg Museum, e. g. a series of wonderful pictures painted in
1913-14 in and around Pompeji. Already ten years earlier he had
there executed the "Pompeian Bakers" (in the Ordrupgaard Collec-

Peter Hansen: Parson Hans Madsen Poling his Boat across to Horneland. (Oil, painted in 1916; *Statens Museum for Kunst*). The subject of this painting is an episode from a 16th century peasant rising in the island of Funen. An ingenious attempt at the realistic historical painting which had been the dream of Kristian Zahrtmann, the artist's beloved teacher.

tion), whose beautifully classical draughtsmanship, almost unparalleled in his works, is his only bow to antiquity. Many of his Italian pictures are based upon groups of figures. They represent folk-life, but how different is their healthy naturalness from the "ballet scenes" produced in Italy by our romanticists. Equally natural was, to his unprejudiced mind, the beauty of the Copenhagen folk-life, which he, coming from Funen, was not long in discovering. The "Enghave Plads, Children Playing" (1907-08) and the "Spring Scene" (1910), representing a girl with a pram make it manifest that, even among the stones of the city, his Impressionist's eye for the picturesque quality of atmosphere made him sense the landscape. He never got a chance to study French subjects on the spot. There is some of the airy grace of a Bonnard in the little "Girl at a Café" (in a private collection), but there can be no doubt that it was painted in Denmark.

Late in life, Peter Hansen called to mind that he had been apprenticed to a history-painter. So he tried to reduce to paint some episodes of the history of his home island. They represent scenes from the unhappy "War of the Count", a Danish off-shoot of the German post-Reformation peasant revolts. His method remained exactly the same as when he used to paint figures in the open. And that is just why his civil war scenes are as life-like as if he had himself gone back four hundred years to follow the armies and make sketches on the spot. It can be done, then, with the simplicity of his "Parson Madsen Poling his Boat across to Horneland to Betray his Parishioners" (1916). And so powerful will be the effect, when it is done with such simplicity that neither Carl Bloch's stagey arrangements nor Zahrtmann's colouristic orgies will bear comparison with its historical and artistic truth. Faaborg Museum's large pastel representing the defeat and flight of the peasants before the iron-clad knights (1917), is unique among his works, and yet, by its gentle earnestness and pure colouristic beauty, it is fully expressive of his temper.

Poul S. Christiansen (1855-1933) was the oldest of Zahrtmann's pupils and became a reliable assistant in his pedagogic work. He has a high place in the history of Danish landscape painting, in which he played a part similar to Cézanne's in France. He strove, without

Poul S. Christiansen: Tibirke Hills, Hot Summer Day. (Oil, painted 1910. *Statens Museum for Kunst*). Almost an Italian interpretation of a Danish summer scene.

surrendering the conquest of light and colour made by Impressionism, to revive classical landscape composition. And, in a manner which was new to Denmark, he used the fine substantial pigment itself as an element of pictorial expression. And with these noble endeavours he combined the lyricism of a humble nature worshipper. As in the case of Peter Hansen, their teacher soon inspired him with a longing for Italy. Even such renderings of Danish scenery as his incomparable "View from the Tower of Viborg Cathedral" (1902) or the "Tibirke Hills, Hot Summer Day" (1910) seem to reflect the grandiose clarity of the Italian landscape. For these are no less classical compositions than Christiansen's rendering of Zahrtmann's beloved "Civita d'Antino

125

in the Abruzzi" (1911).—His "Niels Larsen Stevns" (1910-11) is the finest portrait of an artist done in Denmark, since Eckersberg painted his "Thorvaldsen". And as a noble tribute to a justly admired friend and brother-artist it equals Eckersberg's portrait, which had been inspired by Ingres. This time the source of inspiration was Cézanne. Fired by Zahrtmann's example and his exhortations to high aims, Poul S. Christiansen, all through his career, struggled with large historical, mythological, and biblical compositions. What makes this part of his work so poignant is the evident enthusiasm which went into it. In the best of the pictures, e.g. "Dante and Beatrice in Paradise" (1894-95) he found expressions for the purity of his poetic spirit, expressions so beautiful as to make us forgive technical deficiences which were due to a certain awkwardness, as fundamentally part of the artist's personality as the love of his vocation.

With Peter Hansen are often grouped *Fritz Syberg* (1862-1939) and *Johannes Larsen* (1867-1961). For they all hailed from the island of Funen and made friends while attending Zahrtmann's school. Syberg was harder tempered and has less sense of colour than the others. There is a peculiar bitterness in his early "figures", e.g. the powerful "Death" (1890-92), a Danish pendant of certain works of Edvard Munch. In this connection mention should be made of Syberg's fine sensitive illustrations for Hans Andersen's "The Story of a Mother" (executed between 1895 and 1898, and now in the Royal Collection of Engravings, Prints, and Drawings, Kobberstiksamlingen). These illustrations are, too, closely related with some of his finest water-colours—the technique in which he executed some of his best Italian pictures. His colour-sense did not gain refinement with years, and he arrived in France (in 1908) too late to get the full benefit of Impressionistic influences. Impressionism was, nevertheless, an indirect but fundamental force in the formation of Syberg's conception of nature. In his landscapes the windy dampness of Danish weather is often sensed as an almost tangible presence. And when Syberg, the landscapist, is at his best as in the inspired "Overskov Hill, Winter" (1917), he proves himself a true artist.

Johannes Larsen was more closely akin to Peter Hansen than was

Poul S. Christiansen: Niels Larsen Stevns, the painter. (Oil, painted 1910-1911; *Statens Museum for Kunst*). The most important portrait of an artist since the golden age.

Fritz Syberg. It is more difficult than in the case of the two others to form a valid opinion of Larsen's art outside Faaborg Museum. For only there can we admire the subtle colours of young Johannes Larsen's scenes from his boyhood home at Kjerteminde—. From the 'nineties date his descriptions of the old merchant's house which have preserved some of the child-like innocence which we associate with the painters of the "Golden Age" and their renderings of domestic interiors. We strongly feel the link with Købke, Bendz, and Roed in these pictures by a young artist who had joined the revolutionaries of his day.—Soon he went farther afield and began to depict his bonny island and its surrounding seas. And thanks to the new Parisian gospel of colour and freedom, these paintings became more radiantly beautiful, more spontaneous in their relation to nature. Syberg was predominantly the painter of the Funen fields. Johannes Larsen chose the beaches and the sea for his favourite huntinggrounds. And he never tired of scrutinizing them with eyes and mind open for the ever-changing play of colours over the capricious Danish sounds. He had, too, the naturalist's eye for the bird-life of Denmark's beaches. All through a long life he has described this maritime world of his at all seasons; now in the crude light of spring, as in the "Taarby Beach, April Showers" (1901-07, in Faaborg Museum); often under a luminous summer sky; or in a dense, rainy fog, convincingly rendered as in the "Brent-Geese" (1908, Faaborg Museum); sometimes a fine winter day, as in the State Museum's "Snave Beach, December Sunshine" (1911) and Faaborg Museum's "Christmas Day" (1910), a view of Kjerteminde harbour worthy of a Monet. Johannes Larsen was the only member of the Funen school to receive commissions for large frescos. The most important of these commissions was for four murals representing Funen *motifs* for the ceremonial hall of the Odense City Hall (1933-37). But perhaps he was more successful in his two very large marines with their strangely suggestive renderings of the ground-swell in Kjerteminde Bay. Both are in oil, and unique in the history of Danish painting (1938, Maribo Museum, 1948, the State Museum).

The other Funen painters have often done water-colours, but Johannes Larsen is far superior to them in the quantity of his work, in

Albert Gottschalck: Hillerød, Hill Street. (Oil, painted 1884; *Statens Museum for Kunst.*)
A small-size masterpiece whose creator was the finest colouristic genius of his generation.

Johannes Larsen: Kerteminde Harbour, Christmas Day. (Oil, 1910, *Faaborg Museum.*)
A subtly coloured study, in the spirit of Monet and painted by one of Denmark's
great landscapists.

Fritz Syberg: A Death. (Oil, painted 1890-1892; *Statens Museum for Kunst*). A Danish counterpart of one of Edvard Munch's most famous compositions.

draughtsmanship, and in the skilful use of the etching-needle. Even for wood-cuts he is unrivalled in Danish art, a worthy descendant of Thomas Bewick.

Karl Schou (1870-1938), a pupil of Zahrtmann, was for many years the brother-in-law of Peter Hansen and Fritz Syberg. But, being a native of Copenhagen, he did not belong to the "inner circle" of Funen painters. He was a subtle and subdued colourist, by preference a painter of garden scenes and architectural subjects in the impressionistic manner, i.g. glimpses of the city's moods and atmosphere. Once he had found his artistic form, he stuck to the limitation which constituted his strength. The artistic beauty for which he had an eye he could as easily find in Copenhagen as in Rome or Paris. So although, viewed in the mass, his productions may seem monotonous both in subject-matter and colour, he did pass on to posterity the memory of his refined artistic

culture. He wrote an interesting personal account of Peter Hansen, the friend of his youth.

Albert Gottschalk (1866-1906) is represented in Faaborg Museum by three paintings, and so has won for himself the honorary title of a "Funen painter". He was a pupil of Krøyer and Karl Madsen and, already in 1889, left for Paris. This highly self-critical man was the perfect example of a born painter. He stuck to the same range of subjects as Karl Schou, but played his instrument with far greater sureness of touch. There is in the best of his unpretentious pictures a pure and strong colour harmony. His masterpiece is the "Hillerød, Bakkegade" (1884).

IN SEARCH OF A NEW STYLE

Even before 1890 the days of Impressionism as an organized movement were over. If, that is, the solemn term "organization" was at any time applicable to the campaign fought in the 'seventies and 'eighties by this band of young geniuses. The last of the eight famous exhibitions where, in varying teams, they appeared before the now less sceptical Parisian public, was held in 1886. They were, in short, getting on in years. Although several had many years of life before them (Claude Monet, for one, lived on till 1926), it was in the nature of things that new men with new ideas now took the leading parts on the Parisian stage, the art centre of the world. At this important turning point in the history of pictorial style, we encounter an artist not entirely unknown to our country, a Frenchman, Paul Gauguin, who had even visited Copenhagen. In fact, at his departure from our Capital, he left behind at least one knowledgeable admirer, besides his deserted wife and family,—and not a few enemies. As a gifted pupil of Pisarro, Gauguin had (in 1884-85) attracted the benevolent interest of Th. Philipsen, but Impressionism did not satisfy him. The critical year of his development (whose final phase is represented by his passionate, mystical South Sea visions) was 1888, when he produced those subtly colourful pictures from Brittany which were the first manifestations of his own eccentric personality. They revealed, too, his determined efforts

to replace the Impressionists' atmospheric perception of space with a more decorative conception of pictorial art, which was to give renewed importance to the picture surface. That same year saw the culmination of his famous friendship with *Vincent van Gogh* (1853-90), viz. their stay in Arles which ended so tragically. In the last years of van Gogh's life, the Dutch genius's French paintings infused into modern art an element of wild, unspent force which proved highly important to 20th century painting.

Thanks to *Johan Rohde* (1856-1935), Danish artists almost immediately became acquainted with the transformed Gauguin and with van Gogh. In his paintings Rohde was not, like Philipsen, a pioneer. His own pictures bear the stamp of conservative culture, strangely contrasting with the sure instinct which guided his judgements on even the most radical Parisian novelties. And besides, his most valuable creative efforts were made in the applied arts. As a critic and organizer he rendered invaluable service to Danish art at a critical point of its history. For it was Rohde who, in 1882, as a protest against Academic monopoly, took the initiative in founding the free art school, whose most fruitful consequence was Zahrtmann's pedagogic work. Likewise, it was Rohde who, in 1891, took the decisive step towards the foundation of *Den Frie Udstilling* (The Free Exhibition), which a group of the most gifted members of the younger generation made their forum. This measure led to a permanent weakening of *Charlottenborg,* till then our sole and arbitrary *"salon".* Acting upon Rohde's suggestion, the Free Exhibition in 1893 showed a considerable number of works by Gauguin and van Gogh. This exhibition was lost upon the *bourgeoisie,* but not upon our artists. Ten years earlier, a Gauguin exhibition in the *Kunstforeningen* (The Art Society) had been closed on account of the scandal it caused! Already in 1888 this far-seeing critic had, in his writings, called attention to El Greco, whose rediscovery came at this point of time.

Founded by a few rebels against the tyranny of an ossified majority, the Free Exhibition soon grew to include most of the painters who, in our view, are of any importance to the history of Danish art in the early 'nineties: Philipsen, Krøyer, and the Funen Group. It included, too,

J. F. Willumsen: *Les Bretonnes.* (Oil, painted in 1890; in the *Willumsen museum,* Frederikssund). An early work from the years when the artist was winning his place among the leaders of "Symbolism".

those artists, the subject of this chapter, on whom the movement which in France had succeeded Impressionism had been a decisive influence. However different they might be in temper and in colour, they shared a feeling of the inadequacy of Naturalism. Widely different in artistic powers, in training, and in the philosophies which had gone into the making of their artistic personalities, they all tried to express "a sense sublime of something far more deeply interfused" behind visible reality.

On account of this mystic idealism, which in some of them manifested itself solely as aestheticism and in others as religion, this predominant artistic trend of the 'nineties has been called "Symbolism". However, the movement proved incapable of forming a characteristic style, and none of the artists with whom we are here dealing remained life-long votaries of the ideals of Symbolism. This was simply due to the fact that, at bottom, Symbolism was a philosophic and literary movement. It was not, like Impressionism, an artistic ideology in the proper sense of the term.

French Symbolists took as their starting point Gauguin's new decorative style which found enthusiastic admirers and imitators in the members of the so-called Pont-Aven Group, named after the small town in Brittany where the movement was born. They were also called "Les Nabis", the prophets. Their leading ideologists were *Paul Sérusier* (1864-1927) and *Maurice Denis* (1870-1943), both gifted theorists and teachers, while *Pierre Bonnard* (1867-1947) and *Edouard Vuillard* (1868-1940), the two best painters of the fraternity, soon sought new inspiration in a return to Impressionism. Now, in 1890, two young Danish painters got in touch with these French Symbolists. For not very prolific *Mogens Ballin* (1871-1914) this meeting set the entire course of his short career. Also *Jens Ferdinand Willumsen* (1863-1958) in Brittany received a directing stimulus.

Willumsen's early productions vacillated between historical paintings in Zahrtmann's manner and "Krøyeresque" realism. He was so deeply impressed by the Great French Exhibition (held in Copenhagen in 1888) that, before the end of the year, he was drawn to Paris by the desire of seeing more of the same kind. And next year, probably following Krøyer's example, he left France for Spain. In those years he studied *J.-F. Raffaëlli*, a competent modernist, of whose pictures five had been shown in Copenhagen in 1888, but, in 1890, he joined the Symbolists at Pont-Aven. Willumsen has himself stated that he did not become acquainted with Gauguin until after he had painted the pictures of Breton peasant women (in the museums of Aalborg and Frederikssund) which won for him a prominent place in Danish art history. So he must have been initiated in the new ideas indirectly by Gauguin's

134

J. F. Willumsen: After the Storm. (Painted in 1905; *Nasjonalgalleriet, Oslo*). One of the artist's principal works, and the nearest approach by any Dane to the temper we admire in modern Norwegian painting.

French disciples. This, of course, in no way detracts from the value and importance of his pictures, and before he had reached the age of thirty, Willumsen could be rightly described as "one of the outstanding exponents of Symbolism". It would be quite impossible to take the pictures he painted in Brittany for the work of a French artist. Their most obvious characteristic is a peculiar sharp-cut precision, not to say

coldness. Soon our Nordic symbolist gave proof of a very un-French preference for mountainous solitudes, whence he drew the inspiration for the large "Jotunheim" ("The Home of Giants", 1892-93, in a private collection) and for several later pictures which are among his most highly admired productions. From 1893 dates the draft for his much-discussed and severely criticized "Great Relief", his masterpiece in the Symbolist manner. It is a profoundly subjective fantasia on the aspects of human existence. Willumsen planned it for execution in pottery, but it was fated not to be executed in durable materials (viz. in coloured marbles and bronze) till thirty years later. From the 'nineties date also the most outstanding architectural achievement of this versatile artist, the Free Exhibition Building (in 1913 moved to its present site). In this connection it is to be regretted that Willumsen was not given the commission for the murals of Nyrop's new City Hall, built in Copenhagen about the turn of the century. That would have been the right commission, at the right moment, for an artist of his peculiar powers and lofty aspirations.

In the opening years of the new century Willumsen painted some of his most beautiful pictures which, after the symbolist interlude, were marked by formal and psychological maturity, clarity and vigour of composition, and almost violent colour-effects. In such works as the "Mountaineer" (1904, in Hagemann's College; a replica, dated 1912, in the State Museum), the "After the Storm" (1905, The Oslo National Gallery), the "Scaw Beach, Children Bathing" (1909, Skagens Museum), and the "Sun and Youth" (1902-10, Gothenburg Art Museum) Willumsen competed with *Edvard Munch,* his great Norwegian contemporary, for the first place among Scandinavian painters. In the opinion of some critics he was never better than in the productions of this period, which are the striking expression of a proud and lonely mind. In 1910-11, a tour of Italy and Spain revived his old love of the Mediterranean climate and light. The effect upon his life proved a

Joakim Skovgaard: Salome Dancing. (Fresco fragment; *Statens Museum for Kunst).* This rejected fragment of the decorations for Viborg Cathedral, is a fine early 20th century sample of that peculiar "Viborg Style" whose most important ancestor in European art history was Symbolism.

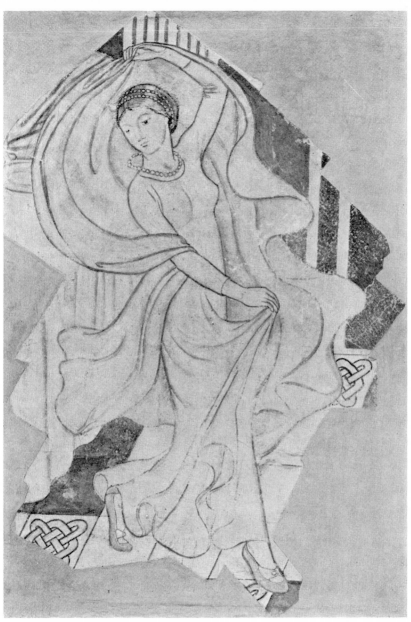

lasting one. For in 1916, after some years of travel, one object of which was a thorough study of El Greco, Willumsen settled permanently in the South of France. The immediate effect on his art of this second visit to Spain is exemplified by the "Triana Bridge, Sevilla" (1913). On the other hand, there are no signs of his later works having been in any way influenced by that contemporary French art which surrounded him on all sides. The works of his old age became more and more like the strange soliloquy of a hermit without listeners. Nevertheless, he had not forgotten his country, nor did he wish to be forgotten by her. For, in the face of violent opposition, he stuck to his decision of bequeathing to a Willumsen Museum such of his works as were in his own possession. This Museum, which has been built in his father's native town of Frederikssund, also includes his large collection, mostly of old art, of whose great value he has declared himself convinced.

In France Symbolism brought with it a revival of the interest in religious painting. Paul Gaugin had painted the Crucifixion and other biblical subjects. And Maurice Denis is known for his anaemic renderings of the Holy Family. In corresponding Danish circles church art was attended to by the sons of P. C. Skovgaard. *Joakim Skovgaard* (1856-1933) and *Niels Skovgaard* (1858-1938) had grown up in the living tradition of the "Golden Age". For the chief exponents of this tradition were: their father, Constantin Hansen, and Marstrand, while they had been taught to look with awe upon Johan Thomas Lundbye, the genius who had been the friend of their father's youth. Still, their own artistic powers were sufficient to raise them to front rank status among their own generation. Their aspirations were high, and the fact that posterity prefers to remember them by their less pretentious works does not diminish our respect for these aspirations.

After completing his studies at the Academy, Joakim Skovgaard frequented Bonnat's school in Paris (1880-81). The following years were spent travelling in Italy and Greece, sometimes accompanying Philipsen

Niels Skovgaard: The Sea-Horse Well. Serpentine sculpture; (1912-1916; in *Det Danske Kunstindustrimuseum*). The versatile artist's principal sculpture.

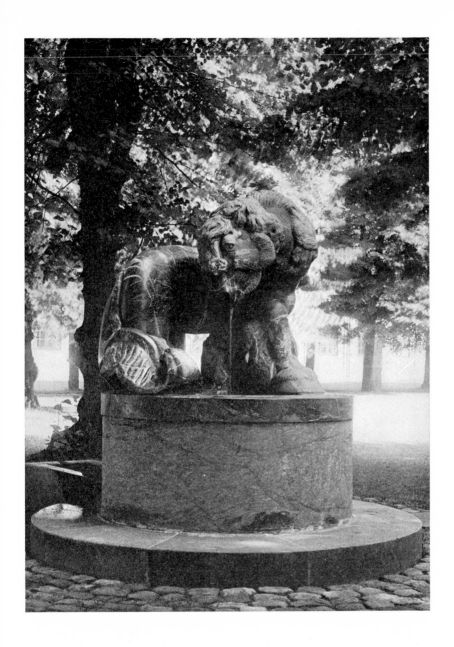

and Zahrtmann. In the early 'nineties he paid repeated visits to Norway. All his life he remained a great traveller, and once even went all the way to Java. At home and abroad this incredibly prolific painter produced numerous landscapes, studies of architecture, and figure-paintings, which would alone win him a high place in contemporary Danish art. Special attention was paid to such large religious compositions as "The Angel Touching the Waters of the Pool of Bethesda" (1887-88, in the Oslo National Gallery; later water-colour replica in the Hirschsprung Collection), the "Pennina Mocks Hannah" (1890-91, in Viborg Museum, another rendering of the same subject is in a private collection), and the "Christ Descended into Hell" (1891-94, in the State Museum). The first shows the influence—so rare in Danish art—of Eugene Delacroix. His frescos in the Church of St. Sulpice, Paris, must have made a profound impression on the young Danish artist. The second is an important work in Zahrtmann's manner, and intelligently reminiscent of Rembrandt. The third and largest is the most original of the three, in so far as it shows us the artist trying to found a Danish school of religious painting inspired by Grundtvig and based upon our highly expressionistic medieval art. The brutally designed figure of Christ, which looks as if cut in wood, was a tremendous sensation and provoked sharp protests, which were voiced by *Julius Lange* (1838-96), the art historian who had succeeded to Høyen's place in our art life. He was an eminent student and historian of Ancient Art, and on this occasion voiced classicistic Denmark's indignation at the new barbarism. The mentioned works naturally secured for Skovgaard the commission for the murals for Viborg Cathedral. This, the greatest task with which any Danish artist has ever been entrusted, was a consequence of the disastrous "restoration" which converted the venerable but dilapidated cathedral into a textbook pattern of what the 19th century believed to be Romanesque Style. The murals, which were not completed until 1906, were done in a style unheard of before or since. This "Viborg Style" resulted from thorough studies of old Italian church art (from the Byzantines to the Renaissance), but its anti-naturalistic tone was entirely modern. Skovgaard seems to have believed that the Ancients, when decorating church walls, had always shown great respect for the

Vilhelm Hammershøi: Girl Sewing. (Oil, 1887, *Ordrupgaardsamlingen*). A beautiful early work by this distinguished colourist — the painting whose rejection by the Charlottenborg "Salon" caused the foundation of "Den Frie Udstilling".

wall surface. However, this is quite un-historical, inasmuch as one of the aims most consistently pursued in old European painting was the conquest of space by means of a lucidly plastic figure style. Gauguin and the Symbolists were the first to revolt against this century-old tradition. So, in spite of much that was aesthetically valuable—

141

especially in Skovgaard's sensitive draughtsmanship, which comes out beautifully in the water colour sketches (in the Hirschsprung Collection)—Viborg Cathedral remained an unsatisfactory compromise. For Skovgaard did not have courage and strength to stick to the radicalism he had displayed in the "Christ Descended into Hell".

Like Willumsen, Skovgaard was a versatile artist; he produced mosaics, tapestries, pottery, and book-craft. His sculptures were produced in co-operation with *Thorvald Bindesbøll* (1846-1908), the architect, whose father was the builder of Thorvaldsen's Museum. Bindesbøll, jun. was himself a prolific artist whose influence on Danish applied arts was considerable. Their best known joint production is the "Dragon Fountain" in the City Hall Square, Copenhagen.

In the old age of the gifted brothers it was confidently rumoured among their Danish *confrères* that, as a matter of fact, Niels Skovgaard was the better artist. One reason for this heresy, widespread among the *dilettanti,* may well have been his not being responsible for the "Viborg Style". For Niels Skovgaard's painting always harmonized with his artistic instinct. Colour was not his forte, and yet he painted such fine pictures as the "Cranes in the Dunes" (1844, the Hirschsprung Collection) and the Italian "The Fountain in the Chestnut Grove" (1909, in a private collection). His greatest asset was his sense of plastic values, and for many years he worked on a large figure composition, by whose subject he had been fascinated on his first trip to Greece (1888-89). This was the "Dance of the Women in Megara" (a series of fine studies for it are in the State Museum). Niels Skovgaard showed originality of draughtsmanship and was, presumably, most successful as a sculptor. Important works in this mode are the polychrome terracotta relief entitled "Aage and Else" (1887), the reliefs for the granite memorial in Skibelund Grove (1898, in memory of the victory of Magnus the Good over the Vends), the "Sea-Horse Well" (1916, Kunstindustrimuseet, the Arts and Crafts Museum), and a large statue, the "Grundtvig Kneeling" (of which a granite copy was placed in the courtyard of the Vartov, Copenhagen, in 1931). Such works have done much to free the younger generation of Danish sculptors from the tyranny of Classicism which had such a firm grip on Thorvaldsen's fatherland. It was

142

Niels Bjerre: View from Devil's Castle. (Oil, 1941; *Statens Museum for Kunst)*. A colourful landscape by an artist who devoted his life to the glorification of Jutland.

no mere chance that Niels Skovgaard's great discovery in Greece was the Olympia Sculptures which, in the world at large, did not get their due of appreciation until the advent of Maillol.

All the experimenters who, in the 'nineties, "set out in search of a style"—the Danish Symbolists—shared, above all, certain literary ideas and besides certain views on composition. But already in this matter of composition their agreement was less obvious, and on other artistic principles it was non-existent. The group did not have a common principle of colour, and that explains how two outwardly so different painters as Willumsen and Hammershøi could remain friends and comrades-in-arms.

Vilhelm Hammershøi (1864-1916) has been dubbed the "painter of deserted rooms". Aristocratic interiors—preferably devoid of human

figures —, neurasthenically coloured studies of dust-motes dancing in a pale sunbeam, between white doors, in the deserted salons of the "upper ten", such subjects make up a large and popular part of his production. But in youth he aimed high as a figure painter. So the large composition entitled "Artemis" (1893), which is said to have been inspired by Signorelli's "Pan" in the Berlin Gallery, is one of the most notable productions of the age. Usually Hammershøi sought his ideals among the Dutchmen, and among the very best of them, for he studies Vermeer van Delft and Rembrandt. But his limited range og subdued colours seems to have been all his own, although pictures by the contemporary American James Whistler may have influenced him. The official Charlottenborg Salon's rejection of his fine "Portrait of a Girl Sewing" (1887, the Ordrupgaard Collection) was the signal for the revolt whose outcome was the foundation of "The Free Exhibition", which put the rebels in a strong position, for it was, in the best sense of the term, a conservative picture, impeccable both in form and content. Hammershøi was, presumably, most successful as a portrait painter. It is an indication of his artistic powers that his largest canvas is also one of his best: the large group representing five of his artist-friends (1901, Thielska Galleriet, Stockholm). In his peculiar, subdued idiom Hammershøi has given us distinguished descriptions of the best of our old architecture: Kronborg, Frederiksborg, Amalienborg; and he did landscapes, too.

Niels Bjerre (1864-1942) was born in the same year as Hammershøi. He was a pupil of Tuxen, and travelled both in Italy and France. Yet all his life his painting remained firmly rooted in his native West Jutland. His healthy, colourful descriptions of nature are in direct opposition to the sophisticated Hammershøi sphere. And yet a large composition, the "Children of God" (1897, in a private collection), his rendering of an Home Mission prayer meeting, has both technical and psychological affinities with the aristocratic Copenhagener's description of his five friends.

In *Einar Nielsen* (1872-1956) Symbolism found one of its most eminent and most loyal exponents in Denmark. A stern philosophy and a weird preoccupation with the artistic treatment of suffering and death,

Einar Nielsen: The Sick Girl. (Oil, painted in 1896; *Statens Museum for Kunst*); an outstanding example of Danish "Symbolism".

and also a profound compassion behind the austere exterior, such is the picture we get of this young artist. His innate pessimism found a rich soil prepared for it in the *fin-de-siècle*. By its title Nielsen's "The Sick Girl" is a Danish counterpart of one of Edvard Munch's most famous paintings. But here is no hope of convalescence. Nor is there any impressionistic play with colour. On the other hand the draughtsmanship is unusually expressive. It affects us as if this hopeless case had some deep significance for our own lives. The melancholy tone of this youthful canvas sounds through all of Einar Nielsen's life-work, whose best part has not dated, although, in spite of a decade of highly appreciated teaching in the Academy (1920-30), he may be said to have been a lonely figure in Danish painting.—One of his best known works is the fine mosaics in the archway of the New Royal Theatre.

So many of the painters active in the 'nineties were sculptors as well. There was, on the other hand, in the group one sculptor who did not

paint, although, as a maker of pottery, he displayed a passion for colour. This was *Niels Hansen Jacobsen* (1861-1941), who was born and ended his life in Vejen, Jutland, where his works form the nucleus of a public art collection, which contains also excellent works by Einar Nielsen, a kindret spirit. This impression of Hansen Jacobsen as a stay-at-home is somewhat modified when attention is called to his ten years in Paris (1892-1902). His art is singularly wilful, and his sculpture reveals basic principles as unorthodox as those of contemporary painter-sculptors. Reminiscences of medieval art together with purely folkloristic elements are the sources of his most original and best known works, the "Troll Scenting Christian Flesh" (1896, in the Glyptotek Garden) and "The Shadow" (1897, in the State Museum). There is genuine poetry in his large female figure "The Dryad" (1918, the State Museum).

SCULPTURE AFTER 1900.
FROM KAI NIELSEN TO GERHARD HENNING
AND MOGENS BØGGILD

The work of Willumsen and the Skovgaard brothers indicated that there were other possibilities for sculpture than those shown by Thorvaldsen. But their efforts could not, alone, change its course. The third generation of "genuine" Danish sculptors (counting from Thorvaldsen), the pupils of H. W. Bissen and Jerichau, carried on in the traditionalists' usual melancholy service, that of mounting guard over the least valuable remains of the tradition created by a genius. *August Saabye* (1823-1916) and *Vilhelm Bissen* (1836-1913) were, presumably, the best craftsmen of their generation. Saabye was the creator of the simple yet strangely animate Hans Christian Andersen monument which is to be seen in Kongens Have (The King's Gardens), Copenhagen (1877). Of course his fine "Susanna before the Elders" (1884, marble copies in the State Museum and the Ny Carlsberg Glyptotek) is more sentimental and less harmonious than Thorvaldsen's Venus. That

Kai Nielsen: The Marble Girl. Sculpture dating from 1909-1910; (in *Faaborg Museum*). The first and unsurpassed masterpiece of the artist who, drawing inspiration from Rodin, renewed Danish sculpture.

it is, nevertheless, based on the same plastic ideal, a comparison with Rodin's "Eve" (1881) will make evident. *Ludvig Brandstrup* (1861-1935), who was a pupil of Vilhelm Bissen's, represented the next generation in the unbroken succession of classicists. He wisely specialized in portraiture, one of his chief works being the powerful portrait of Fru Ottilia Jacobsen (1905, marble copy in the Glyptotek).

Towards the close of the 19th century the conditions under which sculpture was being produced in Denmark, and the facilities for studying this art in our country underwent a radical change. This change was brought about through the enthusiasm and generosity with which *Carl Jacobsen* (1842-1914) built up his collection. Son of the founder of the Carlsberg Brewery, Jacobsen had at an early age started his own flourishing brewery. Having been brought up in a house adorned with works by Thorvaldsen (now the Carlsberg Honorary Residence for an Eminent Danish Scientist), Jacobsen as a matter of course came to adorn his own house with the works of the revered master's pupils. In the late 'seventies he began a regular series of purchases of French sculpture from the Paris *Salon*. Soon he became an enthusiastic and knowledgeable collector of ancient sculpture, too. In 1882 he opened his private Valby gallery to the public, and when, in 1884, Christiansborg Palace, and with it most of the Royal Collection of Sculpture, was consumed by fire, Jacobsen's thoughts of bestowing upon the Nation a large Museum of Sculpture ripened into a definite plan. With grants from the Government and the City of Copenhagen the Ny Carlsberg Glyptotek was built in what was later to be known as Dante's Place. The Danish and French collections were opened to the public in 1897, while the collection of ancient art did not move in till 1906. At first Jacobsen was only interested in the officially recognized French sculpture whose greatest exponent was Carpeaux. In this light must be seen, too, his admiration for *Stephan Sinding* (1846-1922), a Norwegian sculptor. Thanks to Jacobsen, Sinding's ties with Denmark became so intimate that, in 1890, he obtained Danish citizenship.—At the turn of

Kai Nielsen: Mads Rasmussen, Founder of Faaborg Museum. Colossal statue executed 1912-1914 in black granite for *Faaborg Museum*. A masterpiece of Scandinavian sculpture, combining Egyptian sense of form with Danish humour.

149

the century Carl Jacobsen had ripened to appreciation of Rodin's genius, and in his last years he purchased a number of his masterpieces for the Glyptotek.

In a sense, Sinding's Danish work was the necessary preparation for Kai Nielsen's appearance upon the stage. Sinding's taking up residence in Thorvaldsen's City meant the arrival of a Scandinavian sculptor who had won fame in Paris for his mastery of the modern emotional and sensational style which had nothing in common with classical simplicity. Now this simplicity was still dear to the hearts of Danish sculptors, although they had doffed their classic garbs and made—to tell the truth—very hesitating concessions to the increasing demand for realism and expression. If we compare Sinding's bronze group on The Great Northern Telegraph Co. Building in Kongens Nytorv with H. W. Bissen's quadriga on the roof of Thorvaldsen's Museum, we realize that Paris had superseded Rome also as school for sculpture. It was a clear break with the past. A magnificent nude, kneeling with her hands tied behind her back and suckling her baby, that was a startling novelty in sculpture ("Captive Mother", 1884, the Glyptotek). But it took a Dane—Kai Nielsen, in fact—to produce an "Aristocratic Lady Rubbing her Hip with Camphorated Spirits".

Kai Nielsen (1882-1924) was able to free Danish sculpture from the shadows of its great past by forming his style on the best patterns of modern sculpture. He discovered Rodin and behind him Michelangelo. His eyes were suddenly opened to a kind of Ancient Art very different from the Vatican's greyish white realm of shades. With fresh eyes he went exploring among the basalt colossi of Egypt, the alabaster reliefs of Assyria, the oldest Greek polychrome sculptures, the sunbrowned gable sculptures of the Parthenon. And the Romans revealed to him the Hellenistic tradition of their incomparable, realistic portrait art. It had all been there before, but had looked quite different. Kai Nielsen's first mature work, "The Marble Girl", executed in 1909 (Faaborg Museum), is a true daughter of Rodin's "Eve". The full-bodied feminity of this young girl remained typical of Kai Nielsen's art, but none of his

Johannes Bjerg: An Abyssinian. Bronze, dating from 1914-1915; (*Statens Museum for Kunst*). An early work for which the artist drew inspiration from French sculpture.

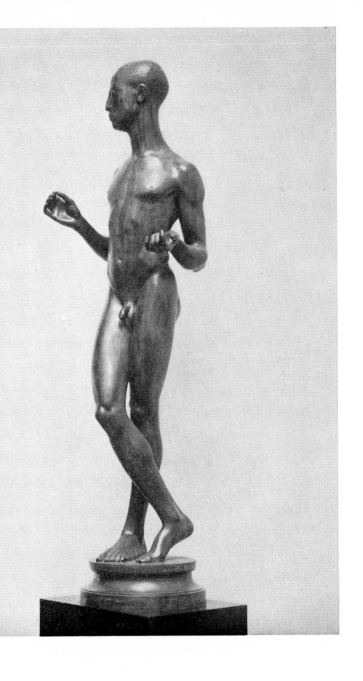

numerous later renditions of female nudes displayed a subtler or more vivid sense of form. For the main hall of Faaborg Museum he, in 1912-14, executed the colossal portrait statue (in polished black granite) of Mads Rasmussen, the founder of the museum. This performance is unique in the history of Danish sculpture, because Kai Nielsen succeeded in creating something like Egyptian grandeur, without losing any of his Danish humour. On the other hand, the art-loving factory owner good-humouredly allowed the artist to portray him in the guise of a giant with allegorical females at his broad-nosed boots. It was not for nothing that both model and artist were natives of Funen, and Peter Hansen, in one of his most amusing pictures, painted a sitting during the creation of the statue. The last decade of Kai Nielsen's short life was incredibly prolific. Even if his productions were not all of them masterpieces, he made a strong impression upon contemporaries, both by his personality and by his art. Loving luxuriant forms and vigorous movement, he was constantly dreaming of large projects, including numerous figures. So, in 1913-16, in cooperation with *Ivar Bentsen,* the architect, he executed the large-scale ornamentation of granite groups for Blaagaards Place in Copenhagen. They were meant as a glorious example of what could and ought to be done by the carefully planned fusion of sculpture with its city surroundings. But Kai Nielsen's lead has, so far, been followed by only a few. It is his sensuous full-blooded female figures that first return to memory at mention of his name: the "Leda and the Swan" (1918, the State Museum), the "Leda without the Swan" (1920, the State Museum and the Glyptotek), and the "Aarhus Girl" (1921, Aarhus stadium, the State Museum and the Glyptotek), all of them figures whose Rubens-like exuberance was without precedent in Danish art.

With Kai Nielsen's productive years coincided a very prolific period in Danish sculpture, but it would not be true to say that he came to found a school of art as Thorvaldsen had done. His characteristic baroque style did not become prevalent among his contemporaries. Here it should be pointed out that, under the leadership of highly gifted *Carl Petersen* (1874-1923), whose masterpiece was the Faaborg Museum building, Danish architecture reverted to a kind of

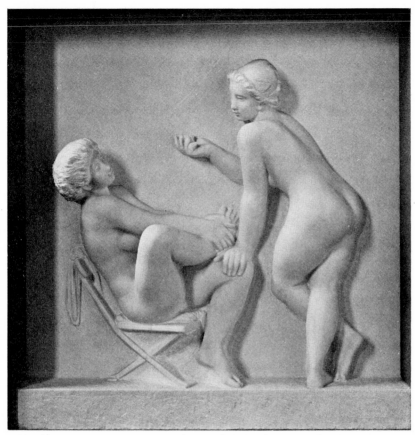

Gerhard Henning: Two Women. Marble relief, dating from 1938-40 (*Statens Museum for Kunst*). The artist's largest and most interesting relief composition.

neo-classicism, based on long-neglected C. F. Hansen. With years, a classical element also became evident in several of the artists who, in youth, had sympathized with Kai Nielsen, and who were to carry on after his death. This was the case with *Einar Utzon-Frank* (1888-1955) who became an Academy professor already in 1918, *Johannes Bjerg* (1886-1955), and *Svend Rathsack* (1885-1941). This attitude unavoidably led them to a receptive sympathy with Thorvaldsen (whom

153

Kai Nielsen despised). Utzon-Frank's enduring admiration of Thorvaldsen was manifested in a statue of the master unveiled (1954) in the artist's garden behind Charlottenborg Palace. Johannes Bjerg, whose *début* with "An Abyssinian" (1914-15, the State Museum), labelled him as the elegant modernist, for decades carried on the work done in the last century by H. W. Bissen, viz. the production of historical monuments and portraits. Many of his productions are closely akin to those of his predecessor by simplicity of style and solidity of workmanship. Svend Ratsack's masterpiece is the fine Sailor's Monument in the Langelinie, which fell to him at the death of Kai Nielsen (1923-28). An exotic element was introduced into Danish sculpture by *Jean Gauguin* (1881-1961), the son of Paul Gauguin. He is the author of a sophisticated fountain group, the "Merman and Mermaid", two full-sized porcelain figures (1928, in the Ordrupgaard Collection, in Aalborg, and in the Tuileries Garden, Paris), and of a polychrome marble figure, "The Radio God" in the annexe of Copenhagen's Royal Theatre (1931). Also versatile *Jais Nielsen* (1885-1961),—who has been active as painter, sculptor, and ceramist—has made his much appreciated contribution to ceramic sculpture. His figure style was inspired by Joakim Skovgaard, his largest work being "The Potter" a life-size stone china figure (1925, the Kunstindustrimuseum). To the same generation belongs *Axel Poulsen* (1885-1972) whose serious yet popular work made him the very man for several of the recent great commissions for national sculptural monuments, e.g. the Reunion Monument in Copenhagen (1920-30), the Marselisborg Monument in Aarhus (1928-34), and the Ryvangen Memorial Grove Monument (1945).

The real heir to Kai Nielsen's fame was Swedish-born *Gerhard Henning* (1880-1967). But their relationship was not the simple one of master and apprentice. Kai Nielsen is said to have drawn the inspiration for his "Leda without the Swan" from a sketchy statuette of his two years older colleague's. But Henning did not execute his first large figure, the sensitive "Danaë", till after the death of his friend. At that time he had, however, already made his mark as a sculptor by an abundant production of figurines, both single figures

154

Astrid Noack: Man Crucified. Crucifix executed in oak, 1943-45; *(in the Refugium at Løgumkloster)*. Here after the plaster version. Perhaps the most poignant work of the sculptress' production.

and amorous groups, most of them for the Royal Copenhagen Porcelain Factory. It is one of the happiest and most interesting events of Danish art history that this virtuoso within a narrow field in mature manhood developed into a great artist. There was no fundamental change of style. Whether he is working in the small or in the large *format,* woman has always been Henning's one and only subject. He has, moreover, remained faithful to only one, plump and very charming, type of ideal womanhood. He is pre-eminently the modeller. The creative work in the clay to him is all in all. In porcelain, bronze, and stone he sees, presumably, only a means of obtaining greater durability. Still, he was too wise and too sensitive not to be aware of the qualitative deterioration to which a piece of brilliant modelling may be exposed in the purely mechanical process of being cut in stone. So, for years he worked single-handed on everything that he produced in this material. And he was no less critical of his own work than of others'. He brooked no set subject; whoever wanted a monument from his hand got Hobson's choice—a fat girl or nothing. In these circumstances, it is small wonder that his ceaseless industry has not resulted in a very large output. The first of Henning's large-sized stone figures is the exuberant "Standing Girl" cut in Bremer sandstone (1928-29, the State Museum), a more staid sister of Michelangelo's slaves in the Boboli Garden. Then follows the slimmer "Modern Girl" (1930, bronze, in the Glyptotek Garden) and the slightly conventional fountain figures for Malmø (1932) and Aalborg (1936). In the late 'thirties he produced the "Seated Girl" (stone) for the Glyptotek, and a large marble relief of two women for the State Museum. Finally, in 1952, he delivered to the Glyptotek the "Reclining Girl", the most perfect of all his rich variations on the favourite theme of his own and all other sculpture. Henning's productions have an 18th century charm, not only because he has made porcelain statuettes, but also because his art is born of the harmonious union of *joie de vivre* and a refined sense of form.

Gottfred Eickhoff: Gustav Falck. Portrait bust, bronze; 1944; commissioned by *Ny Carlsbergfondet.* A brilliant portrait, inspired by French sculpture, of the eminent art historian, during whose curatorship (1925-30) *Statens Museum for Kunst* made its best acquisitions since the days of Frederik V.

Before his death, Carl Jacobsen bought for the Glyptotek a work by Aristide Maillol, a fine terracotta copy of his relief "Le Désir". Thus was introduced to Copenhagen the great sculptor whose enduring merit it was to have guided French sculpture back to the fundamental principles of plasticy. *Adam Fischer* (1888-1968) merits our gratitude for having, in the course of twenty years spent in Paris, worked to make us more intimately acquainted with Maillol, and for having been instrumental in bringing Danish sculptors more closely into touch with their French fellow-artists of the generation after Rodin. Fischer was an intellectual artist aiming to express a regular harmony of proportion and movement. He possessed, too, an obvious sense of the textural beauty of his materials. His chief work is the memorial for Ove Rode, the politician (erected in Copenhagen in 1937); its form shows French influence, but its simple naturalness is Danish. *Astrid Noack* (1888-1954) like Fischer spent years in Paris. So her form was profoundly influenced by that generation of French sculptors whose greatest names are Maillol and Despiau. Still, all her life her work was marked by the thorough knowledge of medieval art she had acquired, before going abroad, through her work as a renovator of Danish church art and furniture. The starting point of her creative work was spiritual, and her workmanship has, at times, something unrealized, not to say *gauche*. But because problems of form had no independent meaning to her, she has produced works of genuine symbolic value. Chief among her many portraits is the gently dignified bronze statue of Anna Ancher, the paintress, at Skagen. But perhaps her individuality comes out more clearly in a wooden crucifix (from 1943) which is unique in Danish art.

Gottfred Eickhoff (born 1902) belongs to the same "French" school as Adam Fischer. He has been influenced by Despiau's intellectual art, but his personality has been strong enough to make him express himself in good Danish when at work on Danish commissions. This is shown by the fine composition of such a bronze group as "The

Henrik Starcke: Head, basalt sculpture (1940), (in *Ny Carlsberg Glyptotek*). Perhaps the most striking example of Starcke's unorthodox love of form.

Working Girls in the Sugar Beet Fields", in Saxkøbing market place (1940) or the splendid portrait of Gustav Falck, the art historian.

Without disregarding individualities—which are after all most interesting—it is surely possible in Danish sculptors born about the turn of the century to point to certain common interests and stylistic features. They all grew up with Kai Nielsen as the great exemplar, but first of all thanks to Utzon-Frank's lead, have accustomed themselves to drawing freely upon both the older and the more recent history of their art. Reliance on the study of nature is one of their fundamental characteristics. To this generation belongs *Jørgen Gudmundsen-Holm-green* (1895-1966) who has an almost Greek preference for the male nude, *August Keil* (1904-1973) who, in his "Fishermen's Monument" near Esbjerg (1942-47), has solved difficult and complex problems, *Anker Hoffmann* (born 1904), and *Poul Søndergaard* (born 1905), two artists whose works have in common a certain trusty solidity, at once homely and soothing. *Knud Nellemose* (born 1908), in his Liberation Monument for Aarhus (1949-50), has executed a work of art which adds depth of feeling to the thorough knowledge of anatomy revealed by earlier performances. *Henrik Starcke* (1899-1973) and *Mogens Bøggild* (born 1901) are the most striking personalities of their generation. Starcke's art is refreshing, because it is unconventional. He aims to produce sculpture with the insouciance with which one speaks and paints when only thinking of conveying as clearly as possible a thought, an incident which must be told, a feeling one wants to explain. Sculptors have used this kind of expression before, e. g. the Romanesque and Gothic stone carvers who worked the cathedral ornaments, or Indian and Javanese artists, or the ancient Orientals. In a fashion, Starcke is no less erudite than the classic artists, and he is as least as versatile. He nearly always eschews mere imitation of some ancient style. For he had so much to say, and it was all-important to him to convey to us his *own* thoughts. As a medium for these aspirations and for his subtle sense of humour he has worked out in his relief a personal style. Men and women, plants, houses, animals, and carriages, all are given just the places where they can best serve the artist's intentions. Thus in his frieze for the meeting-house on the

160

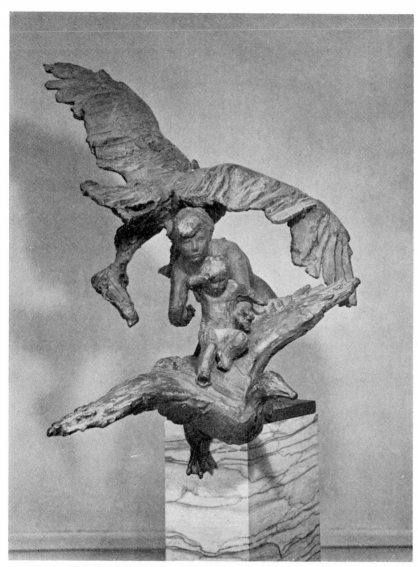

Mogens Bøggild: Sketch for the Main Entrance of *Radiofonibygningen*. Modelled in 1943; cast in bronze for *Statens Museum for Kunst*. The brillant study for a group in which the artist's sense of nature and poetry combine to produce the happiest result.

Skamlingsbanken (1941-43), Starcke gave us his own version of the history of Sleswig. Although a master of stone carving (as shown by some very fine granite and basalt heads) he was at times bored by stone and bronze, and so resorted to making figures whose surfaces are modelled in gaily coloured fragments of broken crockery. A work in this mode is the splendid Fredericia Lion, fresh as an oriental monster of heraldry.

Starcke revitalized Danish sculpture by introducing a new mode and a new style. No doubt he owes something to the painter-sculptors of the 'nineties, and first of all to Niels Skovgaard and to Hansen Jacobsen, but this detracts nothing from his originality. Bøggild's special merits are of a different kind. This eccentric and very slowly working artist excels, neither in striking originality of expression nor in the fecundity of his imagination, but in a peculiar, nay, unique intensity of sensation and observation. In spite of his at times almost irritating preoccupation with detail the result is never pedantic. For fundamentally he looks at nature with the romantic's poetic eye; his art stems from Johan Thomas Lundbye. Chief among Bøggild's works are "The Bears' Well" (1936-39) of Nykøbing Falster, Aarhus' "The Pigs' Well" (1941-50), and the brilliant "Woman with Child and Birds" at the main entrance of the State Radio Building, Copenhagen (1945-50). The vivacity and beauty of his sketches and minor works have not been equalled by any artist since Thorvaldsen. Some critics hold that posterity will rank him even higher than Kai Nielsen.

PAINTING 1910-40.
THE AGE OF LARSEN STEVNS AND EDVARD WEIE

Shortly after the turn of the century a new generation of geniuses caused a sensation in France by joining forces and going into action together. The shock which these yongsters gave their contemporaries was so great that they were not, like the Impressionists, given a mildly sarcastic nickname. They were simply called "the wild beasts" (*les fauves*). The best of them were Henri Matisse, André Dérain, Georges Bracque, and Raoul Dufy. Their movement, which lasted only a couple of years (after the start in 1905), can best be described in brief by saying that they proclaimed the freedom and supreme right of Colour. This they did with an audacity which cannot be explained solely as a further development of Impressionism, but which also stems from a love of van Gogh. Indeed, in one member of the group, Vlaminck, the love of van Gogh was, at this point of time, almost excessive. With inexorable logic the liberation of colour involves the independence of form. So it was no mere chance that, almost at once, "Fauvism" got its complement in Cubism. Nay, it may justifiably be said that, for some of the original *fauves,* Cubism, which was first heralded by Pablo Picasso's painting "Les Démoiselles d'Avignon" (1906) determined the course of their lives. This cleavage in painting was the artistic parallel of the disintegration of renaissance cosmology brought about by natural science. The inadequacy of classical Naturalism was made clear by the fact that form and colour which, according to traditional artistic experience, should have been inseparable, now showed a possibility, nay, a sudden inclination to go their separate ways.

Danish art and its foreign contacts profited by improved 20th century communications which meant a considerable shortening of the distance between Copenhagen and Paris. Not only did travelling become easier and faster, but it also became easier in Denmark to acquaint oneself with modern French art. In 1911 *Carl V. Petersen* published (in the "Tilskueren") his essay on Impressionism, a pioneering venture in Danish art literature. *Helge Jacobsen* in 1914 had succeeded his father, the founder of the Glyptotek, as director of that

museum. And that year it made its first purchases of Monet, Sisley, and Manet. For his private collection Helge Jacobsen had already bought pictures by Bonnard and Vuillard, and soon he came to regard as his special task the creation of a fully representative collection of Paul Gaugin's work. The economic boom due to Denmark's neutrality in World War I made possible the creation of private collections of foreign art of a higher standard than that which Danish collectors are usually able to maintain. Even if not all that would have been worth preserving was allowed to remain in this country when (in the early 'twenties) the slump set in, the sudden wealth of French art in the *Wilhelm Hansen, Heilbuth, Tetzen-Lund,* and *Johannes Rump* collections proved of paramount importance to contemporary Danish art. When, in 1923, Wilhelm Hansen's first Ordrupgaard Collection was dispersed, Helge Jacobsen succeeded in securing for the Glyptotek a number of masterpieces to which, by exchanges with the State Museum he added what our National Gallery possesses in the way of French 19th century art. And in 1927 he donated his own collection, whereby Gauguin became one of the chief attractions of this museum. In 1928 the Rump Collection, whose finest ornament is Matisse, was handed over to the State Museum, and in 1953, Ordrupgaard was opened to the public as a national museum and memorial to invincible Wilhelm Hansen. For he had succeeded a second time in building up a magnificent collection of French art covering the period from Corot to Cézanne. The unwonted energy of Danish collectors in the years after 1914 enabled young painters, who during World War I were at the receptive age, in their home city really to acquaint themselves with current trends in French art from Impressionism to the latest novelties. Novelties were, at the time, intensely studied in the collection of hospitable and legendary Tetzen-Lund, which collection has, unfortunately, been dispersed. The effects of all this soon became evident, as if a pent-up flood had suddenly been let loose and fecundated Danish art.

Niels Larsen Stevns (1864-1941) is in many respects unique in Danish art history. He matured so late as not to come into full possession of his great powers until other artists of the same generation

164

Niels Larsen Stevns: Portrait of the Artist by Lamplight. (Oil, 1918 in *Statens Museum for Kunst*). This frontal portrait of the artist in a blue smock-frock gives Stevns' own complement to Poul S. Christiansen's picture in the State Museum — both evoke memories of Cézanne.

165

Niels Larsen Stevns: Olive in Shade. (Oil, 1923; in *Ny Carlsberg Glyptotek*). Larsen Stevns painted this picture at Cagnes, in the course of the tour which gave him full and free command of his pictorial powers.

had already painted their best pictures. His artistic development shows a rising curve until extreme old age. This made him the leading figure of a period later than might be expected from his age. His artistic radicalism bears the stamp of rare maturity, because it is borne by a personality of the old school, a man combining clarity of vision with humility and profound insight into the traditions of his craft. As a pupil of Zahrtmann's school, he got into close touch with the Skovgaard brothers, who for many years availed themselves of his services, Niels for carving the Magnus Memorial, Joakim for Viborg Cathedral, where Larsen Stevns became the busiest worker on the frescos. Against this background his biblical compositions from 1906-07 seem strangely

166

Niels Larsen Stevns: Christ and Zaccheus. (Oil, 1913; *Randers Museum*). The principal work in the early manner of this great regenerator of religious art in Denmark.

original. This is due to his strong accentuation of space by means of perspective and movement. And that was meant as a protest against the style forced upon him for the Viborg frescos, and which, according to Skovgaard, Stevns at times had difficulty in submitting to. Already at an early age he painted excellent landscapes, especially watercolours, in which mode he equalled the best work of the Funen School. In an oil painting, "Christ and Zaccheus" (1913, in Randers Museum), he succeeded in building up into a modern pictorial unity a large-sized figure group, set against a landscape background. And he did it without weakening the dramatic force of the Christian message of his picture. In early youth he had travelled in Italy, chiefly to study ecclesiastical painting and fresco-technique—and he had been a most

167

observant traveller. In 1922-23 the almost sexagenarian artist made a prolonged tour—his honeymoon trip—of Paris, Southern France, and Italy. And his art was flooded with all the sun and warmth of the South. His pictures from Cagnes and the region round Florence, such as the Glyptotek's "Olive in Shade", mark a peak in his art. Their style may be termed intensified impressionism, akin to that of contemporary Bonnard. This if anything is colour-pure *plein-airisme*. And they displayed, too, a maturity of composition acquired through long years of patient apprenticeship at work on set pieces.

His religious outlook and early biblical compositions, as a matter of course, made Larsen Stevns the purveyor of altar pieces and frescos to several Danish churches. However, there was no demand in his time for any work of approximately the same size as the Viborg frescos, and as a figure painter his largest commissions were for historical pictures. At the age of sixty-five he undertook the decoration of the new Hans Christian Andersen Memorial Hall at Odense. Three years later he handed over the eight large-sized fresco scenes from the poet's life, the richest pictorial cycle produced in this country since the days of Abildgaard, and a monumental rendition in colour of the poetic genius' own legendary life. In subsequent years, Larsen-Stevns followed up this success with the water colours for the large-sized edition of Andersen's "The Story of My Life". And twice after that was the young-minded old painter to demonstrate his powers as a reviver of historical painting. First in the six historical frescos in Hjørring Central Library (1934-36), and secondly in Slagelse's medieval Holy Ghost House (1938). The Hjørring work meant the fulfilment of a dream which had been Peter Hansen's towards the close of his life, nay, it may in a sense be reckoned as the climax of Zahrtmann's triumph. There is, of course, no way of explaining genius, but surely it was no mere accident that it was the descendant of anonymous Danish peasantry who gave us such a description of the old *Vendelboers'* heroic resistance to squires and Swedes. But it should not be forgotten that these very pictures of "The Battle of Svendstrup Moor" and "The Defence of Nørresundby" only became possible because their creator had been able to absorb the finest artistic culture of his continent. But

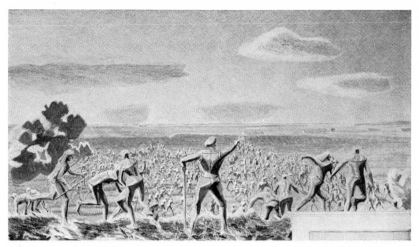

Niels Larsen Stevns: The Battle of Svenstrup Moor (1534). Fresco, dating from 1936, in *Hjørring Centralbibliotek*. In this series of frescos Zahrtmann's and Peter Hansen's dreams of a large-scale, modern Historical Painting was at length realized by Larsen Stevns.

for Italy's frescos and Impressionism, we should never have had Stevns' life-like renderings of our forefathers on their Jutland soil. To the Hjørring murals the artist added two unpretentious over-doors in relief. They were the old wood-carver's most distinguished contribution to Danish sculpture, the culmination of his generation's efforts to make sculpture the equal of painting in expression and movement.

In his last years, when partly paralyzed, Larsen-Stevns painted (with the same creative zest as deformed Renoir) some landscapes, interiors, and two self-portraits. He had long been a true painter in the sense that colour was his means of rendering form, and a true modernist for whom no colour was too pure or too strong, if only it served the purposes of expression within the idiom which was his. These strange pictures, which bear the mark of his illness, had nevertheless a quality of freshness—that amazing daring which is born of extreme weakness. They were moving *documents humains*—but they were, too, works of art in their own right, pure and strong visions, victories of mind over matter.

169

Edvard Weie: Portrait of a Boy. (Oil, circa 1920, *Statens Museum for Kunst*). An in-
spired portrait, regarded by the artist as one of his best works.

170

Edvard Weie: Landscape Christiansø. (Oil, 1914, *Statens Museum for Kunst*). Weie introduced into Denmark his own — congenial, though entirely individual — version of Matisse's "Fauvism".

Edvard Weie (1879-1943) was a born painter, the most powerful artist of his generation, our most subtle colourist after Købke. Having vainly sought admission to the Academy, he frequented Zahrtmann's school, and in 1907 accompanied the master on his visit to Italy. 1912 was the year of his first visit to Paris. His earliest paintings are in the traditional naturalistic manner and often display a peculiar, well-balanced sense of colour. He painted Copenhagen street scenes with such aristocratic clarity of composition and colour that we are reminded of the best productions of the golden age. Zahrtmann's teaching served him, in a general way, as an eye-opener; but it was the meeting with modern French painting which set his future course.

171

Influenced by a slightly older pupil of Zahrtmann's *Karl Isakson* (1878-1922), and through his own studies, Weie acquired a thorough knowledge of the new ideas of pictorial form launched by Matisse and "Fauvism". Cézanne, too, was a decisive influence on his life-long striving for a purified form of the painter's art, expressing poetic truth in tones of pure colour.

Isakson was a Swedish painter, who stayed in Paris from 1905 to 1907 and afterwards made his home in Denmark. In 1911-12 Isakson and Weie discovered that in summer the rocky islet of Christiansø, off Bornholm, offers light conditions more similar to those of the South than usually found in these latitudes. So they became the founders of the third "regional school" of our recent and contemporary painting (the others being those of the Scaw and Funen). Weie's landscapes from those years, notably the State Museum's "Landscape, Christiansø", or the pictures from Sletten on the Sound, have such lyricism and beauty of tone that already in 1915 Carl V. Petersen, the most fore-sighted of critics, celebrated in the thirty-five-year-old artist one of our most powerful painters. Before long there entered into his art an element of romantic narrative. In the "Poseidon Travelling across the Sea, Accompanied by Nereids and Tritons" (the 1917 version in the State Museum) he played, in his own modern orchestration, his variations on a theme from the days of Rubens and Poussin. In the composition of his "The Two Geniuses" (The State Museum's version is from 1922), he produced a lyrico-musical *"stimmungsbild"* quite Mozartian in spirit. Also, during a stay in Paris (in 1924), Delacroix's *"La Barque de Dante"*, a masterpiece of French Romanticism, inspired him for a series of free renderings of its subject (one is in the National Museum, Stockholm). It was always the same artistic idea Weie stuck to whether he was working like a poet on his inspired compositions, or drawing from nature, as from a musical instrument, those marvellously pure tones on whose harmonies he built such powerful pictorial effects. So the imaginative part of his production naturally goes hand in hand with his studies from nature. In 1920 he painted the impressionistic "The Arrival of the Mail Boat" (in a private collection), perhaps influenced by the memory of Manet's "The Folkestone

Edvard Weie: Faun and Nymph. (Oil, 1940-41, *Statens Museum for Kunst*). Weie's last great effort — a poignant monument to his musicality and unerring sense of colour.

Steamer" in the first Ordrupgaard Collection (now in the Oskar Rein-hart Collection, Wintherthur). In the early 'twenties were produced Weie's finest still lifes of flower, fruits, and books, besides the State Museum's sensitive "Portrait of a Boy". In 1923 and 1924 he was at work on the excellent "Langelinie Pictures" (one of them is in Es-bjerg Museum), rendering a contemporary subject including figures moving in the open air, works which hold an important place in the epoch of Danish painting still known as "the Victory of Modernism" *(Det moderne gennembrud)*.

The cool brilliancy often characteristic of Weie's work should not, any more than his virtuose sureness of hand, lead the spectator to the conclusion that his results were obtained easily. Always struggling and searching his own heart, in increasing and voluntary isolation, he strove all his life to approach the wonderful ideal he had in mind. In his posthumous book entitled "Poetry and Culture" Weie spoke of this goal as "The Musical Transformation of Painting" by means of the tonal character and value of colours. His work stemmed from the fruit-ful union of a sensitive romantic mind and a unique gift for the tech-nique of brush and colour. In the last decade of his life he was, seem-ingly, less prolific. But in the late 'thirties, during a summer holiday spent in the island of Glænø, he produced some marvellous landscapes. And after his death there was the surprise of the "Faun and Nymph", the large composition on which he had spent his last strength. He gave us the old yet eternally young theme as a colouristic symphony unparal-leled in Scandinavian painting.

Curiously enough, The Free Exhibition proved as exclusive as old Charlottenborg when the time came for it to make up its mind about a new generation of artistic rebels. Thus came about, in 1915, the foundation of the *Grønningen*. It was to be the organization of the young generation who listened to the latest signals from Paris. And it can safely be said that this new exhibition created a sensation in Copen-hagen. The art lovers of that city were there confronted, among other novelties, with cubistic imitations of Picasso, and at a time, too, when they had hardly got accustomed to Impressionism.

Among the founders of the *Grønningen, Sigurd Swane* (1879-1973)

Sigurd Swane: The Mill. (Oil, 1928, in *Horsens Museum*). Swane's poetic sense of colouristic beaty has made him a leader among the pioneers of the modern school.

belonged to the same generation as Weie. He visited Paris in 1907, and the meeting with Impressionism set his course for life. Back in Denmark, he became closely allied with the Funen School. Swane's large output has won him admirers among all lovers of Danish art and scenery. But only gradually have we realized that he is one of our great painters —one of the few contemporaries whom fastidious Weie mentioned with anything like praise. Swane is not only the master of those beautiful lyrical landscapes which first come to mind at mention of his name,

175

Harald Giersing: The Faaborg Road (Oil, 1920, *Statens Museum for Kunst*). A fine example of Giersing's work as a mature landscape painter.

landscapes of a peculiar luxuriant grace but marked by close observation of light and weather. All his life he has, too, practised figure painting, both portraits and large compositions. The State Museum possesses the beautiful portrait head of his friend Harald Giersing (1908) and the monumental "Mother and Child" (1913) besides the first sketch, dated 1911, for a biblical subject, the "Jacob's Dream", which he was later to execute on a large scale. It is the most important religious painting of that time, outside the production of Larsen Stevns. As a colouristic vision it equals Weie's efforts, but its form is, nevertheless, quite original. After World War II, Swane found a world of new subjects in the Canaries, Portugal, and Spain. In this southern scenery, he painted landscapes which please us by a rich, mellow

176

Harald Giersing: Portrait of the Artist's Father. (Oil, 1907, *Statens Museum for Kunst*).
An early work, testifying to his intelligent response to the new signals in French art.

Olaf Rude: Spring. (Oil, 1926, *Statens Museum for Kunst*). Rude's painting with the chickens is now reckoned among the classics of Danish landscape-painting.

picturesqueness, old-fashioned, perhaps, but of the same imperishable gentleness as Renoir's work.

A dominating figure among the supporters of the *Grønningen* was *Harald Giersing* (1881-1927). He was an intelligent and cultured personality, whose contributions to contemporary art-discussions included pointed aphorisms like the famous "All good art is patriotic, all patriotic art is bad". During a stay in Paris (1906-07) he avidly absorbed all that French art could offer a receptive and inquiring young artist. He went to the sources of Impressionism, right back to Delacroix; he was profoundly influenced by Manet; he understood the interesting variant of Impressionism known as "Pointillisme"; he made the acquaintance af Matisse and rising Cubism—and through it all he had sufficient power and originality to avoid mere eclecticism. His light-coloured early pictures, painted when his impressions of Paris were fresh, such

178

William Scharff: Cumulus. (Oil, 1922, *in a private collection in Denmark*). Scharff's treatment of this simple landscape gives clear evidence of his stylistic powers.

as the "Portrait of the Artist's Father" (1907) display a mature and aristocratic handling of colour, while the portraits reveal his penetrating, yet sympathetic eye for the character of the sitter. Soon his colour mellowed ,and a soft modelling became characteristic of his sensitive figure style, as in the "Girl with Bent Head" and the Manet-like "Portrait of a Soldier" (both painted i 1914, the first in Aarhus museum, the second in the Ny Carlsbergfoundation.). Still later he showed sympathetic understanding of the antinaturalistic trends of the day in such pictures as the "Woman Playing the Mandolin" (1922) and the "Three Ladies Dressed in Black" (1923, in Aarhus Museum). As a landscape painter Giersing succeeded in expressing, in a simplified form and with only a limited range of gentle yet fully tonal colours, a very deep emotion.

12*

Oluf Høst: Killing the Pig. (Oil, 1941, *Statens Museum for Kunst*). Of all the painters of the Bornholm school, Høst is most firmly rooted in the island soil, drawing his artistic strength from an intense devotion to its scenery and life-rythm.

A native gift of expression through the medium of oil, an unfeigned enjoyment of painting in clear and brillant colours, such are the qualities which shine from all the canvases of *Olaf Rude* (1888-1957). He came back from Paris in 1911 a convert to the gospel of French paining. In 1918 he produced cubistic pictures in the manner of Picasso. But soon he returned to nature which he has mostly studied in the island of Bornholm. In so doing, he took for his guides Matisse and, undoubtedly, Isakson and Weie, but first of all his own unerring sense of beauty. The State Museum's "Spring Scene with Chickens" (1926) has initiated many of his younger compatriots in the splendours of modern art.

In his quiet way *Axel P. Jensen* (1885-1959) has done much to popularize the artistic ideas that used to be considered so radical. His starting point was the style of van Gogh. But soon he evolved a style in

180

Christine Swane: The Terrace, (Oil, 1947; *Tønder Museum*). With great tenacity and unerring mastery Fru Swane has upheld the principles of "Fauvism" and made them the foundation of her subtly coloured art.

better keeping with his temperament, and in which he has painted many landscapes. Especially his renderings of Jutland scenery have won him many admirers.—With years *Kræsten Iversen* (1886-1955) found his personal style within the Bornholm School of painters. But his starting point was different, and he has an honourable past as a reviver of the Baroque ceiling picture. There is, for instance, the "Prometheus" (painted 1925-26) in *Videnskabernes Selskab* (The Royal Academy of Science) and historical subjects at Christiansborg Palace (1927-31 and 1935-36). *Aksel Jørgensen* (1883-1957) has always travelled along his own individual ways. He began as an uncompromising realist whose pictures from the early years of the century showed a marked sympathy with "the underdog". Then, about 1910, and partly under the influence of Edvard Munch, the great Norwegian, he was

Vilhelm Lundstrøm: After the Bath. (Oil, 1924; *Statens Museum for Kunst*). This picture was the starting point for Lundstrøm's large mosaics in *Frederiksberg Svømmehal,* classical figure-compositions in 20th century Danish art.

captivated by the Impressionists' treatment of colour. For many years his production suffered because of the hardworking idealism with which he performed his professorial duties at the Academy. His most important achievements belong to the history of the graphic arts.

We might, perhaps, feel tempted to say of some of the young painters of the pre-World War I years that they returned from their Parisian meetings with "Fauvism" in the guise of roaring lions, but have had their claws nicely trimmed. But this could not be said of *William Scharff* (1886-1959) and *Oluf Høst* (1884-1966). For, however different they may be, each in his own way remained true to the ideals of their youth. To Scharff the fundamental problem of art has always

182

Jens Søndergaard: Seascape. (Oil, 1940; *Statens Museum for Kunst*). Søndergaard is the representative of Neo-Romanticism in modern painting, an international reaction against the predominating French influence.

been the balance between nature and ornament. Possessed of a sensitive understanding of all living things, he tenaciously cherished the hope of some day being able to express in paint certaiu universal aesthetic rules. That is why he has so often subordinated colour and feeling to composition, while on the other hand never losing sight of the human message of art. The earnestness with which he fought this battle and his undeniable gift for composition are the valuable elements of his art. In youth he showed a marked preference for large-sized compositions ,such as the semi-abstract fantasias on the pine wood and henyard. Such are also his mysterious "legends", among which he included the "Mother Mist A-Brewing" (1926-28). So, naturally, he was com-

183

missioned for large mural paintings, e. g. at Bjersjöholm Manor in Sweden (1931-33), at the Vordingborg Children's Sanatorium (1939-42), and at the *Studentergaarden* in Copenhagen (1950-52). While Scharff never lost faith in his own peculiar pictorial mathematics, Høst's artistic life was based on an equally unshakeable conviction that nature and feeling are everything. Late in attaining to artistic maturity, he owed much to Giersing and Isakson. Of all the painters of the Bornholm School, Høst was the only native of that rocky Island, and he remained more faithful to it than any one else. His is the everyday world: the beach and bathers, the lonely winter view of the sea, the fishing village. And above all, there are the thatched farm buildings which, with almost incredible perseverance, he has described in changing lights. His pictorial style and treatment of colour stem from Impressionism, but with his nature mysticism he shared the philosophy of a younger generation.

Among the Skagen painters, Anna Ancher was the only woman. Similarly, *Christine Swane* (1876-1960) was the representative of her sex among the artists of her generation. And she represented it, too, with a sureness of hand and a feminine grace, which have won for her a place among the best. As the sister of Johannes Larsen she got her training among the Funen painters, but soon gave proof of her independence by choosing Willumsen for her teacher. She was initiated in her life's work as a painter by "Fauvism" as introduced in Denmark by Isakson, but she had her own entirely personal style. She concieved her landscapes and her beloved still-lifes with flowers as decorative colouristic harmonies of green, blue, and red. So, by persistently sticking to her fundamental artistic principles, she has, within the aristocratic limits she set herself, attained to virtuosity. She is among the very best of Danish painters, the rarest flower of the Funen gardens.

Some of the artists born in the 'nineties brought to Danish painting a new and virile spirit. Already in 1918, *Vilhelm Lundstrøm* (1893-1950) made a *succès de scandale* by his so-called "packing-case pictures", cubistic compositions partly made up af boards and other "real" materials. After 1920, however, and under the influence of changeable Picasso, he began painting still lifes and figure compositions in a style

184

Erik Hoppe: Figure on a Lawn. (Oil, 1944; *Statens Museum for Kunst*). Although, if vouchsafed only a cursory inspection, Hoppe's art may seem to offer little variety, he is mush admired by his fellow-countrymen for the human and pictorial power of his nature-studies.

at once popular and solid, rendering the natural objects in simple but not unattractive colours, but with the full emphasis on composition. The public was not less shocked by this new style of his; especially his figures were considered disgusting. This was, presumably, due to Lundstrøm's painting the girls stouter than people care to admit they like them. In actual fact, this new style in figure painting meant a return to classicism. It corresponds to contemporary architects' return to C. F.

Hansen, and Lundstrøm's large mosaics of bathers in The Frederiksberg Swimming Baths (1935-38), the painted cartoons for which can be seen in Viborg, are our century's counterpart to Constantin Hansen's frescos in Copenhagen University.

Within his generation *Jens Søndergaard* (1895-1957) has been of importance as an exemplar because of his untameable self-assertion and the wilful informality with which he painted his pictures. They are his impressions of nature put directly on to the canvas with a strange wild rapture at handling paint. There is a resemblance with Niels Bjerre which is, perhaps, largely due to their common love of Jutland. And there seems to be an almost paradoxical kinship with subtle Giersing. The most important feature of Jens Søndergaard's art is the originality of his attitude to nature and to the media of pictorial expression. His very lack of discipline secures him a place in an international current, viz. among the artists who have rebelled against French colour and style in favour of a new primitivism of perception and expression. He belongs to the true Expressionists, the artistic descendants of van Gogh.

As in the case of the sculptors, the painters born in the 'nineties all rally round the banner of Naturalism. *Axel Bentzen* (1893-1952) became known for the rather crude force of his violently colourful landscapes and figures. *Erik Hoppe* (1897-1968) prefered to paint subjects afforded him by the streets and parks of Copenhagen and aimed higher than mere portrayal of reality. No doubt, his art is intimately tied up with that revolutionary liberation of colour which, as far as Denmark is concerned, was brought about chiefly by Isakson and Weie. Although, generally speaking, his pictures are darker than those of the "fauvistic" generation, the *fauves* have taught him something fundamental in the painter's art. In his best pictures he strikes chords of peculiar gravity and beauty. There is an element of stylization in the work of *Thorvald Hagedorn-Olsen* (b. 1902), a native of Funen. His strangely simplified colour, dominated by dark blue, green, and ochre, may owe something to Lundstrøm, but Hagedorn-Olsen shares his

Thorvald Hagedorn-Olsen: Model in a Garden. (Oil, 1950, *Vejle Museum*). After the death of Lundstrøm, Hagedorn-Olsen is our leading figure painter in the grand manner.

Knud Agger: At the Window. (Oil, 1939-1940; *Statens Museum for Kunst*). Agger is one of the leaders of a new generation of nature worshippers among Danish artists.

Harald Leth: View of Gudhjem. (Oil, 1929; *in a private collection in Denmark*). An early work by an artist who is obtaining general recognition as one of the finest colouristic talents of his generation.

island's healthy love of nature, and he portrays human beings with a grace which is all his own. His large figure composition in Aarhus City Hall (1939-47) is one of our finest recent examples of the monumental style. *Victor Haagen-Müller* (1894-1959) has created, out of a profound admiration for William Scharff, his own gentler pictorial style, for the expression of his love of the beauty of such places as The Woodland of Tisvilde Hegn and the sandy deserts of the Scaw and the island of Anholt.

The richness of the French palette, the radiance of their luminous

189

Lauritz Hartz: Landscape. (Oil, 1939; *Statens Museum for Kunst*). Hartz's best pictures display the peculiar mastery with which he remembers and renders his immediate impressions of nature, and the almost Japanese virtuosity of his compositions.

colours, has not been forgotten by Danish artists, even if, for a time, darker tones became predominant. *Poul Schrøder* (1894-1957) has dealt with pictorial problems in the French spirit and with profound insight. His exemplars have been Matisse and Bonnard. *Knud Agger* (1895-1973) is a prolific artist whose work has secured him a place among the most solid pictorial artists of to-day. Here is an artist in whom the impressionistic tradition has been adapted to an independent modern personality. *Helge Jensen* (b. 1899), who studied under Giersing, expresses his love of nature in a personal style based on the enamel-like quality of his well-balanced colours. He has painted three large and beautiful murals for *De Danske Studenters Roklub* (The Undergraduate's Rowing Club) in Copenhagen (1942-43). *Poul Sørensen* (1896-1959) was decidedly a lyrical talent, his landscapes and nudes have, in the delicacy of their colour, some of the unreality of dream-visions. *Harald*

190

Poul Sørensen: Model in a Room. (Oil, 1940-1941; *Statens Museum for Kunst*). This artist's works deserve admiration for their subtle colouristic beauty and inherent poetry.

Leth (b. 1899) has gone in for the favourite subjects of our classical painters, viz. the Danish landscape and domestic animals. Not only by modesty of size, but also by purity of feeling, and by substantial refinement of colour do they sometimes remind of the greatest of all

191

Niels Lergaard: Evening, Gudhjem. (Oil, 1941. *Sorø Museum*). Choosing his subjects from the island of Bornholm Lergaard paints nature in a monumental style.

our painters, of Købke himself. On the other hand, *Lauritz Hartz* (b. 1903) has developed into a master of inspired landscape improvisation, a refined reincarnation of Albert Gottschalk.

After his early paintings which were more gloomy in tone *Niels Lergaard* (b. 1893) found an inexhaustible source of inspiration in scenes on the island of Bornholm. A deep feeling for nature lies at the root of all his work, but a search for clarity has caused him to simplify until his paintings achieve their effect because of the sharp contrast between the few colours he uses. Many of his pictures show a view, looking out to sea. A green landscape slopes down towards it, in the

192

Søren Hjorth Nielsen: Fredensbro, Copenhagen. (Oil, 1940—41, *Statens Museum for Kunst*). Copenhagen suburbs form the subject of many of his paintings.

foreground are the gables of houses in sharp silhouette. As a further simplification Lergaard uses colours which have an almost enamel-like brilliance. The inspiration he finds in nature is given a monumental form without losing any of its human significance. In "Evening, Gudhjem", for example, he presents human beings, in this case of different ages, face to face with eternal nature, thereby indicating the transience of this life compared with nature.

At the same time as abstract art began to gain a footing in Denmark during the thirties a number of somewhat older artists were continuing

to paint in the more traditional naturalistic style, though with fresh inspiration from cubism and expressionism, for example. *Søren Hjorth Nielsen* (b. 1901) found new spontaneous inspiration in the Danish landscape, but his earliest pictures bear the stamp of a social indignation which caused him to choose his subjects from among the proletariat and the losers in our society. A large and significant part of his work depicts the suburbs of Copenhagen and the allotment gardens on its outskirts. These pictures are constructed with great attention to form. The colours used for the cubes of the houses and triangles of their gables give them a gravity found in still life studies, but at the same time there is lightness in the finely balanced colour surfaces.

Karl Bovin (b. 1907) belongs to the group of artists known as Corner and is one of the leading figures among those who found inspiration in Odsherred. There is a dark, oppressive atmosphere about his earliest paintings, many of them depicting autumnal scenes. But the Danish countryside had its influence upon his palette. His colour became brighter and his paintings show the change of the seasons and the shifting light of the year. He approaches his subjects with a new directness and a great sense of colour. His works have an immediacy about them. There is not the same tendency to order and summarize which we find in the work of many of his contemporaries, but with the sense of colour and composition of a true artist he draws our attention to the central theme. While staying at Skagen, which has a certain kind of light which has played an important part in Danish landscape painting, he discovered new possibilities in the treatment of light. His participation in an archaeological expedition to Bahrein, where a quite different sort of nature and the brilliant light made a great impression upon him, produced a number of important works comparable to his early paintings.

Another painter from Odsherred was *Kaj Ejstrup* (1902-56) who is worthy of mention for his landscapes and, particularly, a number of fine studies from the life. *Alfred Simonsen* (1906-35), too, was a gifted painter of this period. Unfortunately he died at an early age, just when his talent appeared promising.

Another painter who died early was *Erik Raadal* (1905-41). While

194

Erik Raadal: Girls waiting for the train. (Oil, 1939. *Statens Museum for Kunst*). All Raadal's works depict the countryside around the town of Gjern in Jutland.

his contemporaries were rediscovering the countryside of Zealand as a subject for their canvases Raadal introduced the wide Jutland landscape around the town of Gjern into Danish art. From his childhood he was familiar with this strangely unpictorial part of the country. The strength of his work lies not only in its clear composition with its straight lines but also in the artist's familiarity and acceptance of his subject. In "Girls waiting for the train" the portrayal of the two girls is fixed in their surroundings. The perspective of railway lines stretches in to the distance, the black shadows of the houses accentuate the scene and the two girls waiting for the train populate it and give meaning to it.

Svend Engelund (b. 1908) has worked mainly in Jutland and given us some penetrating descriptions of the flat horizontal lines of Vendsyssel.

With *Ole Kielberg* (b. 1911) we are back again in Zealand. One

of the best of the Corner group of painters he has done a number of often small pictures vividly depicting landscapes and animals. His candid treatment of his subject is matched by his ability to control and concentrate the composition. He has learned from both the painters of the Danish golden age and also the Impressionists. Whether his subjects are taken from Italy or North Zealand his colours sparkle, full of light, across the canvas. *Poul Bjørklund* (b. 1909) has painted landscapes and his studies from life, in particular, reveal a great and comprehensive talent. The work of *Poul Ekelund* (b. 1920) is based upon his observation of nature which he has treated in an expressionist style, so that both the whole and each detail can be fully appreciated. *Jeppe Vontillius* (b. 1915) started by painting studies from life, composed of serene balanced colours. He went on to do strongly personal pictures of the Danish landscape where his use of colour fades his masses into the distance.

Naturalistic painting, particularly landscape painting, still thrives in Denmark.

ABSTRACT ART IN DENMARK

About 1910 there were born a number of artists whose work within the field of abstract art did as much to renew the art of their time as cubism had done some decades before. At the time, their works seemed to be a break with all tradition but the perspective of time has made it more and more plain that they belong to the mainstream of Danish art. As so often before, inspiration and influences were gained from developments abroad, artists were able to visit other countries before war sealed the frontiers and channelled these impressions into the national tradition.

The pioneers of abstract art in Denmark were *Vilhelm Bjerke-Petersen* (1907-57), *Richard Mortensen* and *Ejler Bille. Franciska Clausen* (b. 1899) studied at academies in Germany and Paris, and as a pupil of Leger and Mondrian she became a neo-plasticist of considerable importance. On her return to Denmark in 1933 she came into contact with the group surrounding Bjerke-Petersen, but disappointed

196

over the poor reception of her work she has for many years lived without any connection with art life in Denmark. Only in recent years has her highly individual and consistently outstanding work achieved the recognition it deserves. Vilhelm Bjerke-Petersen had an intimate knowledge of contemporary international art movements and studied at the Bauhaus Dessau in 1930, where he came under the influence of Klee and Kandinsky. He brought back Kandinsky's ideas with him to Copenhagen, but soon became interested in Surrealism and was for a short time joined by Mortensen and Bille. They founded a group called *"Linien"* (The Line) and published a periodical of the same name. However as the other two differed with Bjerke-Petersen's views on Surrealism there was a break between them. Bille and Mortensen started working along new lines. Bjerke-Petersen came into contact with the other artist of consequence for Surrealism in Denmark, Wilhelm Freddie, who was born in 1909. With his profound knowledge of the art of foreign countries and as the author of a number of books on the theory of art Bjerke-Petersen probably had more influence on Danish art as a writer and innovator than as a creative artist. His work has sometimes a dryness about it. After 1943 he lived mainly in Sweden but some of his constructivist paintings done in the late forties made an important contribution to the concrete style which was then beginning to gain a foothold in Denmark.

The main exponent of Surrealism in Denmark is *Wilhelm Freddie* (b. 1909). Without his long and indefatigable efforts this genre would have practically left no trace upon Danish art. His early paintings were in the concrete style and he was the first to hold an exhibition of abstract art in Denmark. Influenced by de Chirico, among others, he took up Surrealism in 1930 and had achieved his own very personal and independent style by the time of the large exhibition "Cubism-Surrealism" which was held in Copenhagen in 1935 and which included works by several international artists. Painters such as Max Ernst and Salvador Dali have had an influence on Freddie's work. His paintings from the years just before and after 1940, for example, bear a close though by no means direct resemblance to those of Dali. He paints strange, unreal beings in the midst of a naturalistic land-

197

scape in the detailed, precise style which Dali called "photography by hand".

This period in Freddie's development coincides with the beginning — and almost at once triumph — of fascism. The unreal, symbolically ambiguous content of his work may be seen as a protest against the reality which led to war, the petit bourgeoisie that was always apparent, and religion which gave rise to hypocrisy. But the attacks are made with humour, always disarmingly present. For many years his work was hostilely received, both by the public and by the authorities. Several of his paintings were confiscated, among them "Sex-paralysappeal" (1937) and German threats during the occupation forced him to escape to Sweden. After his return to Denmark in 1950 his work changes character. Detail gives place to masses of colour, pink as flesh, dismembered and sardonic at the same time.

Richard Mortensen (b. 1910) is probably the Danish abstract painter whose painting has undergone the greatest changes. As an artist he has never found it easy to work with others and has never had a close connection with any of the groups which other abstract painters formed. From the very beginning his work has possessed enormous, all pervasive energy. Each one of his paintings is full of expression and an openness which he seeks to control within an enclosed form.

As in the works of the other abstract painters the war is ever present in Richard Mortensen's important early paintings. After his earliest works, with elements of surrealism in them, he chooses subjects which — though abstract — show clearly that nature has been his inspiration. Leaves and other forms of vegetation are recognisable. His attempts at a more formal and symbolical style were succeeded during the war years by strongly expressionist compositions in which line and colour violently combine to fix the horror of war on his canvas for ever. Compositions entitled "Scene of sacrifice" (1945) and "The mad leave their dwellings" (1943) are typical of Mortensen at this stage. The finished paintings are not only violently expressionistic but also contain the many thoughts and impressions which have gone into their creation. They present themselves to the viewer both as a result of the war and as a reaction to it.

Wilhelm Freddie: Sex-Paralysappeal. (Assemblage and mixed techniques, 1936. *Moderna Museet, Stockholm*). Freddie is the only Danish surrealist who has won international renown.

199

Richard Mortensen: Nightly sacrifice. (Oil, 1945. *Statens Museum for Kunst*). During the war Richard Mortensen painted more spontaneously and in line with other abstract painters than he was ever to do again.

In this period of his development Mortensen was closer to the other abstract and more unsophisticated Danish painters than he was ever to be again. They painted spontaneously. With his deep knowledge of pictorial art Mortensen was more inclined to draw and construct his way towards the finished composition so as to control the strong sensibility to be found in all his work.

When the others were ready to join *Cobra,* and all this international group stood for, Mortensen's style was approaching its very opposite, namely French Constructivism.

He had gone to Paris with Robert Jacobsen. There he had made the acquaintance of such artists as Dewasne, Deyrolle and Vasarely, and became one of the leaders in the movement towards concrete realism. There is a certain dryness in some of Mortensen's work just before 1950, due to the almost ascetic objectivity and clarity of form

Richard Mortensen: Bourgtheroulde. (Oil, 1955. *Aarhus Kunstmuseum*). While other abstract painters were striving towards spontaneous expression Richard Mortensen chose the concrete style.

201

he was striving for. Later line, in particular, became of dominating and characteristic importance in his style. It has the same power of expression and commitment that we find in the paintings of Goya. It encircles his colour surfaces as an outline or runs through them like a nerve.

Like Bjerke-Petersen and Mortensen *Ejler Bille* (b. 1910) was a painter whose own particular form of artistic expression had as its starting point a set of intellectual, analytical ideas. After some early experiments with Surrealism he worked as a sculptor for a few years, making in particular small statues of animals, pared down to such an extent that they are pure form and animal in one. In the paintings he did immediately afterwards there is also the same sculptural conception of his subject. But it was during the war that Bille began to paint in the style which was to become characteristic of him. A multitude of small shapes spread and multiply across his canvases, filling them completely. There is constant movement; each form is present not only by virtue of its own existence but also as a part of the coherent whole. His paintings seem to grow like plants and according to their own inner compulsion, the artist simply being there ready to make any adjustments. The components of the picture gain cohesion from this almost natural growth. The lines and crisp colouring have the effect of extending the picture, so that from a distance it is full of subdued splendour but at close quarters all is boundless life and brilliant colour. Due to various influences, not least his travels, Bille's use of colour has undergone changes. Once his palette was brown, at other times white and green have been the preferred colouring.

The epoch begun by Bille and Mortensen was soon continued by other artists, though they did not build upon the same analytical foundation. The most important of these will be discussed below, but this is a suitable place to mention briefly the background common to them all and the general climate of the times which saw their break through. Very few of them had studied at the Academy of Fine Arts, most of them were adherents of communism and their work had its roots in society. In defiance of academic traditions they sought inspiration in popular art and the life of the common people. In their youth

Ejler Bille: Animal forms. Vejby Strand. (Oil, 1956. *Statens Museum for Kunst*). Bille's works bear the stamp of the places where they were painted and are often called after them.

they travelled abroad and artists such as Klee, Kandinsky, Max Ernst and Miro had an immense and decisive influence upon them. Many

years were to pass before their work was to meet with any real understanding and, in order to show that other artists in Europe were trying to do the same as they were, they arranged an exhibition in 1937 of works by Arp, Mondrian, Max Ernst, Tanguy, Miro, Klee and Kandinsky among others. They were fascinated by the art of primitive cultures, in particular the negro mask. They were in the midst, each one of them, of this process of self-education when the war broke out and the German occupation of Denmark sealed her frontiers. They brought their various experience together to form a group which during the war published a magazine called *Helhesten* (Ghost horse). In it they wrote about each other's work and also about psychoanalysis, which with its theories about the subconscious mind had opened a new and unknown world to them.

Influences from abroad were partly replaced by an enthusiasm for Danish popular art, ranging from the wood-carvings of the Vikings to medieval church frescoes. Danish landscape painting, which could be seen in museums, became once again the object of study and, in Denmark under the shadow of war, there grew up thanks to mutual inspiration an art which, it was realised later, had been achieved because it relied upon both a national characteristic and a number of strongly individual artists. Thanks to Asger Jorn's initiative an international group, *Cobra*, was formed.

Unlike most of his contemporaries *Henry Heerup* (b. 1907) studied at the Academy, though this had no appreciable influence upon his work. As early as 1934 he showed some of his junk-sculpture at the first exhibition held by "Linien". These are perhaps his most important and unique contribution to Danish art. In them he combines all the diverse ingredients into a whole that is full of the intrinsic value of each detail. Heerup has an eye for small, ordinary things. Whatever he discovers in them becomes, as far as at all possible, part of the whole without losing its own character. One might argue that someone like Kurt Schwitters had discovered the artistic possibilities of junk material and since him many others have done so. But Heerup made use of them, not like Schwitters for pictures, but for sculptures. There is an astonishment and extraordinary pleasure in his use of all these

Henry Heerup: The harvest of death. (Junk sculpture, 1943. *Louisiana*). Making use of objets trouvés for his sculptures Heerup is among the most important abstract artists in Denmark.

things which he saves from destruction. He is the first sculptor who works by adding together instead of carving away or modelling. Many

of Heerup's junk sculptures have disappeared. One of the finest which has survived is "The Harvest of Death" though it is not full of the vigour and appetite for life which is characteristic of much of his other work.

Heerup has also done more traditional sculpture, though this is not entirely true. He has modelled clay and carved granite — Robert Jacobsen was strongly influenced by him — but with the same care as he makes use of junk materials Heerup discovers, too, the individuality which is to be found in a piece of stone. He cuts no more away than is necessary to reveal it. "A human being does not resemble a stone. Why then should a stone resemble a human being?" he asks.

Like his contemporaries Heerup derives much of his inspiration from such typically Danish sources as the ornamental carvings of the Vikings and popular art. Heerup's work awakened his contemporaries to the awareness of their unique Scandinavian past. There is a vigorous enjoyment of life in his painting. Objects and people are perpetuated on his canvas as ornamentation. As early as 1934 he produced the serene, monumental Vanløse Madonna, where the Virgin is no longer a cult object but a representation of everyday human happiness.

Abstract art was introduced into Denmark by a few artists, but after it had gained a foothold one after another took it up and made his contribution to the common fund of inspiration. *Egill Jacobsen,* who was born in 1910, wanted to be a painter and his early attempts were in the naturalist style, which he found unsatisfactory. Deeply impressed by the ideas on abstract art then current in Denmark he went to Paris in 1934 and it was there he found his real inspiration. In direct opposition to all he had learnt hitherto he soon after painted his first picture in which he made use of masks, and "Accumulation" (1937 or 1938) is probably the first spontaneous painting to be done in Denmark.

It was inspired by the approaching war, and was the first already fully developed example of what Cobra achieved later. Colour and

Henry Heerup: The Vanløse Madonna. (Oil, 1934. *Nordjyllands Kunstmuseum,* Aalborg). Instead of a cult figure a vigorous picture of the joys of everyday life.

Egill Jacobsen: Accumulation. Composition. (Oil, 1937 or 1938. *Statens Museum for Kunst*). This is probably the first spontaneous painting to be done in Denmark.

Egill Jacobsen: Orange Object. (Oil, 1940. *Statens Museum for Kunst*).

brushwork make the canvas as pregnant with meaning as any words could do. It is the universal recognition of the horror of war and chockfull of indignation. A great mask faces us, full of sorrow. In front of it a black grating is closing. The total impression is extremely powerful — the red glow of war, the black bars across the white face of fear.

Egill Jacobsen is perhaps the artist who has most consistently made use af masks in his work and the possibility the mask offers for reflecting every expression. It is a simplification of the face which fixes the fundamental features in an instant frozen state. With an incredible feeling for colour he makes use of the structure of the mask to show externally a number of inner reactions. Often his colours are Danish and his fondness for green seems to spring from his love of the Danish landscape. In his travels abroad, for example to Cagnes-sur-Mer with Ejler Bille in 1947, his use of colours changes under the influence of his surroundings.

Carl-Henning Pedersen (b. 1913) and his wife, Else Alfelt, were two other painters who exhibited at the Høst exhibition of abstract art. It was Carl-Henning Pedersen's ambition to become a composer but under his wife's influence he was attracted towards art. His first attempts were as a sculptor but soon afterwards he realised that it was as a painter his talent really lay. The mask pictures of Egill Jacobsen were among his early sources of inspiration: since then his work has developed along its own lines.

His paintings are a poem in colour which he has not finished writing. His first canvases, whether sorrowful or happy, were executed with an honesty and innocence which are otherwise only found in the drawings of children. Later he lifts the beings in his pictures higher and higher above the earth until at last they are weightless defying gravity, inhabitants of space somewhere above housetops and mountain peaks. When Carl-Henning Pedersen uses colours the result is a fairy tale. By means of them he explores sacrosanct, universal situations and his own deepest innermost feelings.

All his paintings, in fact, reveal not only an occupation with the joys of this life but also an awareness of its brevity. The large canvas

Carl-Henning Pedersen: The Eater. (Oil, 1939. *Nordjyllands Kunstmuseum,* Aalborg).
The fascination of children's drawings and the art of primitive peoples is found in the
earliest abstract paintings.

"Story of man and the sea" is one of a series which he did in 1957.
Four figures are on a beach. Out at sea a ship, all sails set, disappears
over the horizon, a bird takes wing into the sky, only the humans can
go no further. A child grows out of the beach. The race exists for ever
but each one of us has only his brief life.

In most of Carl-Henning Pedersen's paintings men are able, because
of their inner life, to lift themselves high above this earth. Perhaps
the finest expression of the combination of the eternal and the mo-
mentary is to be found in "The Cosmic Sea", a great mosaic which
he did between 1959 and 1965 and which was immediately accepted
as one of the finest works of art ever to be produced in Denmark.
Here the painter has exchanged the quick stroke of the brush over the
canvas for the laborious task of placing in position the many thousand

Carl-Henning Pedersen: Legend: Mankind and the sea. (Oil, 1957. *Louisiana*). Where eternity and the present meet.

pieces of mosaic. The result is a huge, breaking wave sweeping unrestrained before our view. He has managed to hold it, frozen in a single moment, as only the greatest artists can do. It is illumined by an inner strength, equally powerful and overwhelming every time we look upon it.

Apart from Sonja Ferlov Mancoba, *Else Alfelt* (1910-74) is the only woman who made any contribution to abstract art in Denmark. After many difficulties her performance as an artist improved to such an extent that at her death her work was aesthetically the purest and most consistent of the whole group. Born in a low country she dreamed of mountains before she ever saw them. From the beginning they lift themselves sharp and prismatically towards the heavens as a recurrent theme in her paintings. After the war, when travel abroad became possible again, she cultivated and learned a new use af colours in the course of her many long journeys. Her brushwork attained a sensitivity and strength which reminds us of Japanese calligraphy. Her palette varied between a number of tones, among which pink in par-

Else Alfelt: Earth, water and mountains. (Oil, 1952. *Nordjyllands Kunstmuseum,* Aalborg). Profoundly interested in mountains Else Alfelt painted them throughout her life and produced some of the finest works, aesthetically, of all the abstract painters.

ticular resulted in a period in her production which does not appear to be appreciated as much as it should be.

The latest, but one of the most active, abstract artists was *Asger Jorn* (1914-1973). After training as a teacher he went to Paris in 1936 where he studied under Fernand Leger. Later he was for a short time a pupil at the Academy of Art in Copenhagen. He was in Copenhagen when war broke out and, like the others in the circle, he had to depend upon the inspiration they gave each other to develop the influences he had reecieved. In his early work during the war years it is possible to trace the influence of Bille in the way he covered his canvas with a multitude of small beings. As masks or ornamental animals they occur in rows and masses as Jorn departs further and further from the clear, symmetrical composition which he learned in France. Forms are sharp and faceted, colours chill and Northern. But like several of the other abstract painters Jorn was incredibly sensitive to his surroundings

213

Asger Jorn: Law of the eagle. (Oil, 1951. *Silkeborg Kunstmuseum*). Jorn presented a large collection of his own and other's work to the museum. (Photo: Lars Bay).

Asger Jorn: Gossip. (Ceramic plate, 1953. *Silkeborg Kunstmuseum*). When he went abroad in 1953 Jorn started working in ceramics. Apart from small objects such as this he carried out a large decorative work in the material. (Photo: Lars Bay).

and their colouring. During a visit to the island of Djerba, off the coast of Africa, the former clarity of form and colour was replaced by a tropical luxuriance in his treatment of both.

It was after this journey that Jorn, together with Constant and then Dotremont, formed *Cobra*, a group of artists with Danes, Dutch and Belgians among its members. During this period his style became spontaneous and in a very brief space of time he produced a number

215

of sharp highly dramatic pictures which earned him a European reputation.

The lyrical quality which had been evident in Jorn's work after his visit to Djerba was, about 1950, superseded by visions of dread: for example in the series of paintings called "The right of the eagle", from about 1950, which was exhibited shortly before the outbreak of the Korean war. The eagle with two heads stands rampant and threatening, its beak open showing teeth. Forebodings of war belonged to the times and reveal the fear of sudden destruction which had become a fact since the atom bomb was dropped on Hiroshima. The eagle's profile recalls that of the atomic mushroom and Jorn refers directly to it, calling one of his works "The destruction of Hiroshima".

While he was in hospital with Dotremont in his hometown of Silkeborg he painted a number of large canvases which he called "The seasons" and "The silent myth". In the latter series he hearkens to an inner voice and paints intimately his own part of the country and all the anonymous generations which have lived there. After 1953 he lived mainly abroad and while in Albisola, in Italy, he started working in ceramics and discovered hitherto unrealised potentialities in this material. In addition to a number of lesser works he carried out an enormous ceramic decoration for a school in Århus. Like a rugged stream of lava, endless and always changing, it sweeps through its cultured surroundings. As a continuation Jorn designed a large tapestry, with Pierre Wemaere, called "The long journey", which he presented to the school in Århus.

Jorn's work was continually developing and shows many various stages. It took him several years to conquer the preparatory process of composing his pictures but then his paintings grew in stature and spontaneity according to their own rules. A museum has been opened in Silkeborg to house the large collection of his own and his friends' work which Jorn presented to the town.

Robert Jacobsen (b. 1912) was somewhat later starting than the others in the group. His early work in granite was plainly influenced by Henry Heerup. But whereas Heerup carved the stone just enough to reveal its intrinsic nature Robert Jacobsen treated it as a more

216

Asger Jorn: La belle bête. (Oil, 1960. *Silkeborg Kunstmuseum*). Many of Jorn's works reflect the Nordic Expressionism of such artists as Munch and Nolde. (Photo: Lars Bay).

impersonal material. He cut into it from all angles, carved holes in it and drew out its shapes as if they were threads. After working in this manner for several years he reached a point where it was no longer possible to achieve fresh results from his material. He made a sudden decision and went to Paris with Richard Mortensen. In Paris he came under the influence of Constructivism and instead of his former more organic sculptures he began to make taut sculptures in metal which by 1950 made his name known internationally.

In his sculptures in stone Robert Jacobsen had handled form in such a way that spaces had the same importance as the mass, and in his metal sculptures he follows this method with new results. He uses the metal like contour lines to limit and surround a piece of air. The

217

Robert Jacobsen: Metal sculpture. (1964. In front of *Kunstpavillonen, Esbjerg*). Robert Jacobsen was attracted by Concretism in Paris and started working in metal instead of granite.

Erik Thommesen: Female figure. (Bog oak, 1960. *Louisiana*). Concentrating on very few themes Erik Thommesen has produced work that is unique in Danish abstract sculpture.

218

sculpture lives by virtue of the dramatic spaces confined within it. For a time Jacobsen gave up the concrete style and instead produced a number of dolls and smaller figures. They are touchingly expressive but nevertheless only present a minor and limited part of his production as a sculptor.

Erik Thommesen (b. 1916) also belongs to the abstract school. Since 1938-39 when he did his first sculptures in wood this material has been his favourite and working on only very few themes, he has made use of it in an endless number of ways. His early work had something of the sharply carved pathos of German and Scandinavian medieval wooden sculpture. Later he pared his work down until it has a unity, pregnant with strength and form, that has at once a rising tension and a solid down to earthness. In works such as "Mother with child", "Girl with plaits" and "Self portrait" he allows the rhythm of the sculpture to emerge from within and find its own form. His sculptures vary — either concentrating themselves into a heavy, vigorous form or extending coherently depending on the inspiration behind them. But in them all is a quality which, calmly and unaffected by all externals, has grown from within.

Sonja Ferlov Mancoba (b. 1911) showed her work in the earliest exhibitions of abstract art to be held in Denmark, but since 1936 has lived mainly in Paris and only exhibited in Denmark. She was strongly influenced by Bille's early sculptures and in Paris the work of Giacometti made a great impression upon her. There is a warm and embracing humanity in all her work. By adding to and subtracting from the sculpture until it was there she has succeeeded in endowing the simple, completely abstract form with something human and committed. After early work, particularly with masks, her sculptures now bring to mind an upright figure, which seen from a distance is still and serene but close to reveals the lively and mobile treatment of its surface.

Mogens Andersen's (b. 1916) early work in still life was done under the influence of Cubism and the Paris School. A number of paintings from this time, in both clarity of composition and execution, show the influence of French art. Then, influenced by Soulages, Mogens

Sonja Ferlov Mancoba: Sculpture. (Bronze, 1941—46. *Statens Museum for Kunst*).
Often a slow worker, in their final form her sculptures have clarity and a rich humanity.

Andersen began to paint in the abstract style, with strong brushwork and powerful rhythmic use of colours which spans many shades from brilliant ivory white to black.

After early efforts in Cubism *Egon Mathiesen* (b. 1907) has achieved a style where he balances his colours so brilliantly that his paintings have movement and life.

Outside the mainstream of Danish art mention must be made of *Sven Hauptmann* (b. 1911), who is one of the few in Denmark who has worked consistently with collage. Using junk material of paper and similar he has composed pictures of remarkable gentleness and strength.

Frank Rubin (b. 1918), too, has produced collages which have both humanity and artistic excellence. As a watercolourist he is one of the best in Denmark.

Ever since *Frede Christoffersen* (b. 1919) began to paint the sun has been his favourite motif. He has simplified it to a taut, almost abstract form enclosing an immense, controlled statement.

Dan Sterup-Hansen (b. 1918) paints human beings in space, in the

simplest possible way, often using subjects which reveal an obvious social indignation.

At the same time that Asger Jorn was founding Cobra a group of younger artists in Denmark were taking the preliminary steps towards ensuring the continuance of the pioneer work that Line had stood for. Line II was formed at a meeting in 1947. Less rigidly subscribing to the tenets of Dadaism, the majority of them turned towards Concretism which had taken Paris by storm. Richard Mortensen and Robert Jacobsen were living in Paris at the time and the latter took part in an exhibition of concrete art of the works of Arp, Deyrolle, Dewasne, Poliakoff and Le Corbusier amongst others, held in Copenhagen in 1948. Among concrete painters of the younger generation in Denmark Ib Geertsen, Albert Mertz (b. 1920) and Richard Winther are worthy of mention. Several French painters were working in Denmark at the time and a fruitful exchange of ideas took place.

While the French painters were mainly concerned with producing isolated works of art the Danes were attempting to integrate art with its surroundings and produced many fine works. *Ib Geertsen* (b. 1919) one of the members of Line II has most faithfully worked according to its original beliefs. Besides paintings he has done mobiles and sculptures which have been used in children's playgrounds. Recently he has done a number of colourful works for Danish hospitals, achieving an organic connection between art and its surroundings. *Paul Gadegaard* (b. 1920) has done work for a factory in Herning and successfully tuned his paintings to the architecture of the place. *Gunnar Aagaard Andersen* (b. 1919) painted a series of pictures on such themes as the right, acute and obtuse angles. He has strived after a directed Tachism and among his many works, which show him to be one of the most experimental and inventive artists in Denmark, is his interior of the forestry museum at Gävle. *Ole Schwalbe* (b. 1929), taking Malevich as his model, has painted severe, architectonic canvases with their own poetry. *Søren Georg Jensen* (b. 1917) is a sculptor completely concrete in style. Using granite and particularly clay in a number of cases he has managed to achieve a concentrated tension between the various elements of the sculpture. *Preben Hornung's* (b. 1919) first works of

Svend Wiig Hansen: Riding on Human Beings. (Oil, 1958—59. *Aarhus Kunstmuseum*). With violent visions such as these Svend Wiig Hansen is one of the most important painters and sculptors of his generation.

any importance were non-figurative paintings, but he has gone through several stages and now produces improvisations of great lyrical beauty and colour.

At the beginning of his career *Richard Winther* (b. 1926) based his work squarely on the concrete style, but under the influence of certain great masters he has now returned to the human body as the point of reference in his paintings. He uses people and situations freely in his works, but bound together by a deep sense of form and a brilliant, masterly use of colour. He has also done a large number of very personal small sculptures in clay.

Svend Wiig Hansen (b. 1922) began as a sculptor but has turned out to be one of the most important painters of his generation. His earliest sculptures, many of them of the human torso, have a certain sweetness about them, somewhat on the lines of the work of Gerhard Henning, for example. Later, thanks to his ability as a sculptor, he developed a violently expressionistic style as regards colour and form,

Willy Ørskov: Sculpture. (Bronze, 1958—72. *Louisiana*). Contrast between fluidity and rigid form occurs often in his work.

using human beings as his subjects. He uses the strongest possible means, employing colours verging on the impossible and deformed shapes in his sculptures in order to achieve the greatest range of expression.

Among younger artists in Denmark the sculptor *Willy Ørskov* (b. 1920), the painter *Arne Haugen Sørensen* (b. 1932) and his brother the sculptor *Jørgen Haugen Sørensen* (b. 1934) are especially worthy of mention.

MUSEUMS AND OTHER ART INSTITUTIONS

By far the most important collection of Danish paintings is that of *Statens Museum for Kunst* (The State Museum of Art) in Copenhagen. The State Museum's collection is supplemented by *Den Hirschsprungske Samling*, founded by Heinrich Hirschsprung and opened to the public in 1911. The Hirschsprung Collection excels in the art of the Danish golden age and is, too, of interest as a monument to the artistic outlook of the opening years of the new century, when P. S. Krøyer was regarded as the last word in Danish Naturalism. Also the *Ny Carlsberg Glyptotek, Ordrupgaard, Nivaagaard* and *C. L. David's Samling*

Arne Haugen Sørensen: Genealogical triptych. (Oil, 1972—73. *Nordjyllands Kunstmuseum*, Aalborg). His pictures swarm with life like a marionette theatre.

contain notable collections of Danish paintings. *Det National-Historiske Museum paa Frederiksborg* (The Frederiksborg Museum of National History) and our other historical museums afford valuable supplements to the collections housed in the art museums.

Thorvaldsen is best studied in *Thorvaldsens Museum*, his pupils in the *Glyptotek*, recent Danish sculpture also in *Statens Museum for Kunst*.

At Humlebæk, in North Zealand, the art gallery *Louisiana* houses a small collection of Danish art as well as an extensive collection of modern international art which has been built up in recent years.

Quite a few of our provincial towns have museums of Danish art: The museum of *Faaborg* and *Skagen* are special collections of the regional "schools", and so is *Bornholms Museum*, at Rønne. *Viborg* has its *Skovgaard Museum*. Frederikssund its *Willumsen Museum,* and *Silkeborg Museum* contains a large collection of the works of Asger Jorn and also of other artists, which he presented to the town.

The most modern provincial museum *Nordjyllands Kunstmuseum,* designed by the famous Finnish architect Alvar Aalto, was inaugurated in 1972. It goes in for 20th century art exclusively. The same applies to *Esbjerg Kunstpavillon.*

225

Jørgen Haugen Sørensen: Sculpture. (Various materials, 1971—73. Presented by the State Art Fund to *the Danish School of Journalism*, Aarhus). According to legislation passed in 1965 several artists have been commissioned to carry out decorative works and Jørgen Haugen Sørensen's is one of the most successful.

In the *Ny Carlsbergfond*, founded 1902 by Carl and Ottilia Jacobsen, Denmark possesses an art institution with (for the size of the country) considerable financial resources. Since the nineteen-twenties the Fund, which was obliged at first to devote all its resources to the Glyptotek, has rendered valuable services to contemporary art by purchases for the museums and by paying for the decoration of public buildings, places, and parks with paintings and sculptures. This work was inspired by Carl Jacobsen's dictum: The museums are for old art; the proper place for contemporary art is in the midst of life.

In 1956 the State Art Fund was established by law and allotted a sum for the decoration of public buildings with visual art, plus a smaller amount for grants to deserving older and talented younger artists. In 1964 the law was altered and the amounts available raised considerably so that the annual grants to the visual arts were:

226

20 three-year allowances of 20.000 kr., each	400.000 kr.
For buying works of art .	400.000 -
For once-and-for-all payments	350.000 -
For decoration projects .	1.500.000 -
	2.650.000 kr.

These amounts have since been increased in step with price rises.

Danish artists keep going a large number and variety of exhibitions. Mention has already been made of *Charlottenborg, Den Frie Udstilling* (The Free Exhibition), *Grønningen* and *Corner*. There are the art clubs which are found all over the country and which, besides arranging exhibitions, spread information about art by means of lectures and purchases of works of art for distribution among members or for permanent collections.

Many libraries have opened a special department for lending paintings and other graphics. The period of loan is three months at the most, after which each work of art can be exhanged for one or more new ones. Travelling art exhibitions which are shown at secondary schools all over the country, have been instrumental in bringing young scholars into direct and often fruitful contact with the best of modern painting and sculpture.

NOTE ON ART LITERATURE

For the theoretical study of the history of Danish pictorial art readers are referred to four encyclopaedic works which include exhaustive bibliographies:

"Danmarks Malerkunst fra Middelalder til Nutid", ed. by Erik Zahle, 3rd edition, Copenhagen 1947.

"Danmarks Billedhuggerkunst fra Oldtid til Nutid", ed. by. V. Thorlacius-Ussing, Copenhagen 1950.

"Weilbach's Kunstnerleksikon I-III", Copenhagen 1947-1952.

"Dansk Kunsthistorie" 1-5, Politikens forlag 1972-75.

A survey on the same lines as this book is Henrik Bramsen's "Dansk Kunst fra Rokoko til vore Dage", Copenhagen 1942.

Note: Paintings referred to in this book without mention of the owner belong to the State Museum of Art.

INDEX

233

234